Prewriting Your S

Prewriting Your Screenplay cements all the bricks of a story's foundation together and forms a single, organic story-growing technique, starting with a blank slate. It shows writers how to design ea) that they perfectly interlock like pieces of a puzzle, creating a stro undation that does not leave gaps and holes for professional script ind. This construction process is performed one piece at a time, on a time, building and incorporating each element into the whole.

The book provides a clear-cut that teaches how to construct that story base around concepts as indi vriter's personal opinions, helping to foster an individual writer's voi tures end-of-chapter exercises that offer step-by-step guidance in app sson, providing screenwriters with a concrete approach to building a ation for a screenplay.

This is the quintessential bool rs taking their first steps toward developing a complete narrativ ng, getting them over that first monumental hump, resulting in a well-formulated story concept that is cohesive and professional.

Michael Tabb has developed projects for and with Universal Studios, Disney Feature Animation, Intrepid Pictures, the Canton Company at Warner Brothers; producers Paul Schiff, Sean Daniel, and Lawrence Bender; directors Thor Freudenthal and Mike Newell; comic book icon Stan Lee; and actor Dustin Hoffman. A decade-long current and active WGAW member, Tabb serves on the WGAW Writer's Education Committee and co-created the union's first mentor program. Tabb has lectured at writers conferences from coast to coast and in classrooms at UCLA, USC, and Florida State University, and is a multiple award–winning MFA professor at Full Sail University.

Prewriting Your Screenplay

A Step-by-Step Guide to Generating Stories

Michael Tabb

Routledge
Taylor & Francis Group
LONDON AND NEW YORK

First published 2019
by Routledge
2 Park Square, Milton Park, Abingdon, Oxon OX14 4RN

and by Routledge
711 Third Avenue, New York, NY 10017

Routledge is an imprint of the Taylor & Francis Group, an informa business

British Library Cataloguing-in-Publication Data
A catalogue record for this book is available from the British Library

Library of Congress Cataloging-in-Publication Data
Names: Tabb, Michael, author.
Title: Prewriting your screenplay : a step-by-step guide to
 generating stories / Michael Tabb.
Description: New York : Routledge, 2018. | Includes bibliographical
 references.
Identifiers: LCCN 2018009018 | ISBN 9781138482289 (hardback) |
 ISBN 9781138482296 (pbk.)
Subjects: LCSH: Motion picture authorship—Handbooks, manuals,
 etc.
Classification: LCC PN1996 .T23 2018 | DDC 808.2/3—dc23
LC record available at https://lccn.loc.gov/2018009018

ISBN: 978-1-138-48228-9 (hbk)
ISBN: 978-1-138-48229-6 (pbk)
ISBN: 978-1-351-05827-8 (ebk)

Typeset in Times New Roman
by Apex CoVantage, LLC

My father wanted me to get a degree in business.
My mother said, "I'll talk to your father."
My dad paid a fortune for my training in the arts.

This book is dedicated to
Harvey & Natalie Tabb

Contents

ACT 3
Culmination

Figures

Foreword

As a screenwriter, author, and editor of *Script* magazine, I'm always striving to learn new techniques to improve my writing. I go to conferences, read books on the craft, and soak in all the information I can from my mentors and friends in the industry. One of those friends is Michael Tabb.

I first met Michael when we both were lecturing at the Screenwriters World Conference in Los Angeles. As I listened to his thoughtful advice, and the audience's reaction to his words, I knew his insights would help our *Script* magazine readers. In our discussion of him becoming a contributor, Michael revealed he already had about 285 pages of notes to write a screenwriting book. I suggested he organize his thoughts, use *Script* as a way to channel his vision, and then take those articles and use them as the basis for a book.

What Michael submitted for publication was better than most articles I had ever read on the subject of character. Then after his character series, he raised the bar yet again by writing detailed and innovative articles on genre and premise. I knew I would learn as much from his words as my readers would, which was exactly my wish come true.

For *Prewriting Your Screenplay*, Michael has expanded well beyond those articles, adding lessons regarding high concept, loglines, three-act structure, and outlining.

His insights into the importance of premise are critical. Unfortunately, these are lessons writers don't learn early enough.

A story's premise isn't about characters, plot points, or outlining. It's about the theme and the message you want to say regarding the human condition. What do you want people to feel when they read your work? What will pull them in and want to explore that hypothesis with you? What will make them discuss your story long after they've put it down?

Exploring the human condition is the purpose of storytelling. Michael helps writers discover the premise that will ignite their drive to fervently investigate the story's opinion. If we aren't passionate about our writing, no one will be passionate about reading our words.

Most writers don't spend enough time on premise, assuming creating interesting characters will grab a reader's attention. But a character is not a story premise.

Your characters are what you use to argue that premise, giving your story meaning through the actions and evolution of that character. Your characters cannot thrive in a world with a weak premise. The creation of premise has to be thoroughly explored, long before characters and outlining.

Think about the story-selling process. The first thing an executive will ask is "What's the logline?" The logline stems from the pursuit of your premise. If the hook doesn't intrigue them, they immediately pass. You might have exceptional story structure and character development skills, but it won't matter because no one will read your work unless the whole thing is stellar. In fact, many managers and agents will have their clients go through hundreds of story ideas before giving them the green-light to tackle the first draft.

This book leads readers from premise all the way to the other end of the story-development process, into loglines and making an idea high concept. When it comes to story development, this book explains it in a straight line, from A to Z.

As a writer, the expression "writing is rewriting" is endlessly drummed into our heads. But if you do the work preparing your story properly, your first draft will be more like a third draft. What Michael has created in *Prewriting Your Screenplay* is a way to get to the core of a story and find its essence before you do anything else. He even takes it one step further by providing a section on turning that idea into a high-concept one, including tips on outlining. All of this prestory work will save you countless hours of frustration. You'll get to that "light-bulb moment" faster so your words can fly on the page.

In this attention-deficit age, your ideas have to be better than ever. One of the most common questions an agent or manager will ask is "What else have you got?" Having a solid technique to elevate your stories will enable you to consistently come up with marketable ideas, increasing your chances of a successful writing career.

Many writers don't have representation simply because they can't effectively come up with one great story idea after another. As a professional WGA writer himself, Michael understands the value of harnessing your imagination into a sustainable career.

Prewriting Your Screenplay is long overdue. Not only will writers, students, and readers thank Michael, but I also have a feeling a lot of agents, publishers, editors, and Hollywood executives will sing his praises, too.

I, for one, am looking forward to using Michael's *Prewriting* process.

Jeanne Veillette Bowerman
Editor, *Script Magazine*
Co-founder of Twitter's #scriptchat

Acknowledgments

"If there is a magic in story writing, and I am convinced there is, no one has ever been able to reduce it to a recipe that can be passed from one person to another."
—John Steinbeck, letter to Edith Mirrelees (1962)

With that in mind, I am going to do everything in my power to prove the great Mr. Steinbeck wrong. I believe that so many talented, working screenwriters hail from the same renowned film schools for a reason. If my writing concepts are any good, it's because those who taught me inspired them. My education at USC, NYU, and the UCLA School of Film & Television made me what I am. When I put all those amazing ideas and theories together, I developed my own technique for approaching story.

I compiled my notes and all that wisdom for a possible book on writing for years, but I was blessed with the career of a working WGA writer. I never took the time to organize it. I had about 250 single-spaced pages of notes . . . and growing. I kept asking myself, "Who cares what I think and do?" As an oft-bullied, overweight, redheaded, freckled Jew, who had to wear braces with headgear to middle and high school, let's say that confidence has ever been my thing. Sure, I'm a working writer with more than 10 years vested membership in the guild, but I'm no William Goldman.

The truth is, I was procrastinating.

Meanwhile, writers and friends asked for advice, and they would come back to me saying I had changed their writing process forever. I opened myself to being a special guest to educators in classes and on panels. I've always been a solid communicator. Talking truth is easy, but putting it down in the right words is hard. I kept notes and spoke to classrooms and on panels for USC, NYU, UCLA, Columbia College's Summer in Los Angeles program, and even in my agent's online class for Florida State University. The more you speak about what you do and how you do it, the clearer the words become.

Before I knew it, I was orchestrating and moderating panels at the Writers Guild of America, West, as a member of the Writers Education Committee. I stepped up and co-founded the WGA New Members Committee's first ever mentor program

at the guild. Getting something like that off the ground was a huge deal, and I discovered that I wasn't the only one wanting to give back. With a handshake and a conversation, I was shocked at how much writers can give back. My contacts stepped forward in droves: David S. Goyer, Ted Elliott, Roberto Orci, Craig Mazin, Nancy Meyers, Marc Guggenheim, Bill Prady, Jeff Melvoin, Damon Lindelof, Katherine Fugate, Matthew Nix, Alex Litvak, and John August and Academy Award winners Aaron Sorkin and Eric Roth to name a few. If these great and generous writers make the time, I have no excuse.

That experience inspired me to carve out a little more time for giving back. I started teaching one class at Full Sail University's completely online Creative Writing MFA program. Since then, I've developed projects with Universal Studios and a new TV pilot with producers while feeling incredibly fulfilled working with students. This proved I could simultaneously be a working writer and give back just like those mentors.

After I spoke on panels for F+W Media's Screenwriter's World Conference, Jeanne Bowerman asked me to write for their online publication, *Script* magazine, at Writer's Digest. One post a month was all she asked. I used this format to force myself to incrementally flesh out concepts for chapters in my book until there was enough for a spine. Now, in print, I can tie everything together and do what the articles did not, which is to gather all those individual elements and show how the puzzle comes together.

I want to thank all of the people I have been fortunate enough to work with over the years. In every writing experience I have had, something was added to this book along the way. You all taught me everything. So, thank you to Jay Cohen, Dustin Hoffman, Nathan Kahane, Mark Canton, Lindsey Hughes, Lawrence Bender, Mike Newell, Roy Disney, Fredrik Malmberg, Dan Rosenfelt, Marc Evans, Trevor Macy, Katherine Brown Ryan, Paul Schiff, Tai Duncan, Branko Lustig, Sean Daniel, Jason Brown, Evan Spiliotopoulos, Jonathan Hensleigh, David Hoberman, Todd Lieberman, Patti Jackson, Lisa Gooding, Gill Champion, and the incomparable Stan Lee. I want to thank Alcon Entertainment's Andrew Kosove, Broderick Johnson, Steve Wegner, Christopher Fealy, and Chris Alexander for the experience of being a script analyst and the two Chris' for each recommending me for writing jobs outside the company. You were all my teachers on top of the countless amazing educators at the universities I attended.

A Hollywood writer is only as busy and organized as his team helps make him. So, I need to thank my agent, Ryan Saul; manager, Justin Silvera; attorney, Darren Trattner; and CPA, Robert Fromson, who take care of my business.

Lastly, I'd like to acknowledge Douglas Texter for taking time to proofread this book. I would never have felt comfortable sending it to publishers without someone I trust looking over it as thoroughly as he did.

Preface

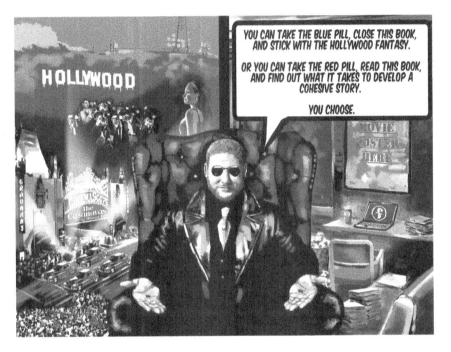

Figure 0.1 Jason Lockwood (Lettering by Denise Deems) – Blue pill, red pill: stepping out of the fantasy Hollywood Matrix into the reality.

Character credit: *The Matrix* (Warner Brothers)

I've never had writer's block.

I never have to wonder what I'm going to write or how to cinematically show it.

Why?

I have a method.

It starts before characters, structures, outlines, and beat sheets.

Building a spinal column starts with a single bone.

I stack each bone atop the next until I have a complete skeleton for a script.

Working out these key details in advance dramatically diminishes endless rewriting.

The *Prewriting* method shapes each piece of the story puzzle to interlock perfectly.

This book explains my step-by-step process for finding a story.

I'd love to share with you how I do it.

Here's to paying it forward.

This is how I go from zero to story.

Act I

Story origins

Chapter 1

Premise

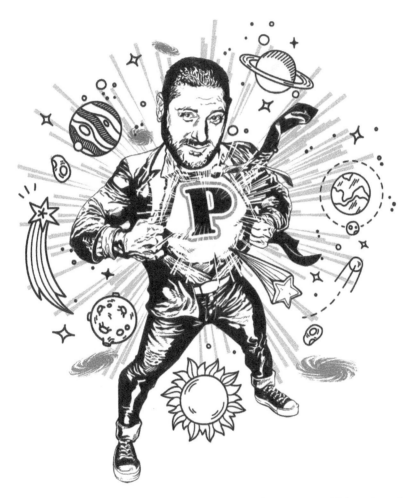

Figure 1.1 Greg Lee Dampier – P is for premise: a writer's superpower. It's how the writer projects a personal truth into the universe.

"You can't wait for inspiration. You have to go after it with a club."
 −Jack London, Getting Into Print *(1905)*

In the beginning, there was darkness. A void. Most writers spend an endless amount of time staring at a blank page, waiting for ideas to come to them. There's this great line from the movie *Real Genius*, "You can't dictate innovation." Yet that's how most writers work. They wait for an idea/concept to dawn on them, or they go looking for it like a set of keys they misplaced. Those writers try to design a story from the outside, and then they work their way inside. Well, at least the better ones do. They try to reverse engineer a soul into an idea. Don't get me wrong, a writer can reverse engineer a premise into an idea that already exists, but what happens when you don't have that big idea?

Instead of waiting for an idea to come to you, I am going to share with you a routine to bring you to the idea. You don't have to start with an external search for a story idea and backtrack inward on a search for meaning. Instead, you can start with the heart of the story, which is right inside of you. Throughout this book, I will break down how a series of steps taken in a specific order will lead to creating story ideas, so stick with me. This is a method I have used for years, and, because of this process, I have never had writer's block a day in my life. You never have to stare at a blank page waiting for inspiration. Why? Because you actually have everything you need to start writing inside you already – in your heart.

Wow. That sounded incredibly cheesy. Nothing like trying to swallow a giant chunk of sharp cheddar. Let me wash that down with an explanation that isn't quite so hard to digest.

I rarely start writing with a whole story idea in mind unless I've been hired to adapt a preexisting property or idea by a studio. Do you want to know why? What makes every truly great story striking is the unique voice from deep inside the DNA of the person writing it. The only thing nobody else can bring to a script when they write it is *you*. That is what makes each written work one of a kind and totally original. Only you can write from your perspective. We all have things that truly bother us, hurt us, scare us, and affect us deep and strong. That deepest part of our psyche is the place from which your truth, your ideas, and your artist's voice will come. Tap into it.

I always figure that if my story comes from the heart first, the soul of the movie will be strong. That soul is a foundation worth building upon for any script. Unlike those who start with the story, working from the outside in, I am going to teach you to build from the inside out. That's where I want to start.

Everything has to start with something, somewhere. I start every script with a premise, the core of a strong idea in all visual media. The idea should be presented as a single statement, no more than that. It must be an incredibly clear and succinct point of view that the writer intends to explore. Story and characters come later. First comes the creative spark. It's the birth of a story idea whose origin stems from a single point.

The act of narrative creation is an exceptional metaphor found in the origin stories of our universe. Whether you believe in biblical creationism or the Big Bang theory, which are not mutually exclusive, this explosive act remains an uncanny parallel to concept conception. If the protagonist is the Earth and the other characters are the moons all around it, premise is the Big Bang itself, day one, and then there was light. Premise is the origin of all the ideas hurtling through space.

What exactly is a premise?

You're going to laugh, but my take on this all stems back to my mother. Every single time she took us kids to a movie, without fail, she would ask us tikes, "What was the moral of that story?" What I didn't realize at the time is that she was asking us what the writer was trying to say. She had no idea that she was training me for my future career. She'd have us boil the movie down to one thing. Every good movie had a single answer to that question.

Albert Einstein once said, "If you can't explain it simply, you don't understand it well enough." A writer needs one clear statement. My mother had me doing story analysis, figuring out the core value behind every single movie I saw, from the age of 5. By the age of 7, after every movie, no question was being asked. We'd just start talking about it before we walked out the theater doors. Looking back, it's no surprise that I started creative writing for the fun of it when I was 6.

The most important question for a writer to ask about his story is, "Why?" Unless there is a reason, a story is just a series of meaningless events and circumstances. A mother kills her child, but that's not a story. It's a situation. The story is why she did it. Can you imagine a writer not knowing the answer to why? There's this great, classic cliché of an actor constantly asking the director for his character's motivation. Motivation grounds a story in reality and truth; it gives a character perspective. Writers spend so much time making sure they know why everything happens in the script because this *why* is what writers have to be able to make clear on the page. Everyone in the story development process is always asking one of two simple questions: why or how. The enormous irony of that fact is that the writer figures out why every character makes every choice, yet forgets to ask the biggest why of all.

Why write the story?

Have you ever watched a show or film that had all the right things that a good story is supposed have – characters, conflict, high stakes, love, great action, cool effects, etc. – but somehow it still managed to feel empty? That's because the writer didn't figure out what it was all trying to say. Some writers think cool ideas and characters are enough. It's not. How can a writer expect an audience to follow a story if the writer doesn't know why he or she is writing it?

Yes, the writer needs to learn from the actor here and ask, "What's my motivation?" I think this is why so many actors find it totally natural to try their hand at

writing; writers ask the same questions actors do. A writer needs the story to have a motive. Without that core, there's nothing binding all those elements together to feel like it's one story with purpose. Hemingway's *The Old Man and the Sea* (1952) remains meaningful to readers to this day because it reads as if it's about much more than an old man who likes to fish. The same goes for all great stories, from the plays of Shakespeare to modern cinema.

You can call it a lot of things. A premise is the core belief system of the script and the lifeblood of the story. The best and most logical way to think about this concept was something another former USC student, screenwriter, and film school educator once said to me: "If you see the screenplay as a creative term paper, premise is the hypothesis of that paper." Garrick Dowhen was right, and it's the perfect analogy. Now, there can only be one premise per script, from which all the ideas it contains serve. Otherwise, the script loses its focus and sense of purpose. Premise is hypothesis. It's the story's purpose for existing at all.

I think of a premise in terms of how I would answer one specific question. The answer to that question changes based on where I am in my life. So, when looking for yours, maybe you'll ask yourself the question I always ask myself:

> If you could convey just one truth to the entire world from your deathbed, and all the world will hear it with your final breath, what would you say?

An analogy to explain this is that the writer is the power source, the story is the vehicle, and the premise serves as the power cables. Every script should have a premise in which to ground it. The premise is the electrical current that keeps the engine running no matter what note any executive gives the writer. As long as the writer can keep the proverbial battery charged, he or she has the grounding wire for powering the story. A strong premise allows the writer to march forward with whatever the studio throws at him or her. I've heard it wisely said, "Don't give it 5 minutes if you're not willing to give it 5 years."

The premise and how important it is to you are why you won't give up on this script after 10 rewrites for the studio. It's why I can keep rewriting for as long as they pay me. An executive or a producer can ask a writer to change the characters, story, relationships, everything – but the premise stays the same. It gives the writer something to fight for and keep working toward.

The soul of your movie is on the line with every draft. You will be trying to crystalize this statement with each edit. A premise is the writer's entire reason for telling the story and the main reason he or she does not get sick of writing it.

Premise is not a word, theme, feeling, story, question, plot, or tone. It's not about a person; it's about the world in which we live (even if your story is not set in our world). It's a strong statement with a point to make; it's the theory the writer is trying to prove or disprove. This theory defines the author's perspective, helping readers and script analysts understand you as an artist and the kinds of things about which you were born to write. Whether the scribe is an optimist or a nihilist

comes across in what the writer says with his or her story. The premise is what the writer will prove to be true at the end of his or her story.

The use of premise applies to all storytelling in all mediums, including comic books, television shows, and films.

Premise is the writer's personal opinion. It's a general-life statement. It doesn't have to be nice; it needs to be what the writer believes. A writer will spend the entire script proving it. It's like J. D. Salinger writes in *Catcher in the Rye* (1951), "The mark of an immature man is that he wants to die nobly for a cause, while the mark of the mature man is that he wants to live humbly for one." This's what writers do.

To make a long diatribe short, the best screenwriters know how important sub-text is in dialogue. Your premise is the subtext of the overall story.

The very brief history of dramatic premise

For the original master of defining a strong, dramatic premise, we look to Lajos Egri's *The Art of Dramatic Writing*, published in 1946. While Aristotle's *Poetics* originally analyzed and taught the mechanics of plotting at the core of storytelling, Egri took a new angle. He felt that the best stories are character driven, and premise is at the core of any character-driven tale. It's the premise that inspires the protagonist's two journeys and defines his or her character arc.

Egri was writing about the concept of premise in scriptwriting long before Syd Field, William Goldman, and Blake Snyder and using it to analyze the classic stories that survived the greatest test – time. Egri's mathematical equation for premise contains three variables: protagonist, conflict, and resolution. His phrasing is a simple formula with either a positive or negative result. The positive is traditionally worded as *this defies/leads to that*. The negative is *that conquers/destroys this*. I equate this to one of those simple math equations where something is either equal to, greater than, or less than the other side of the conflict. Some of Egri's examples include Shakespeare's classics, including *Othello* (jealousy *destroys* itself and the object of its love) and *Macbeth* (ruthless ambition *leads to* its own destruction). Now, none of those statements are ever stated in the dialogue of those famous plays, but the story continues to resonate over 500 years after they were written because of the subtextual truth of each premise. In the end, the technical phrasing of a premise doesn't need to be complex. It just needs to be true.

That said, even Egri admits that it's hard to start an idea knowing who the hero is, what the central conflict is, and how to determine the result of that conflict from the start. It's just a lot to try to wrap your head around from the beginning. He says sometimes you have to come back to the premise as you research. Well, for me, if the starting step isn't something you can do as the first thing, it's obviously not the perfectly designed first step.

Therefore, before I break down how I create a premise differently, we need to ask . . .

What does a premise need to do?

The one constant is that a premise clearly states exactly what the writer is trying to say.

1 It states the script's hypothesis.
2 It says a tremendous amount about the writer.

When figuring out a premise and starting to mine for that deathbed declaration, a writer asks him- or herself a series of questions all basically asking the same thing in different ways:

- On a subatomic level, what message can endlessly fuel a fire in your belly for finishing this story?
- What makes this more than entertainment?
- What makes your tale important enough that it's worth years of your life to get it right?
- Why is it worth producing?
- What would you like to say to people you deeply love to stop them from making the same, stupid, self-destructive mistakes?
- What would you say to all the politicians running for office on either side of the aisle?
- How could we make life better?
- What could actually bring world peace into being?
- What quintessential thing about life does the world in general seem to not understand?
- Why do you want to keep breathing?
- What makes you want to stop breathing?
- If you could say one last thing to the one that got away, what would it be?
- If you had a day to live, don't ask what you would do, but why would you do it?

Answer these questions for yourself.

The best premises are based on a personally held belief by the writer that is true yet *contradicts* common, public opinion. In *Leaving Las Vegas*, the premise is arguably proving wrong the old adage and widely believed common misconception that "Life goes on in the wake of deep, personal tragedy." According to that movie, not even a new love can fill the aching gap left by the loss of true love.

The first half of this chapter has covered *what* a premise is, which leads us naturally to a question of *how* to create a premise.

Creating a premise

While Egri teaches that it's perfectly acceptable to write stories based on a tried-and-true preexisting premise, I would feel utterly unoriginal using someone else's exact wording for the meaning behind my story. As a career writer, I know

everything has been said before in some form or another, but I'll be damned if I'm not going to find a way to say it that is not original in some way. Much of screenwriting is an artist learning to present his or her own voice into tried-and-true storytelling structures, rubrics, and equations. I believe in making everything my own, so I do not always use Egri's model.

Egri and I agree that the truth never gets old as long as the story is fresh. I say it's perfectly acceptable to bring the writer's individuality into a premise's wording. I believe that specificity of unique, powerful wording in the idea origins will echo throughout the final material. So, when trying to figure out what a premise really is, I took a step back from Egri's math and looked to a more universal source for definition.

Merriam-Webster defines *premise* as "A statement or idea that is accepted as being true and that is used as the basis of an argument." Now, that's a much more versatile form of first-step story conception. From that, I take the word *true* and the fact it's a *basis of an argument*. I use that to create a hypothesis.

Sometimes my dramatic premise does present itself in the terms Egri teaches (character, conflict, and resolution), but at other times it does not. So, if Egri's equation isn't a foolproof approach all of the time for opening the door, that lack of being a universal skeleton key doesn't mean it's wrong. It just means you need to recut the key to fit your lock. Egri's method is a theoretical jumping-off point. It's not always the right key to open every lock. Writers must always retain creative license over their own individual process of creation. Egri launches us. All creative theorists expect the best and brightest of us to come up with our own take on their teachings. Egri puts us in the ballpark, and then we can always run with the ball. Yes, I know that's a mixed metaphor of baseball and football, but you get the point.

We each have to find the recipe for premise that works for us as individual writers. Therefore, I sometimes adjust or defy theories, methods, and what some call rules. No rule works 100% of the time in all situations. The minute we think only in terms of rules, artistry and creativity become stagnant theories. That doesn't mean that you ignore wisdom; it just means that situational adjustments are nothing to fear if necessary once the options have been thoroughly considered. Knowing exactly when to stray from proven precepts that professionals know work takes some experience and knowledge. If you break story model traditions, you'll need to be able to explain it far better than "I thought it was a good idea at the time." It should be thought through and come from a place of intelligent design.

So, as I tweak Egri's theories, I always stay faithful to the spirit of what premise is designed to mean. For me, an origin premise is just a simple moral that needs to be vetted, discussed, and played out visually. That's my fantastic jumping-off point. This means I put two of Egri's three components aside (characters and resolution) and focus on the conflict. Everyone has to start somewhere specific. All I need to figure out is what I want to say. What am I

wrestling with when I look at the world today? Here are some examples I have come up with:

- There's never *enough* because there's always *more*.
- Liberty is merely permission currently granted by law, but freedom is yours until you give it up.
- Nobody today would put the betterment of others before themselves.
- Life is about how you treat the people in your life.
- Love trumps greed (which is not something as generic as "good triumphs over evil").
- The needs of the family trump personal satisfaction.
- You owe even horrible parents their due.
- Always go for it because regret haunts you until you die.
- Secrets are essential to a happy marriage.
- Guilt is the roadblock to happiness.
- Lies devastate lives.
- Fear squashes freedom.
- Each person is responsible for humanity's destiny.
- Irresponsibility is the secret path to happiness.
- Justice is a second crime.
- Dying for a cause is wasteful.
- Relationships should serve you, not the other way around.
- Addressing your emotional guilt is the painful process of growing into a better person.
- Power is a death sentence.
- A mother's love has its limits.
- Absolute power has no true friends.
- Ignorance is dangerous.
- Nobody wins in life.

You should notice that a strong premise says what is true. It proves what works or wins.

Resolution versus realization

Some of these maxims do not contain a resolution as Egri teaches they should. I believe in writing entertaining stories with deep, subtextual meaning as he does, but I want to write them for a highly evolved mind. Ian Watt (1974) argues that the novel developed only with the rise of the middle class. While society continues to evolve, so must the medium of storytelling in order to speak effectively to those masses. Mankind's evolutionary development requires growth in how we write for civilization's entertainment. Therefore, sometimes I write toward an ultimate goal of realization rather than Egri's model of resolution. I believe that thinking is a bit more evolved. Occasionally, I don't even pinpoint the protagonist in the premise because whatever is being realized implies where the protagonist starts his or her journey. When a premise is about realizing that "Life is about how you treat the people in your life," then obviously the protagonist is not thinking of his or her friends when making selfish decisions at the top of the story.

Consider the following examples of premise in different visual media:

- *The Breakfast Club* is a film about surviving an entire day stuck in a place with a group of people with whom you would never be caught Deep down, the premise is we really are all the same just as much as we are individuals.
- *Angry Birds* (game) insists that there is always a right, best way to accomplish any task. The key to targeting is the way in which everything is connected together.
- *Psych* (television) says that the skill of observation is so important that it's a sixth sense.
- *Spider-Man* (comic) teaches the thematic statement, "With great power comes great responsibility."
- *Saving Private Ryan* says with every team member's death that showing mercy in wartime gets the merciful killed. So, mercy is good, but it has a price.

You will notice that these are all realizations, not resolutions. Therefore, I think of premise as a profound observation.

Egri explains that the premise doesn't need to be true 100% of the time; it only has to be true for the story you told. I agree. That said, some writers prefer to write toward constant, universal, conventional truths and wisdom. Now, I prefer not to, but in such cases when I do, it makes more sense to base the final analysis of the premise in a realization instead of Egri's concept of resolution. A realization can affect different characters in different ways. It provides layered conclusions in a situation with more predictable, conventional wisdom. For example, a realization-based premise doesn't doom all people to the same resolution. Mathematically, the end is less predictable if the premise doesn't demand one outcome/resolution. The difference is significant if you think about it.

Ironically, Egri designed his model to start looking at story from a character's perspective, but to base a premise in the resolution is a plotting perspective. Meanwhile, a realization ties directly to the concept of an inner journey or character arc. This means that by switching the resolution part of the equation to a realization, I think I've figured out a way to make Egri's initial goal truly grounded in a character-driven model as opposed to plot-driven one. It's the difference between a physical, plot-centered concept and an emotional, character-centered concept.

Be original

Whenever possible, the writer's remedy for the problem being faced by the characters should be unique, fresh, and specific among a pantheon of produced cinema, television, games, and comics. Whether it be a point of view based on injustice or a common misconception, avoid clichés or at least give a new twist on them. Challenge yourself to stand out from the 99% of writers who will not get hired because they sound just like everybody else. Stay away from using conventional universal truths as a premise. I'm not saying you shouldn't use them. I'm just saying don't let something we already know be the whole point of your story.

Universal truths are necessary to communicate to an audience in a way in which they can relate, instead of hoping readers keep up with the nuances and subtext that skilled writers layer into their work. These truths are misused as platitudes at times, but they are needed in order to communicate something more complex in a way everyone can understand. So use them, but I say take one more stride on top of that. Instead of basing a premise in universal truth, use universal truth in plotting to prove a more *personal truth*. That's how writers lay claim to a story.

Having a totally personal, unique view of the world is the bedrock of defining your point of view as a writer. This viewpoint makes you different from all other writers. In fact, it's why you are writing at all. If you have nothing to say to the world, why write? How can you outline a story if you have no idea what it is you are trying to say with it? Admittedly, your premise may evolve while working on your story, but the premise needs to always be a strongly held opinion. It's important that it's something we have not seen exactly that way in other movies. Specificity and uniqueness of perspective of the world are at the core of an original voice. Universal truths are clichés and themes; premise is personal. Personality plays a role in premise. That's why I break the Egri mold on wording and scour my mind for a fresh version of those common conceptions or misconceptions.

Casablanca is a love story set in a volatile region and time. We want to believe that love conquers all, but, at the end of *Casablanca*, regardless of all the good that Rick does, we cannot escape the fact that he ends up without the girl. Love trumped Rick's self-interest, but it didn't conquer all.

If the truth will out, *American Psycho*, *Memento*, and *Nightcrawler* didn't get that memo. Movies like *The Wolf of Wall Street* prove that money and excess can buy happiness; it's just too bad for them that the law has the power to take it all away. Nightly newscasts constantly remind us that evil is still alive and thriving in the world, so clearly good hasn't yet triumphed over evil (as the universal truth would have us believe). Even if you don't like it, we know better from personal truth. These are the things we must ponder in our stories to give them a real sense of authenticity. A good premise can ram a truck through those misconceptions that people want to believe.

Don't get me wrong. A premise can support universal truths and be supported by them, but the writer must be sure to stage a fight we have not seen. Nobody wants to pay for an opinion that's been heard a million times. Find your own personal truth. A story uses universal truths and clichés to make a point and explore common themes, but none of those things make a great premise. The cornerstone of every script should be original or else the entire script is a rehash of something everyone already knows. A writer's premise is a fresh hypothesis, showing that writer's unique point of view to the world. This is how a writer's voice stands out from amongst the pantheon of other writers and the pile of scripts competing for every development executive's attention.

How to nail down the premise

A premise must (1) show conviction on behalf of the writer and (2) have a meaning that would be crystal clear to any stranger who reads it. The wording should

leave absolutely no room for confusion or misinterpretation. If writers want their story to be written with passion and purpose, they form a strong opinion and clear premise.

Get to the bottom of what bothers you. The pet peeves we have are streams that run from a much larger body of water. Figure out why something ticks you off so much. What does it mean? What does your discontent say about the human condition and human behavior? The specificity of one perspective that stems from personal truth all comes from writers' willingness to go to the deepest, darkest places inside themselves – places where only a masochist would willingly go. Hence, the cliché of a tortured writer exists.

Yes, the added benefit is that you may learn more about yourself. This education may be therapeutic. One of the reasons I think so many people are drawn to trying their hand at writing is because it's an evolved form of mankind coping with the concepts and realities that trouble us. Let's not forget that human consciousness and evolution are partially based on narrative perception. Everything we learn stems from an experience we involuntarily construct into a story in order to explain it to ourselves. Otherwise, we might have suffered the same fate as the dodo bird. Our brains are hardwired as narrative machines by grand design. Therefore, it makes sense that storytelling is the ideal delivery system for communicating any message to mankind.

Themes are universal topics addressed in stories. "Love conquers all" is a classic theme. Shakespeare's *Romeo and Juliet* says something far more specific and unique, which is that "Great love defies even death."

The statement made with a premise is something the writer thinks either (1) should apply to everyone/everywhere but doesn't or (2) does apply to everyone, and they just don't know it yet.

The fact that the statement is a truth not yet understood universally is exactly why you have to write it. If all people believed it already, the story is already a cliché before you even write it. A premise is something a writer sets out to prove and illustrate through characters and conflict.

Let this self-exploration lead you to making a list of things you're dying to make clear to the world. In your heart, you have a set of core beliefs about the universe. Everyone does. Write them down.

Each premise is a separate story.

- A premise is *not* in the form of the question; a premise is the writer's answer.
- The premise should *neither* mention specific characters *nor* situations of your movie idea. It's a core belief that will inspire those things.
- It does *not* have to be about peace or love if that's not who you are.
- It's *not* simply a situation. It's the author's attack on one.
- It *never* mentions the story's title or genre.
- *No* clichés. You'll never stand out as a writer by saying something a bunch of other artists have already said before you.

- A premise is literal, which means *no* metaphors, exaggerations, *nor* similes.
- It's clean and clear, which means the premise states one certainty, *not* two or more possibilities.

- The premise is a declarative opinion. Therefore, you should *not* use words like *usually, can, may,* or *might.*
- Try to keep the word *not* out of your premise.

With regards to the last bullet point on the list, remember that we want to say something with our premise. For example, "Murder is not the answer" is not a strong premise. Putting aside that it would be a cliché, that premise literally is a nonanswer. It's telling us what isn't, not what is. A premise has purpose, offers progress, drives story forward, does or pursues something, and is going somewhere. We want premise to provide movement, action, and a desire for accomplishing something. When a writer uses the word *not* in the premise, it becomes a boring vacuum, equivalent to being trapped in stasis without an answer. It doesn't go anywhere.

Louis Scheeder (a classical theater educator and Broadway director) explains the distinction best. Louis was directing NYU's main stage production of *A Midsummer Night's Dream*, and he gently told a student lighting designer:

> Don't tell me you want the look of our show 'not blue.' I can't see 'not blue.' I don't know what 'not blue' looks or feels like. What we don't see provides us with no answers and no frame of reference. It's way too wide open for interpretation. We could feel around in the dark, get nothing right, and be devoid of answers if all we know is one thing it's not. Our work will never be right if we don't know what right actually is instead of what it isn't. Talk to me about what we do see.

Great writers are intuitive enough to find wise answers. This world needs creative thinkers with fresh ideas. I'm reaching out to writers smart enough to unscramble life's mysteries and see the truths others miss. Say something and offer solutions to a world so full of complexities. Have a voice and a bold statement. Be brave, and risk offering opinions. If you want to play it safe, you shouldn't be a writer. If you're a nihilist, that's fine. A premise can be a hard truth to stomach. We don't have to be happy about your premise or what it means; we just need to believe it's true. You need to deeply mean it. If you prove it and strike the raw nerve of truth, your voice will carry.

Great writing is all about saying the most with as little as possible. Find a way to say it succinctly. So, yes, you guessed it. It should be one clear sentence. That is all. It should all boil down to a singular statement. It needs be articulated in a way that conveys significance, clarity, and power. Edit down each premise concept of your belief system separately. Keep the premise simple and focused. Avoid conjunctions like *and.* Your premise should be one sentence, making one statement. Succinct. Powerful. Your truth.

The best writers argue a point and make their point crystal clear without ever stating it in the script. They don't have to because the ending makes the point clear.

Expansion through brainstorming

After you have a list of premises, start a long list of ideas, physical actions, situations, and characters under each one that you could use to fight for and against the premise. Draw from personal experience, stories from the news or friends, and then use your imagination. Let it run rampant with imagery, actions, reactions, and potential conflicts proving or debunking that premise. The length of the list tells you how much you personally have to say about the subject.

Don't edit yourself at this point. You add to the list; never subtract. Just because an idea or specific situation is on the list doesn't mean you're going to use it in your script. This is all just building a color palette for each concept. Just keep adding and adding. You're simply brainstorming in order to spin the visual and emotional fabric of a story you have inside you.

Creating this list is the first step of the organic story-growing process. You do not have to pick which premise you are going to write first. You are just laying a foundation for several movie ideas at once. Eventually, while climbing the steps of this process, one idea will sprout best and root itself deepest in your subconscious as the one you need to write first.

So come up with your premises and keep expanding the list of attributes for each one.

Keep the premise concepts in a file so you can always add to them. Add concepts as well as images to go along with ideas for new premises as life teaches you lessons.

When an idea is ready to be taken to the next step, writers feel it in their bones.

When looking back at a premise

My roadmap for idea generation starts and ends with premise. Once a writer has created a premise, filtered it through genre, sculpted the major character types, and locked down a story idea, he or she should return to the premise. It's only at that point in the process that writers will know enough to lock down a premise that fits Egri's model if they wish to use it. The character–conflict–resolution model is great, but even he admitted that a three-layer premise doesn't occur to a writer right away. Egri's understanding of the difficulty of using this model is why I felt it was a good idea to share with you my own method for a way to unlock a premise that can be used every single time without fail.

The key to never having writer's block is to never stare at a blank page waiting for an idea. I insist on never being without a way to unlock inspiration. Great story ideas float around in the ether above and around us. I don't ever have to wait for them to land on me or drift my way like a feather on the wind. Premise is my harpoon gun; it reels the stories right into my head.

The story idea is what you sell. It's the big front door to your script when you pitch it to anyone else in town. The premise approach is the secret back door entrance for creators. Others might see it as the service entrance. Either way, this approach is my key to the kingdom of concept creation and a firm foundation for world-building.

Now, as much as that's a big deal, we're not done with premise and its functions. Premise is far more than a foundation. Premise is a stabilizing agent that runs through the DNA of the entire project.

The gift of premise is its ability to keep the script on track

Once you know what your premise is, you should never feel lost in the woods. In the dark of night, all you need to do is look to the sky and premise is your North Star. It's always up there to guide you home to the story's core truth. If you don't have a premise, go back to the idea and figure out what it is. Dive deeper and ask yourself why you wanted to write that story in the first place. What compels you about the subject matter? What troubles you about it, and what does this troubling feeling make you want to say to the world? What are your arguments for and against the premise? Where did you stray from it? What did you forget? I always start there.

When you need to cut pages, go back to the premise and ask yourself what scenes aren't making a compelling argument on one side or the other. This process is extremely helpful when a writer overwrites a first draft and isn't sure at first what to cut. Cut what has nothing to do with your premise.

From first to final draft, premise is the key to clarity, vision, and voice of a film. If the film never had a heart, you just discovered why you're having trouble.

As great writers have noted before me, in the end, when you look back, you will find that premise is the intersection where individual plot meets universal theme. It's the seed at the center of it all.

The three most common premise mistakes

I Unsubstantiated victory

It's awful when someone spends an entire film making a point, but the film doesn't hold our interest. A badly written script with a strong premise can be incredibly boring. That state of affairs happens a lot. There's always one common denominator as to why good and meaningful ideas bore the hell out of us. The boredom happens for the exact same reasons some well-conceived protagonists are boring to watch. They can both suffer from the same problem. The writer loves the character and premise too much. You'd think that's a good thing, but this love can turn around and bite the writer in the ass. Deep down, the writer doesn't want to hurt the characters. The writer wants to protect them, keep them safe, put them high

up on a shelf behind safety glass, and gaze lovingly at the splendorous beauty and meaning they represent like some stunning relic in a museum. Sadly, to make a great script, everybody has to get their hands filthy, fight hard, and spill a little of their own blood along the way.

Therefore, the big irony of proving your point is that you must also fight tooth and nail for the other side of the argument. If it's not a good fight, we check out and lose interest. *Scent of a Woman* only works conceptually because as much as the Colonel believes that the value of living has an expiration date, Charlie (his young mentor) never stops fighting for the value of living. Fight extremely hard against your premise so that the point feels proven. Without a hard-fought battle featuring great arguments on either side of the premise, the film is just a piece of propaganda with an agenda. Great movies aren't preaching one idea from atop a soapbox. I believe this preaching is why religion-based businesses take a hit when times are good. People go to houses of worship in the wake of death and when they have something they need to pray for or understand. It's a fight for light in the darkness. Attention and purpose are spurred on by palpable conflict. Unless times are tough, what are they praying for? This is why the primary Jewish prayer for the meal is said after having eaten. Before, people will say whatever to get what they want. To pray from a place of comfort – that is devotion.

Audiences want a compelling argument. Really uncover the sometimes beautifully intentioned flaws in the counterargument to your premise. Just as obstacles should not be easy for your protagonist to overcome, neither should the path to proving your premise. You have to give your premise a black eye and bust its ribs with strong body blows. You must show it for all the qualities that allow that belief system to thrive in the world in order to make the point of your premise clear so you can dismantle the argument, scene by scene. A premise's triumph must always be earned through adversity.

In *Leaving Las Vegas*, it proves wrong the old adage, "Life goes on." The writer threw every wonderful argument in the character's way he could. Ben was given enough money, the love of a beautiful woman, more booze than anyone could need, no need to work for a living, a city that's full of entertainment of every kind, yet none of it cured his woes from the loss he endured. The movie disproved a common misconception with a character's personal truth. There are some things a person does not get over, which is why suicide exists. The movie debunked what many people consider to be a universal truth and showed it for the common misconception that it can be under certain circumstances. That is the key to proving or disproving anything: finding the right, personal situations in which to display your opinion. They need to be specific and truthful in order for audiences to go along with your argument.

This is all a rigged game because a smart writer knows what the wrong side of the argument is from the start. Writers plan and plot the downfall of misconceptions at the end of the film, but that fact cannot allow the writer, who knows the ending, to get lazy. The writer cannot short shrift the argument. A writer must create a counterargument for the misconception so that it can defend itself, forging

a strong opponent to the premise. Otherwise, your premise is trying to claim an unearned victory. The creation of a contrary argument is a lot harder than it sounds because the writer knows all along the misconception is wrong. Meanwhile, the misconception should appear to be the far stronger argument from the start.

A protagonist never becomes the hero without a good fight. The same can be said for the writer. A writer doesn't shine unless he or she puts up a huge brawl to prove the premise. For the protagonist to be the underdog at the beginning of the story, he or she must take on someone who holds all the cards. The writer's argument needs to feel like it's an Atlas-worthy, uphill battle with the entire world on his or her shoulders. That's a fight worth watching. That battle can only happen if the misconception the writer struggles to disprove puts up a damn good, down and dirty match. The misconception is the weapon of the antagonist. The central character, the champion of the writer's premise, dismantles that belief system by poking holes in it with relentless attacks and proactive, bold choices.

Misconceptions can often be what people say to console themselves. They are comfort food in a reality that is often unpalatable. Normal people don't necessarily want to challenge comforting misconceptions. They lure people into a sense of security and exploit the general welfare of society. Now, if you can make the unpalatable truth so entertaining that the audience will enjoy it, that's gold.

2 Inconsistent vision of the story

Inconsistency happens a lot when a story is adapted from one medium to another. Have you ever seen an adaptation of a preexisting intellectual property (most frequently novels, comic books, or stage plays/musicals) that seemed to get ruined in the adaptation? Too many, right? Many of those films went awry because the writer did one of three things:

1 The writer was unable to reverse engineer a meaning into the story that perhaps was different from the source material.
2 The writer put his or her heart into a piece of material that was not suited for the original material.
3 A writer who tells a story grounded in the series of beats (a string of pearls connecting a series of cinematic events, attempting to form a single story) never really takes that important step backward to figure out the heart of the original idea. He or she so often forgets that without a premise, there is no spine of events to follow; those beats are just a list of moments building to something without meaning.

I never take an adaptation writing job unless I can tell (or find out) what the material was trying to say and go along with its premise, trying to prove it with the tools best suited for my medium of expression. The writer's heart has to get in sync with the story or forget it; the work is a lost cause from inception. Examples that fall under these categories include: *Land of the Lost*, *The League of Extraordinary*

Gentlemen, The Golden Compass, Daredevil, Dune, The Fantastic Four, Inspec-
tor Gadget, The Great Gatsby, Ender's Game, and *Bonfire of the Vanities.*

3 Outside influence

This error often is out of the writer's control. When people other than the writer
mess with premise, we usually wind up with a film that reads and looks like it was
overdeveloped (i.e., losing the vision and intent). When they change the ending
and the change messes with the premise, movies get lost and become unsatisfying.
These nonwriters frequently ask for the writer to change the ending of the film to
something that makes the movie career wildly and doesn't fit anything the script/
story was designed to say. A perfect example of this was *The Scarlet Letter.* The
stories of interference happening are long and painful to hear. The story Kevin
Smith tells of the producer who wanted desperately to put a giant, mechanical
spider into a movie comes to mind, and he finally got his way in *Wild, Wild West.*
It happens to the best screenwriters.

Sometimes the other people involved with making the film will want to change
things that unintentionally destroy the film's integrity and shatter its foundation.
At that point, if you cannot save them from themselves or get behind what their
changes would mean, you have to walk away. Let those nonwriters explore their
idea with a writer who can get behind it. You have to accept that if you cannot get
behind the new core belief system their ending is reinforcing (which may cause
reevaluating the entire film that led up to that moment in order to make it right),
you may no longer be the correct writer for the job. It's their material now. Kiss
it gently goodbye and take comfort in the fact that producers often wind up rehir-
ing the original writer later on to bring the project home after all the things they
needed to try and do. Let them. The writer plays out all the scenarios in his or her
head and sees the endgame. Sometimes the people paying writers need to wander
down those paths without you and get lost in the woods. You're always there for
them if they need you and want to find their way back to the highway.

There is no need to pitch your premise

There is a trick to help alleviate some degree of outside influence where unneces-
sary, and that trick is to *not* make the premise a topic of conversation. Let your
premise be the *subtext* of your story. A premise should be so well argued and
proven in a script that explaining or pitching it to anyone would be utterly redun-
dant. You don't need to wear your heart on your sleeve. Great writing makes
the hypothesis understood and self-evident without ever spouting it. We are all
intelligent people. A reader can feel it. Therefore, I never mention my premise to
anyone, and they never have to ask.

Bringing up the premise to a team of people who all wish to find ways to make
the script "better" is like offering them the end piece of thread on your sweater.
Everybody sees the world differently. Therefore, somebody is going to yank on that

stitching. Every garment has an end thread, and the premise is ours. If the premise isn't broken, don't put everyone in a position to try and fix it. I avoid being the person to mention the premise, and, as a result, I have rarely ever had to discuss it.

At the same time, I do not hide my premise. It's in plain sight. I'm simply not making it a conversation topic. If someone asks what the moral of my story is, I'm happy to discuss it. That said, I've been a WGA writer for a decade and worked with hundreds of people in the development process. In all that time, nobody has ever asked me what the moral of my story is. Development people, producers, studio executives, and any note-giving literary representative will focus on making sure the script does three things:

1 Makes sense.
2 Attracts talent.
3 Lives up to its marketability.

I've never worked with anyone who cared about my premise so long as the script did not interfere with those three things.

The only time I do talk about premise is when the development team wants a change in the script that fundamentally goes against everything the script is about for me. Remember, the premise comes from the writer's soul and is the bedrock foundation for everything in the story. When a company I write for is bent on a script change that alters the meaning of the film to something that I cannot understand or get behind, that's when a story meeting needs to become a heart-to-heart discussion. That discussion happens very rarely, but it usually happens when the nonwriters want a specific and different ending to the film because the ending is the final analysis where the premise is proven. Premise is the one proverbial line in the sand on which a writer does not compromise. Make the premise better, clearer, and truer while keeping it original or don't change it. Thankfully, a clever writer can usually figure out a way to give everyone what he or she wants while keeping true to the premise.

The good news is that most people do not understand this use of a technical script premise because it's not explained in any of the modern seminal books on scriptwriting. Therefore, don't fret if you don't want to talk about it and someone asks for your script's premise. Simply tell the person the dramatic situation of your story idea in a single sentence. That's usually all he or she wants to know. For example: a radioactive spider bites a high school kid, giving him superpowers (*The Amazing Spider-Man*). A botanist and mechanical engineer astronaut gets stranded on Mars (*The Martian*). A married artist goes on a journey of self-discovery that culminates in the first sex change operation (*The Danish Girl*).

The premise wrap-up

Producers and studios may like a story idea, but premise is what connects them to it, whether they know that or not. A studio will buy a fantastic idea, but the writer only gets a crack at not being replaced instantly if under that surface idea there

is a soul behind the gimmick that is felt in its reading. Otherwise, another writer, who might be selected because of professional clout, will likely quickly replace the original writer. That writer may also possess a creative soul (which is revealed through a strong premise) that deeply connects with the hiring party as a reader. Preferably both.

The protagonist's journey and arc revolve around the premise, and all other characters revolve around the protagonist. Clearly, premise is kind of a big deal. It's the foundation of everything. If everything has an origin, the origin of story is premise. It's why we tell stories at all. In the immortal words of James Baldwin (1979):

> "You write in order to change the world, knowing perfectly well that you probably can't . . . The world changes according to the way people see it, and if you alter, even by a millimeter the way people look at reality, then you can change it . . . If there is no moral question, there is no reason to write."

Once a writer figures out *what* to say, it's time to decide *how* best to say it. In chapter 2, it's time to shine the light that is the heart of our film (premise) through the prism of genre.

Exercise I

Wording for all chapter exercises should be as succinct as the English language allows. When dealing with script foundation information, there should be unequivocal clarity and precision in its wording. This is where a mastery of word selection and editing skills come into play. The economy of word usage results in the purity of its concentrated statement. So, using the most precise words you can muster . . .

1 Write many premises and select one.

Qualifications

- It's original.
- It's a hypothesis.
- It's about a single truth.
- It's a clear-cut opinion (a statement of firm belief).
- The meaning is crystal clear to any stranger who reads it.
- It has an exceptionally strong (possibly popular) counterargument.
- It's worth fighting for – you want to make this hypothesis clear to the world.

- If it's inspired by a cliché, the cliché is taken further and is more specific so that it feels more focused and targeted, making the unique writer's take on it clear.
- It concisely expresses the hypothesis of the film through its resolution. This means the premise often tells the writer how the film ends.

Disqualifiers

- Clichés.
- Plot ideas.
- Questions.
- It's obvious.
- Specific characters.
- The counterargument is weak.
- Metaphors, exaggerations, similes.
- It offers more than a single solution.
- States a situation instead of an opinion.
- It's negatively worded, saying what something is *not* instead of what it *is*.
- Avoid wishy-washy words or qualifiers like *sometimes, especially, could, should, usually, might, can, may,* or *might*. Be definitive.

2 Once you figure out what to say, start listing all the different ways you could show the arguments for and against that hypothesis. Create a list of potential actions and visuals to exemplify and defy the premise. Cast a wide net to start. You will not use all the actions and visuals. Don't worry about creating a singularly cohesive version of a story just yet. We'll start that task in the next chapter when we filter these ideas through genre.

Genre

Figure 2.1 Jacob Redmon – Genre: dressing up the premise.

"A serious adult story must be true to something in life. Since marvel tales cannot be true to the events of life, they must shift their emphasis towards something to which they can be true; namely, certain wistful or restless moods of the human spirit, wherein it seeks to weave gossamer ladders of escape from the galling tyranny of time, space, and natural law."

–H. P. Lovecraft

What is genre?

Genre is how films are categorized through establishing one of three popular constants:

1 Setting (example: westerns or road-trip films)
2 Topic (example: coming of age or crime)
3 Mood/tone (example: comedy or thriller)

Genre allows us to identify, classify, and segregate the styles of storytelling from which a writer may choose. Before I get into the complexities and details of genre classification, I want to explain some considerations of the genre-selection process.

Genre says a lot about the writer

Once I have selected a *premise* (the hypothesis I want my script to communicate) and brainstormed situations to argue it, it's time to start imagining how the premise might look in different genres. While some premises might fit better into a specific genre, other heartfelt premises can be told through any genre lens. Only the writer can figure out which mood best makes the case and how to make it. For example, the story of western colonization unjustly eradicating indigenous cultures can be seen through a historical genre like *Dances with Wolves* or through science fiction, as seen in *Avatar*. Both films tell the tale of a soldier from an invading force with superior weaponry expanding into an epic, new frontier. During the second act, a female of that indigenous tribe, against her own initial personal wishes, is ordered to serve as liaison to the soldier and educates him in the ways of her people. The outsider falls in love with the woman as he also falls in love with her culture and its people. Eventually, he protects them against his own kind. These are the same exact stories.

It's intoxicating to watch visually imaginative films, which makes it easier to absorb profound concepts presented in an entertaining context that feels further removed from our reality. Allegories like *Avatar* are a great way to reach the hearts of viewers without looking like you are lecturing your audience from a soapbox. Use of genre is one way to make a deeply meaningful premise into something commercial. Meanwhile, showing this same story in a historical context communicates the thematically identical premise in a unique yet equally compelling format. *Dances with Wolves* won a slew of Academy Awards, including Best Picture, for the power of this vision, and *Avatar* shattered a slew of box office records. Both versions represent valid choices. So, it stands to reason that genre selection speaks volumes about the writer. This selection is one of the most significant ways in which writers convey their voice as artists to buyers and reveals how each writer tackles subject matter.

Therefore, think hard about the kind of movies you want to write when picking the genre, because genre is often used to define the writer. I would be remiss if I didn't remind writers that when selecting a genre for a script that selection might

determine the types of writing opportunities for which one might be considered. Genre is more important than ever to a writer's career.

"But I don't wanna write only one genre!"

Many screenwriters want to know why Hollywood needs to define them by genre. Now, I know those of us who studied screenwriting in college can write in any genre; it's just a matter of tool selection. A screwdriver is still a screwdriver, whether Phillips or flathead. Screenplays are all written with the same structure, and all flawed characters can be created the same way regardless of a story's tone. I don't disagree with this argument that some writers make, but it will not change how executives think. It's like asking, "Why do they keep putting people like Jim Carrey, Will Ferrell, Ben Stiller, Jack Black, and Adam Sandler in comedies?" The answer is because they have proven they're good at comedy. Therefore, doing so makes sense and is smart business.

If feeling pigeonholed ever bothers writers, they can write their way into new territory at any time. It's not the same for actors or directors who wish to change direction. For them, it requires a significant investment. For us, we just put a little time aside and do what we do best.

I should also mention that once in a long while, this common genre-specific hiring practice is broken. If it weren't, Steve Kloves wouldn't have been selected to write seven of the eight *Harry Potter* films. Now, I'm sure it didn't hurt that J. K. Rowling was a huge fan of his film *The Fabulous Baker Boys*, and it likely helped that he was nominated for Best Adapted Screenplay at the WGA, Golden Globes, and Academy Awards for *Wonder Boys* just prior to the search for a *Harry Potter and the Sorcerer's Stone* writer. That said, it's unusual for even WGA writers to get that kind of latitude from Hollywood executives. A lot of stars need to align to make it happen.

So, write something different if you want. Nobody in the world is stopping you. I do so all the time between writing gigs and drafts. I have writing samples now in most genres.

Why is genre important?

Premise provides the film's purpose and fills a story with passion and meaning. Meanwhile, genre allows the writer to choose how to relay that message. It takes that light of inspiration from the premise and allows the writer to shine it through a specific lens. Think of genre as sunshine through a kaleidoscope. Genre establishes mood, color, and tone for the reader (audience). Genre conveys more than just the style of the film.

Genre tells studios how to sell the movie and to whom. You turn a feeling and a statement into a movie through the marketing tool of genre. Genre tells a studio how they will sell your idea. This state of affairs didn't always exist. In the olden days, basic genre duality was exemplified by the eternal symbol of theater, comedy and tragedy masks.

By Shakespeare's time, stories were divided into three major categories: comedy, tragedy, and histories. Comedy didn't mean funny back in Elizabethan times.

Tragedy meant a sad story traditionally ending in the death of the central character(s). Comedy meant it did not end in tragedy (happy endings featured love and marriage), and histories were "inspired" by real people or events. Later, tragedy started to be called *drama* because comedy started to be associated with humor, and not all dramatic stories ended in tragedy.

Perception and greater clarification are constantly being sought in order to categorize and market stories. This clarification helps audiences enter the theater in the right mindset, and it helps producers market the story to their customers. The smarter humanity has become about buying and selling entertainment, the more clarity people want. People want to know what they are buying. Therefore, the number of genres has vastly expanded.

Today, you would still call *Much Ado About Nothing* and *As You Like It* comedies, but modern producers would call *The Tempest* and *A Midsummer Night's Dream* fantasy. *King Lear* and *Hamlet* could still be called tragedies or dramas, but *Macbeth* would be considered a psychological thriller. *Romeo and Juliet* would be called a romantic tragedy, and *Titus Andronicus* might even be considered horror. The King Henry and Richard plays were dubbed histories. Today, we would call them biopics, but each would likely include a supporting genre as well. The Henrys are war stories with the conflict taking place either within England's hierarchy or France, whereas *Richard III* operates more as a thriller as the title character murders his way to the throne.

Genre has slowly transformed from a form of simplification into a tool for pinpointing marketing appeal and strategies. Production companies specialize in specific genres, be it comedy, horror, or action. Inexperienced people in our industry think artists are the only people who get pigeonholed. That notion is dead wrong. Studios want to buy product and put behind the scenes people who have worked successfully on that type of product before, so even producers get typecast and pigeonholed.

Then there are genres that most companies don't even want to consider, mostly historical pieces. Everything in a period piece increases the cost of production. Costs include replicating period-appropriate transportation, locations, set dressings, costumes, and props. A period piece is even harder to write because dialogue cannot break the illusion of the period or setting. Everything becomes stylized. Nowadays, it's more difficult to get anyone to read westerns than it is to write them. Believe it or not, even comedy is a niche market because comedic sensibilities differ from country to country.

Meanwhile, thrillers are popular internationally because the stakes (life and death) are a universally understood set of circumstances.

Like it or not, those are the facts about genre. Writers need to understand these facts so they know the challenges before selecting a genre.

Hollywood insiders follow genre trends and popularity. Spec scripts that sell are often categorized by genre in marketplace analysis. When people talk about current trends in movies, they don't talk about character driven versus plot driven or premise driven versus concept driven. People will sometimes look at whether

star-driven films are hitting, or whether original versus previously existing intellectual properties are trending, but, more than anything, trends are almost always discussed in terms of genre. Even subgenre trends are debated. As audiences have gotten savvier, the genre classifications have become more nuanced. Measuring audience numbers in the most detailed subgenre trends is common. Insiders no longer say movies about monsters are selling. Rather, industry analysts pinpoint which type of monster: vampires, werewolves, or zombies.

It's important for writers to understand that this extreme market segmentation is how the industry works outside of our creative bubble. Given the number of moving variables, you might be wondering one thing:

How should genre trends affect my decision-making?

As much as genre is a huge part of the picture for buyers and sellers, all of that trend thinking actually has little to do with what genre a writer chooses to write. I never chase trends because by the time a decent writer pens and edits a great spec for a hip trend, chances are that the trend has already passed. Writers need to know what's going on in the markets because we all have our little treasure chests of unsubmitted scripts waiting for the right time to see the light. When it comes to what we are starting to write in the present, genre boils down to two things: the writer's personal voice and the form that speaks best to the subject matter (premise). Trend has, ultimately, nothing to do with genre choice. We write what we write, and we understand that market fluctuations are just a part of the game. These fluctuations are simply something to understand; do not worry about them. These are the fads and phases of our industry, but unlike real trends that don't always come back into popularity, genres do wax in popularity every so many years. Besides, I have always held the belief that when a script is amazing, great writers make trends, not follow them.

Of all the reasons genre is important, this is the most important . . .

Genre creates certain expectations within the viewer and opens a door for the writer to deliver upon them. Each genre promises to elicit certain responses or feelings inside the audience member based on the person's prior experience from having seen those types of stories. Screenwriters use the audience's ingrained knowledge of the genre to produce new reactions in audience members by using familiar tropes in original ways. This old-and-new method represents a backdoor way of sneaking into the dark cellar of the imagination of the audience before the lights even dim in the movie theater. When audiences go to see a comedy, they are ready to laugh. When they pay for a suspenseful thriller, something as simple as a slow walk down a long hallway can put viewers on the edges of their seats, creating expectation because audience members know that something can pop out at any moment.

Yes, it is a form of emotional manipulation, but it's voluntary. In fact, it's why they're paying to see the movie. Genre is the unspoken agreement between the writer and the audience that the writer will deliver a certain kind of experience. We use what the audience already knows about the genres so that we don't have to start fresh on page one of the script. We use expectation to seduce and affect audience members, playing the strings inside the human instrument – inside the viewer.

There are so many great metaphors for the way genre impacts an audience. It's like writers have an inside man deep undercover already in the audience's collective brain. Genre is our secret agent behind enemy lines. It's the I.V. already stuck in a viewer's vein as he or she sits in the theater. Genre makes sure that the viewers are predisposed to be moved when we want to get their blood pumping. We use genre as a tool to reach an audience more effectively. We're queued into their receptivity. Genre is the open door into the subconscious, full of preexisting, preprogrammed, conditioned responses planted there from their earliest memories of entertainment. The use of genre exploits an audience's Pavlovian training if the writer is skilled enough to correctly play upon a genre's tropes.

A movie can sometimes be poorly told, but audiences will still enjoy it because it delivered on the promises made by the genre in advertising. When advertising is done perfectly, a movie's campaign ensures that the writer, without ever having spoken with members of the advertising team, is working in tandem with the marketing team that handles all the P&A (print and advertising) for the film. This advertising ensures that the viewer comes to the movie with the right frame of mind to hear the writer's story.

The misnomers of genre

I never think of genre as something I have to use. Instead, I would consider myself foolish if I didn't take advantage of its attributes. I would never deprive myself of the opportunity to affect my audience in whatever particular manner I wish. Genre guides the context for my premise into an effective delivery mechanism; one that offers a proven method of distribution of my hypothesis. This delivery mechanism gives story a clear and linear path, not one that meanders or veers capriciously. Not all writers, though, view genre in the way in which I do.

Defining a film's genre can be restrictive to writers, making them feel painted into a corner with an obligation to make their work conform to stereotypical tropes. Inexperienced writers often don't feel deft and agile enough with a genre's tools to build everything they want with their story. Learning to use genre appropriately takes time and patience. Directors have told me that when they are forced to make something work within certain parameters, the limitations sometimes allow them to focus and find the specific solutions they need that are simple and most meaningful. Genre can perform a similar function for writers. We know to explore the mood and tone set forth by the genre, so we can feel our way forward with clarity

and focus. Personally, I find utilizing genre liberating and helpful. In fact, genre doesn't restrict my choices; it does, however, tell me where I need to break new ground.

Inexperienced writers feel as though genre selection makes their scripts predictable and confined. I never feel confined because my goal is always to take the genre places to which it has never journeyed. In an action script, I focus on writing action sequences with acts that are brave, heart-pounding, original stunts I have never seen in a film. For adventure, I consider what wild, never-before cinematically explored locations I might bring to life. In science fiction, I want to use technology in a way no other movie has. In comedy, I want to laugh at things people haven't laughed at before. The use of genre is all about perception and innovation – breaking new ground with fresh ideas. Nobody ever said that it would be easy making something the same but different, yet this task is our job as artists. The writer can't blame the genre if he or she can't do something new with it any more than a painter can blame his or her brush.

Genre types

Although there is a little fluidity between genres, there should be one constant tone throughout the script. When describing a script of mine, I never pitch it as more than a mash-up of two dominant genres. Two is the maximum. Listing too many genres is like wearing a neon sign around your neck that flashes "Amateur Writer." Some of the following films utilize the tropes of more than one genre, but I list the films under the primary genre.

If your screenplay is going to catch the eye of a studio, the story should be written for the buyers but still speak from the heart with its premise. You don't pitch a premise to others. If anyone does ask you for the premise of your story, chances are they are asking for the story's basic situation. They are using the word premise in the way in which it's found in any dictionary, not as the term of art explained in Chapter 1.

Meanwhile, you always pinpoint the genre for them. Doing so shows buyers that you know your audience and specifies the cinematic and visual devices studios can use to sell your idea to the audience. You will notice that in many genres the world in which the story is set has scope that fits the tone.

The following are my simple definitions for each genre. Ask yourself which genre can best convey your premise in the most entertaining way. Here are your choices:

- **Drama**: Stories featuring an exploration of a serious, deeply moving situation or issue.
- **Comedy**: Stories centering on characters and situations designed to make people laugh.
- **Adventure**: Stories of off-road, epic quests and journeys.
- **Action**: Stories with constant, fast-paced physical movement and/or fighting.

- **Science fiction**: Stories involving major plot elements drawn from projected scientific or technological innovation.
- **Fantasy**: Stories containing characters and plot devices that are impossible in the world as we know it, usually containing more mystical elements commonly associated with fairy tales.
- **Supernatural**: Stories in which circumstances and situations cannot be explained by practical or theoretical science; these stories contain some type of paranormal or unnatural phenomena.
- **Horror**: Stories about extreme physical violence, exploring a terrifying, human fear in order to scare audiences.
- **Mystery**: Stories in which the entire outer journey and plot focus on trying to discover "Who done it and why?"
- **Thriller**: Stories that present edge-of-your-seat suspense.
- **Crime/heist**: Stories told from the point of view of investigators or criminals in which a protagonist's outer journey in the story centers on criminal activities.
- **Western**: Stories set in the western United States prior to 1912 (most commonly the Wild West era between the American Civil War and the turn of the century), traditionally featuring frontiersmen, cowboys, and/or Native Americans.
- **War**: Stories set during wartime in a war-torn land.
- **Family**: Stories appropriate for all audiences of all ages, including small children.
- **Musical**: Stories in which characters sing numerous songs as part of the tale; traditionally (but not necessarily) a musical has at least one big dance number.
- **Historical**: Stories about an event that changed the course of history.
- **Biopic**: True stories based on and inspired by one real person and that person's accomplishment(s).
- **Romance**: Stories in which the main plot and protagonist's outer journey focus on the pursuit of romantic love.
- **Erotic**: Stories with explicit sexual content and themes.
- **Disaster**: Stories in which a large, catastrophic, or even cataclysmic, event threatens a large number of people.
- **Sports**: Stories set in a specific sport integral to the characters, story, or plot.
- **Road**: Stories in which the majority of the second act is spent traveling a great distance; an emotional, inner journey reflects a physical one.
- **Coming of age**: Stories traditionally set somewhere between middle school to college where the central characters "grow up," with emphasis on strong inner journeys for the central character(s).

There is a reason drama is mentioned first. Drama is the tone onto which all other genres are built. All stories are inherently dramatic because they are driven by conflict. Therefore, a writer only calls his or her script a drama if no other major genre type dominates the material. If you think about it, even comedy is high drama with a sense of humor.

Drama should only be named as part of a dual genre when paired with smaller dramatic subgenres such as courtroom, art-house, prison, malady, and social justice dramas. We will get a little more into subgenres in a moment.

Here are examples of successful films in each specific major genre type:

Drama: *The Shawshank Redemption, Boyz n the Hood, A Few Good Men, Spotlight, The Big Short, Midnight Cowboy, Coming Home, Network, Good Will Hunting, Ben Hur, Gone with the Wind, City of God, Crash, Boogie Nights, The Big Chill, 12 Angry Men, Do the Right Thing, Mr. Smith Goes to Washington, Taxi Driver, Muriel's Wedding, Fences, An Officer and a Gentleman, Escape from Alcatraz, Sophie's Choice, Wall Street, Cool Hand Luke, The Defiant Ones, To Kill a Mockingbird, One Flew Over the Cuckoo's Nest, Forrest Gump, The Help, Whiplash, Ordinary People, The Blind Side, Basketball Diaries*

Comedy: *Groundhog Day, Tootsie, Arthur, Liar Liar, Wayne's World, City Slickers, Sister Act, 50 First Dates, My Big Fat Greek Wedding, Wedding Crashers, Happy Gilmore, Mr. Mom, Anchorman, Bridesmaids, Austin Powers, Naked Gun, Stir Crazy, Legally Blonde, The Hangover, 9 to 5, Trading Places, Down and Out in Beverly Hills, Three Men and a Baby, The Nutty Professor, The Jerk, Airplane!, The 40-Year-Old Virgin, Uncle Buck, Miss Congeniality, Shallow Hal, Son in Law, Max Dugan Returns, Ace Ventura: Pet Detective, Born Yesterday, City Lights, Duck Soup, Some Like It Hot, The Producers, Blazing Saddles, History of the World: Part 1, Bananas, Back to School, Vacation, Caddyshack, Stripes, My Blue Heaven, Twins, Junior, Raising Arizona, Basketball, The Court Jester, Roxanne, Clueless, Real Genius, Van Wilder*

Action: *John Wick, Die Hard, True Lies, Skyfall, The Rock, The Dark Knight, The Avengers, Kick Ass, Air Force One, Commando, Top Gun, Lethal Weapon, Rush Hour, The Long Kiss Goodnight, Iron-Man, Desperado, Bourne Identity, The Seven Samurai, Enter the Dragon, Conan The Barbarian, Speed, Mission Impossible III, Charlie's Angels, Hard Boiled, The Transporter, The Raid, Kill Bill, Crouching Tiger Hidden Dragon, 13 Assassins, Red, The Fast and the Furious, Point Break, The Kingsman: The Secret Service*

Adventure: *Raiders of the Lost Ark, The Adventures of Robin Hood, Indiana Jones and the Last Crusade, Goonies, Romancing the Stone, The Three Musketeers, The Mask of Zorro, The Adventures of Huckleberry Finn (1939), Around the World in 80 Days, National Treasure, Apocalypto, Life of Pi, Captain America: The Winter Soldier, Hercules, Tarzan, Crocodile Dundee, Sahara, Hidalgo, The Mummy, The Da Vinci Code, Tomb Raider*

Fantasy: *Harry Potter and the Sorcerer's Stone, The Lord of the Rings, The Princess Bride, The Wizard of Oz, Wonder Woman, X-Men, Rise of the Guardians, Maleficent, Splash, Avatar, Cinderella, Ella Enchanted, Enchanted, Dune, It's a Wonderful Life, Weird Science, Pirates of the Caribbean, Plant of the Apes, King Kong, Clash of the Titans, Jason and*

the Argonauts, Sinbad, Jumanji, Edward Scissorhands, Beauty and the Beast, Gremlins, Night at the Museum, Ladyhawke, Pleasantville, How the Grinch Stole Christmas, 20,000 Leagues Under the Sea, The Watchmen, The Mask, How To Train Your Dragon, Peter Pan, Hook

Science fiction: Star Wars, Ready Player One, Star Trek, Galaxy Quest, The Matrix, E.T., Jurassic Park, Children of Men, Bill & Ted's Excellent Adventure, Back to the Future, The Terminator, Guardians of the Galaxy, The Martian, Edge of Tomorrow, Chronicle, Passengers, Arrival, Blade Runner, The Last Starfighter, THX 1138, Transformers, Fahrenheit 451, Soylent Green, Escape from New York, Mad Max 2: The Road Warrior, Logan's Run, The Blob, The Black Hole, 2001: A Space Odyssey, The Race to Witch Mountain, Close Encounters of the Third Kind, Westworld, Enemy Mine, Gravity, RoboCop, Hunger Games, Men in Black, Tron, Dark City

Supernatural: The Exorcist, Coco, Flatliners, The Dead Zone, Ghost, The Sixth Sense, Poltergeist, Ghostbusters, Donnie Darko, Sleepy Hallow, Scrooged, Ghost Rider, Blade, The Crow, Constantine, Final Destination, Paranormal Activity, The Ring, The Blair Witch Project, Insidious, The Others, Thirteen Ghosts, Amityville Horror, Sinister, What Lies Beneath, Carrie, Christine, Frankenstein

Horror: A Quiet Place, Psycho, Scream, Jaws, A Nightmare on Elm Street, Get Out, The Descent, Halloween, Cujo, The Omen, Zombieland, Shaun of the Dead, Dawn of the Dead, Evil Dead 2, The Conjuring, Lost Boys, Saw, The Strangers, Friday the 13th, Children of the Corn, An American Were-wolf in London, Texas Chainsaw Massacre, 28 Days Later, Cabin in the Woods, Cabin Fever, The Thing, The Fly, Dracula, The Wolfman, Hellraiser

Mystery: Seven, Manchurian Candidate, Who Framed Roger Rabbit, Clue, The Player, The Mighty Quinn, The Constant Gardener, Day of the Jackal, The Silence of the Lambs, Silver Streak, Memento, Vertigo, North By Northwest, Rope, No Way Out, The Osterman Weekend, Dead Again, Eyes of Laura Mars, The Third Man, Laura, Ten Little Indians, In the Heat of the Night, The Fugitive, The Game, Deep Red, An Inspector Calls, Shat-tered (1991), D.O.A., and most Sherlock Holmes films

Thriller: Get Out, Arlington Road, Marathon Man, Deathtrap, The Shining, Man on Fire, In the Line of Fire, Rear Window, Misery, Alien, The Birds, A Clockwork Orange, Dial M for Murder, Buried, The Night of the Hunter, Wait Until Dark, No Country for Old Men, Cape Fear, Blood Simple, The Edge, Gaslight, Diabolique (1955), Black Christmas, Basic Instinct, Fatal Attraction, The Postman Always Rings Twice, Three Days of the Condor, The Hunt for Red October, Gone Girl

Crime: The Godfather, The Untouchables, Training Day, A Fish Called Wanda, 48 Hours, Scarface, Goodfellas, Ocean's Eleven, Bonnie and Clyde, The Sting, Magnum Force, Chinatown, Maltese Falcon, L.A. Confi-dential, Double Indemnity, The Big Lebowski, The Big Sleep, Beverly Hills Cop, The Usual Suspects, Set It Off, Internal Affairs, The Departed, Mystic

River, Touch of Evil, The French Connection, Kiss Me Deadly, Brick, Sunset Blvd., Klute, Kiss Kiss Bang Bang, At Close Range, Sin City, Dog Day Afternoon, Catch Me if You Can, Now You See Me, The Nice Guys

Western: *Butch Cassidy and the Sundance Kid, The Frisco Kid, 3:10 to Yuma* (2007), *Unforgiven, My Name Is Nobody, Django Unchained, Young Guns, Silverado, The Wild Bunch, The Good, the Bad and the Ugly, Fist Full of Dollars, For a Few Dollars More, Shane, High Noon, High Plains Drifter, Pale Rider, Tombstone, The Shootist, The Searchers, Winchester '73, The Hired Hand, The Outlaw Josey Wales, The Magnificent Seven, Thunderbolt and Lightfoot, My Darling Clementine, True Grit, Once Upon a Time in the West, The Lone Ranger*

War: *The Bridge on the River Kwai, Glory, Platoon, Apocalypse Now, Full Metal Jacket, Red Dawn, Battleship Potemkin, Saving Private Ryan, Dirty Dozen, Wings, The Deer Hunter, Generation Kill, Ride with the Devil, Guns of Navarone, The Last of the Mohicans, Three Kings, Victory, Lone Survivor*

Historical (event based): *Hidden Figures, Selma, All the President's Men, Argo, Hotel Rwanda, Battle of the Bulge, Midway, Tora! Tora! Tora!, A Dangerous Method, Guadalcanal Diary, Gettysburg, Titanic, Z, The Longest Day, A Bridge Too Far, Enigma, The Battle of Algiers, A Man for All Seasons, Apollo 13, Darkest Hour*

Biopic (character based): *Trumbo, Lawrence of Arabia, Patton, Hacksaw Ridge, Erin Brockovich, Ed Wood, The Elephant Man, Schindler's List, 12 Years a Slave, Spartacus, Lincoln, Gandhi, The King's Speech, The Social Network, Malcolm X, Rudy, Raging Bull, Milk, Ray, Walk the Line, The Last Emperor, American Splendor, The Coal Miner's Daughter, Frida, Donnie Brasco, Braveheart, Elizabeth, My Left Foot, A Beautiful Mind, The Pianist, The Doors, Serpico, Silkwood, The Founder, Good Morning Vietnam, The Danish Girl, Monster, Into the Wild, The People vs. Larry Flynt, Boys Don't Cry, Born on the Fourth of July, Unbroken, The Queen, Awakenings, The Imitation Game*

Family: *Spy Kids, Fly Away Home, Babe, Benji, Lassie, Flipper, The Black Stallion, Old Yeller, Turner and Hooch, Akeelah and the Bee, A Christmas Story, Miracle on 34th Street, Candleshoe, Mrs. Doubtfire, Freaky Friday, Pollyanna, Bright Eyes, Apple Dumpling Gang, Curse of the Cat People, Children of Heaven, The 5,000 Fingers of Dr. T, The Ghost and Mr. Chicken, Hot Lead and Cold Feet, The Incredible Mr. Limpet, Herbie the Love Bug, The Prize Fighter, Dick Tracy, Millions, Holes, Gus, Elf, The Parent Trap, Big, Home Alone, Uncle Buck, Kung Fu Panda*, the majority of animated Disney and Pixar movies

Musical: *Pitch Perfect, Mary Poppins, West Side Story, All That Jazz, Singing in the Rain, Moulin Rouge, Little Shop of Horrors* (1986), *The King and I, Rocky Horror Picture Show, Rent, Bedknobs and Broomsticks, The Sound of Music, Sweeney Todd, Fiddler on the Roof, Fame, 42nd Street, The Commitments, Chitty Chitty Bang Bang, An American in Paris, Willy Wonka and the*

Chocolate Factory, Hair, Annie, Grease, Chicago, Into the Woods, Cabaret, Jesus Christ Superstar, Showboat, My Fair Lady, Kiss Me Kate, A Chorus Line, Phantom of the Opera (2004), *Sweet Charity, The Music Man, Bye Bye Birdie, Tommy, Jailhouse Rock, Sgt. Pepper's Lonely Hearts Club Band, Across the Universe, The Greatest Showman, How To Succeed In Business Without Really Trying, A Funny Thing Happened on the Way to the Forum, South Pacific, Mama Mia!, Oklahoma!, Oliver!, Hello, Dolly!*

Romance: *The Fault in Our Stars, The Notebook, Twilight: Breaking Dawn: Part 2, Her, When Harry Met Sally, Shakespeare in Love, Love Actually, Pretty Woman, Notting Hill, While You Were Sleeping, Love Story, Working Girl, Annie Hall, Somewhere in Time, Casablanca, From Here to Eternity, Sabrina, Dangerous Liaisons, The Artist, Bridget Jones' Diary, An Affair to Remember, The Competition, Sleepless in Seattle, Warm Bodies, Love Story, Roman Holiday, The Red Shoes, Sideways, Sense and Sensibility, Eternal Sunshine of the Spotless Mind, Four Weddings and a Funeral, Midnight in Paris, Knocked Up, Moonstruck, Brokeback Mountain, Much Ado About Nothing, The Theory of Everything, Crazy Stupid Love, Romeo & Juliet, Scott Pilgrim vs. The World, Dirty Dancing, Now Voyager, Moonrise Kingdom*

Erotic: *Nine and a Half Weeks, Body Heat, Eyes Wide Shut, Secretary, Wild at Heart, The Hunger, The Last Seduction, Fifty Shades of Grey, Lolita, The Piano, Risky Business, The Story of O, Putney Swope, Nymphomaniac, Last Tango in Paris, Nine Songs,* the *Emmanuelle* films

Disaster: *Towering Inferno, The Poseidon Adventure, The Hindenburg, Earthquake, Twister, Avalanche, Flood, Day After Tomorrow, Volcano, Cloverfield, The Day After, War of the Worlds, Armageddon, Deep Impact, Outbreak, The Omega Man, Daylight, Last Night, The Perfect Storm, The Mist* (2012), *The Happening, The Crazies, Apollo 13, Godzilla, I Am Legend, World War Z, On The Beach, Invasion of the Body Snatchers, The Swarm, Titanic, Alive, The Core, The Day the Earth Stood Still* (1951), *Independence Day, Mars Attacks!*

Road: *Thelma and Louise, Little Miss Sunshine, Almost Famous, The Blues Brothers, Y Tu Mamá También, Mad Max: Fury Road, Cannonball Run, Death Race, The Hitcher, Easy Rider, Rain Man, Midnight Run, Paper Moon, Sullivan's Travels, The Sure Thing, National Lampoon's Vacation, The Muppet Movie, Are We There Yet?, Pee-Wee's Big Adventure, Homeward Bound: The Incredible Journey, Finding Nemo, It Happened One Night, Smokey and the Bandit,* Spielberg's early films *Duel* and *The Sugarland Express*

Sports: *Rocky, Hoosiers, The Champ, On the Waterfront, The Hustler, North Dallas Forty, Slap Shot, Any Given Sunday, Wimbledon, Bull Durham, Victory, Raging Bull, The Cutting Edge, Major League, Angels in the Outfield, Field of Dreams, Goon, Miracle, Chariots of Fire, Rudy, Million Dollar Baby, The Endless Summer, Murderball, Rush, Senna, Tin Cup, Moneyball, The Bad News Bears, Brian's Song, Vision Quest, Seabiscuit, National Velvet, The Sandlot, The Fighter, Remember the Titans*

Coming of age: *The Graduate, The Perks of Being a Wallflower, The Breakfast Club, Boyhood, St. Elmo's Fire, Rebel Without a Cause, Some Kind of*

Wonderful, Ferris Bueller's Day Off, Sixteen Candles, Home Alone, Fast Times at Ridgemont High, Risky Business, Saturday Night Fever, My Body-guard, Breaking Away, The Last American Virgin, Animal House, Accepted, Stand by Me, The Outsiders, Heathers, Footloose, Superbad, Juno, Diner, Foxes, Thirteen, WarGames, School Ties, With Honors, Reality Bites, Fla-mingo Kid, American Pie, Less than Zero, Little Manhattan, Dead Poet's Society, Can't Buy Me Love, The Karate Kid (1984), Ten Things I Hate About You, The Girl Next Door

Whichever genre you select for your story, you should have seen all the movies listed for that genre.

Important things to consider when selecting genre

There's a saying in the industry that if a story doesn't need to be animated, it shouldn't be an animated film. Some might say that the same concept applies to genres such as science fiction, fantasy, the supernatural, and the musical. If the concept, plot, and story do not involve the necessity of those budget-burdensome elements, why use them? Their use makes your film harder to produce. Most writers who have written anything set in a previous time period have heard something like the following from a producer: "If you had just set this today . . ." In short, people reject work simply based on the genre and the era in which the writer sets it. Don't let that fact dissuade you. There's a great lesson in this conundrum.

Once a writer selects a genre, it's important that he or she infuse that story with visual elements and plot developments that specifically fit that genre. The entire story needs to feel as though the genre selected fits perfectly, and it should be hard to imagine it being done any other way. Genre should be insepara-ble from the plot. *Gravity* must be science fiction because it's about someone stranded in outer space. *Pitch Perfect* is all about an a cappella singing group trying to win a performance competition, so how could it not be a musical? There's no way to tell the story of a boy going to wizard school without *Harry Potter* being fantasy. Alfred Hitchcock's thriller *Rear Window* explored the ter-ror of a wheelchair-confined man witnessing a murder and then being unable to escape as the killer discovers his only loose end. The Best Picture of 1978 tells the story of a soft-hearted street thug in Philly who gets the boxing opportunity of a lifetime in *Rocky*. How is that not going to be a sports film? Picking a genre is the beginning of integrating traditional cinematic concepts into the hypothesis of the story, your premise.

Genre selection determines how you plan on telling the story. Let's say you want to tell a story about aging. If the story is science fiction, the plot could focus on characters employing new scientific methods of dealing with aging as occurs in the film *In Time*. The story could consider the way in which older people are discarded by society as does *Logan's Run*. If you want to put aging in an innately supernatural story, consider the concept of *The Curious Case of Benjamin Button*. If you want a drama, the person could be battling Alzheimer's as the protagonists

do in *Still Alice* and *Away from Her*. In a disaster film, the frail body of an elder protagonist should make everything the character does in order to survive harder, from outrunning a tornado to climbing out of a hole.

A script should not include or force superfluous things into it just for the sake of illustrating genre. A good writer does not just insert a bunch of cool ideas because they are cool. Those moments must conform to genre *and* relate to the major escalations within the plot.

The key is to nestle the premise so deep within the genre that they become inseparable. Premise and genre fuse to form a blueprint for the story, where everything in it should be a necessity of telling that specific story.

Now, genres even have subgenres. Here are a few examples of subgenres:

- Broadway, concert, dance, Bollywood, and rock musicals
- Gothic, splatter, slasher, and monster horror
- Slapstick, satire, parody, sex, screwball, and black comedies
- Psychological, revenge, and political thrillers
- Detective, gangster, and heist crime films
- Swashbuckling and globetrotting adventures
- Sword-and-sandal, Civil War, World War II, and Desert Storm war movies
- Sword-and-sorcery, fairy-tale, and magical-realism fantasy
- Chase, superhero, vigilante, and martial-arts action films
- Adolescent, teen, and college coming-of-age stories

Subgenres narrow the framework of the story for more direct targeting, giving the script a hook on which to market the film. Some subgenres can slip into more than one genre, like:

- *Spy* thriller, action, or comedy films
- *Buddy* comedy, action, or romance
- *Noir* crime, thriller, or mystery

Subgenre consists of the details within the details.

The more clearly defined the story is, the clearer the picture of what you hope to write becomes. This process of defining is a large part of unfogging the mist within the crystal ball so that the writer can get a clear view of the future story. Once you select a genre, this selection informs the way in which your script should be consistently written in tone and mood. The selection pilots the script into the seas in which the writer will set his or her story.

Pick your genre

Before deciding which genre you want to use for your story, start asking yourself how you would tell your premise in each genre. How would the premise be

interpreted in an action versus adventure story? Is there someone in history who made you feel the way you do about the hypothesis you have made, and would that person be well known enough to prove a worthy topic of a biopic? What war or sport would you set the premise in, and why? Can the hypothesis work as a mystery, thriller, or crime film? How would a fantasy, supernatural, or science-fiction version of that premise be explored? Play with genre. Considering where and when would be the best (most poignant) place to set that premise might lead you toward one genre or another. You may find yourself with more than one viable way to tell the story. Then you get to do the best part of the writer's job, and that is to keep the best and cut the rest. Just because you pick one genre now doesn't mean you can't tell this premise again in a totally different genre at another time.

After exploring all your options for how to make your point with each genre, ask yourself which genre could be used to serve your premise best. Which inspires the most visual storytelling? Which genre generates the most interesting situations and ideas? Which feels the most original? Which version gets you the most excited to sit down and dig your teeth into it? Infusing your premise with each specific genre will provide a whole slew of new visuals regardless of those that would stem directly from your premise. I'll explain more in Chapter 3 how I use genre as a form of visual brainstorming. Allow yourself to find sheer excitement when you figure out the right genre.

Pick a genre for each premise that:

- Is a genre you know well enough to honor its conventions and reproduce its mood throughout the script.
- Would be a cool way to approach your core premise.
- Helps to prove your premise in a unique way.
- Qualifies as the type of script you would be interested writing in the future.

Genre selection brings me to an important classification of writers. Some scribes are *thematic writers*, whereas others are what I call *genre writers*. Thematic writers hop around from genre to genre, and the thing that gets those writers going is the statement that they want to make to the world with their core premise. Others aren't tied to a specific message or personal truth at all. They are storytellers of a specific genre, and they can say anything within it.

The writers who get the most work establish themselves as experts in a single genre. Having a specialty helps sell the writer to buyers on specific projects. So, if there is a specific genre you love and want to develop a name for yourself in, start doing so now. Again, it's not enough to be a fan of that genre; the genre writer needs to become an expert in it. The expert writer would have seen every movie listed earlier next to his or her main genre for starters. Young writers should give serious thought to a specialty. You don't want your ear, nose, and throat doctor in charge of your open-heart surgery. It's the same concept with writing. Having a genre specialty works in all mediums, not just film. So, if there's a genre in which you wish to specialize, this step in the process is easy as hell; the genre is chosen.

Why motion picture studios focus on genre for marketing

Genre has played a role in film marketing since the studio-system days. Studios once controlled all three aspects of their assembly line (production, distribution, and exhibition). Because the studios owned a percentage of the movie theaters, they didn't have to fight one another for screens. The studios owned everything they needed to reach their audience, from creative inception to the venues of consumption. They always had a place to show their movies to make their money back. Just as writers today are pitched because of their specialty skills, each studio specialized in specific genres, carving out individual audiences for themselves, investing their branding dollars in selling the studio's niche genres. MGM sold epic spectacle films. Paramount was synonymous with glamour. Warner Brothers sold grittier crime films, and Universal cornered the horror market.

It took a while for the antitrust laws that were approved in a 1948 Supreme Court ruling outlawing the studio system's monopoly on the motion-picture industry to take effect. When the studios did fork over control of the exhibition part of the pipeline (and the writers and actors became independent contractors instead of bound to one studio), anyone could make any kind of movie. The types of films each studio could produce became competitive and diluted. Each studio lost its stronghold on its genre. Filmmaking became a free-for-all, yet the business of advertising film product did not change. Studios had already conditioned their audiences to pick films based on the genre each studio specialized in hocking. This conditioning helped studios to sell their brand, and they never stopped. From the beginning, studios sold films based on genre, and so the situation remained long after the studios diversified their production slates.

So, no matter how good you think you are as an artist and scribe, you cannot ignore a century of audience conditioning. Because that's how studios sell movies, you can affect a screenplay's potential if you make common mistakes in executing genre. A movie audience has expectations, and the screenwriter must recognize these expectations at the inception of any story idea he or she intends to pursue. If the writer creates within the genre construct, the genre provides a valuable tool that helps an inspired scribe to determine the best approach to establishing and exploring premise.

Even the most unique artists understand and work within the boundaries of applying rules to their own creations. Individualists like Pablo Picasso painted within a set canvas of art classifications, including still life and portraits. Picasso then infused those forms with his unique style, playing with shapes, angles, perspectives, and color. Look at Picasso's *The Old Guitarist, Portrait of Dora Maar*, or *Still Life (Nature Morte)*. Even a true artist figures out how to meld the concept of individual artistry with the good, common business sense of knowing what people pay artists for within the world of their craft. Nobody in their right mind wants to struggle their whole lives as an artist; we all want some level of success if for no other reason than to afford us the time to keep doing our work. Therefore,

a smart artist understands where and how to get his or her bread buttered. This understanding serves the business half of the term *show business*. Studios spend millions upon millions to make a single movie, and then they double that figure to advertise the film. If you plan on asking the studios to buy and green-light your script, it's not an illogical assumption that you should write one that the studios can sell, which means writing within a known and marketable genre.

Part of our knowledge about our craft includes knowing how not to screw it up. Just as weak story plotting and poor character development can throw off a film, so can the misuse of genre. When someone commissions a portrait of a person, can you imagine the buyer's response if the painting is of a hand or the back of the subject's head? You'd laugh and think, "Duh," but there are basic precepts about genre just as fundamental as those of portraiture that some writers still get wrong in filmmaking. It's hard to believe that something so taken for granted, like the standard operating procedure of applying genre to story, can adversely affect a script's execution or box office potential. Yet, genre misapplication happens all the time and costs studios tens, even hundreds of millions of dollars per film when they make such mistakes.

Genre gone wrong (the three most common genre concerns)

Let's take a hard look at the potential potholes in the road ahead with regards to genre misuse. We'll explore the most common genre pitfalls, starting with the most obvious:

I Lack of genre genius

The key ingredient of genius is the ability to bring innovation to something. A lack of originality and imagination is the most common and universal cinematic problem with writing at any step in the creative process, and this problem has very specific and clear ramifications within the execution of any specific genre. The trick is to be original within the genre. Franchises are built upon doing something within that genre so new that an audience wants more of it. *Star Trek* is the franchise about the future of humanity where cultures have come together and explore the universe to obtain understanding and peaceful coexistence with other planets. The franchise perfectly fits the genre.

Let's talk about science fiction for a moment. It was *how* Spielberg broached the classic motif of "first contact" stories that made *Close Encounters of the Third Kind* so viscerally original and gripping. Films such as *Contact*, *Edge of Tomorrow*, and *Interstellar* get green-lit because they take the genre to places it has never been before. *The Martian* did something with the literary Robinsonade subgenre we have not often seen since *Robinson Caruso on Mars*. Whether you like those movies or not, they broke new ground in science fiction, and those properties

would not have been developed at the studio level otherwise. New scripts need to be fresh, even in old genres. Obviously, this need for a little genius goes for all genres. For example, the author of *Twilight* reinvented some of the rules we all knew about vampires, such as why they do not go out in sunlight.

The unimaginative use of boring clichés in genre that viewers have seen a million times will not excite an audience. Setting a script in space with laser guns will not make a strong sci-fi film unless you do something with the tropes that people have not seen in recent cinematic history. A script should not simply regurgitate everything we've seen in other movies. There's recycling, and then there's just plain copying. I'll never forget the stories about how everyone was pitching movies back in the 1980s – *Die Hard* at sea (*Under Siege*), *Die Hard* in a bus (*Speed*), *Die Hard* on a plane (*Passenger 57*). And then I heard the funniest thing. Someone was going around pitching *Die Hard* in an office building. Without the new, inventive twist on an idea or genre, you don't have a new movie.

To sum up, make the script conform to genre so that distributors can market your story, but be original enough within that genre to make it worth paying for the new product with fresh capital. Make the story the same but different. This is the catch-22 of our job. Being creative for a living is not as easy as it looks from afar. All writers and their work need a little bit of innovative genius inside them to not fall into the traps of tired genre clichés.

2 Misguided genre pairings

Some genres pair up exceptionally well because the mood and tone they instill are very compatible. It was early on that films like *It Happened One Night* illustrated how romance and comedy paired well. Disaster films are almost always action movies with the exception of a few dramas like *World Trade Center*, *The Road*, and *Alive*. Mystery, crime, and thrillers play nicely in the same sandbox together. Erotic marries well with thrillers because both genres draw out and create a tingling build of expectation, elevating the heart rate. These genres share certain qualities, creating perfect market overlap. They have chemistry because their kindred audiences are similar. Therefore, when a professional writer hones in on two principal genres for a script, we think about whether the genres will be butting heads or walking in tandem.

Many artists say, "Never say never."

So, what I will say is that some pairings simply don't mix well, like oil and water or square pegs in round holes. Some think that because a certain genre pairing may have worked in other media, a movie audience will pay to see it as a film, but they are frequently disappointed at the box office. As examples of this nonmixing, let's look at a couple of the biggest box office fiascos in the western genre when writers tried to pair it with science fiction or the supernatural. Movies like the comic book– and television show–inspired adaptations of *Jonah Hex*, *Cowboys & Aliens*, and *Wild, Wild West* come to mind. The major conceit of these films is a meshing of genres that really don't fit well together. The writers try

valiantly to force fresh genre pairings to find a new spin on a classic genre, but such efforts fare no better than they did in *Billy the Kid Versus Dracula*.

A great western knows what it is and what it isn't. It possesses qualities that the world associates with that genre. Keeping the script true to a period is one of those necessary qualities when the story is set in the American West. Now, that's not to say there isn't room for steampunk in the western since it fits the period, but it needs to be done in a way that still feels like a western and not a wannabe spy movie with James Bond–like train cars, gadgets, and plans of world domination as was the case in *Wild, Wild West*.

Mixing westerns and science fiction is like trying to force together two magnets of opposite polarity. Westerns are about a much simpler time that's over a century old, and sci-fi explores the complexities of technology that's far more advanced than we have today. Literally, each genre draws upon the exact opposite audience and mood. You couldn't ask for a pair of genres to repel one another *more* than sci-fi and western, because the concepts of each are totally opposed to one another. Some opposites simply do not attract. In fact, the wrong pairings cancel out audiences.

Film concepts need be understood by audiences in a television-friendly trailer (less than 30 seconds). You can achieve that understanding by pitching a concept that falls neatly into a clean, genre-specific tone that viewers can quickly conceptualize. I occasionally get readers who like to argue, so let me head off something at the pass. Because westerns are set in the historical American West, science-fiction films such as *Westworld*, *Firefly/Serenity*, and *Star Wars* (with its resident saloon-regular, quick-draw cowboy with a leather hip holster in the form of Han Solo) are not westerns. They are not set in the west. These are science-fiction films.

Throwing dragons into a western is probably not going to often work either. It's not that dragons or westerns aren't awesome; the flaw is in the pairing.

Filmmaking risks are an expensive gamble. For the record, I'm glad we never stop trying to reimagine how to make things work. This reimagining is the heart of art, which offers an opportunity to try something new. However, I'm saying that some gambles are bolder than others.

The key in genre-pairing situations is for the writer to craft complementary actions that fit the visual expectations of the genres. For example, westerns pair exceptionally well with specific other genres. The western employs action elements such as shootouts and chase scenes featuring a posse. Westerns mesh well with crime elements such as robberies of stagecoaches, trains, and banks. And because the post-Civil War period in North America was an era of colonization and westward expansion, it's perfect for road films. In a solid pairing, the elements of one genre naturally feed into the visual roots and needs of the other. Those genres make sense and can be packaged and sold together. The key is finding where audiences cross over.

If a studio is going to try and make opposite genres fit together, the smart move would be to fully exploit the absurdity of the pairing. Comedy is fabulous genre glue because it allows people to laugh at odd couplings and plays up the way in which the situation is totally ridiculous. Unlike the rigidity of some genres,

comedies pair well with almost everything, but even comedy has a hard time pairing with thrillers because those genres have nothing tonally in common. In fact, one genre is about sustaining suspense, and the other is about releasing suspense. The pairing of comedy and thriller has been done a few times, but most pairings were considered to have not delivered on their potential when measured against expectations. People go to the movies either wanting suspense or comedy. Like science fiction and westerns, suspense and comedy are opposite genres.

When members of an audience can't get a clear picture on what singular mood you are trying to sell them with the trailer, it's hard to get these folks to spend money on it. There's always something else playing in the Cineplex that will deliver exactly what they're paying for with their time and money.

3 The genre goulash

Goulash is a Hungarian stew made with whatever ingredients are left lying around the kitchen. So, the genre goulash is cooked up when there is a lack of specificity and cohesion of tone, making for a hot mess of genres and ideas. Hodgepodge genre movies can be great fun to write and watch, but they lack the clarity and specificity needed to target an audience. When the script could be advertised in several different ways to several different audiences, looking like a different film to each demographic, it's not a solution – it's a problem. When you look at *the top 100 grossing films of all time*, you never question each film's genre based on commercials. Genre was always crystal clear.

Therefore, when someone pitches that they have everything in their movie that anybody could want . . . be afraid. Quantity is not necessarily quality when it comes to marketability. It's hard to mix three or more genres and still be able to market the result well. Look at the sci-fi, disaster, action-comedy film *Mars Attacks!* I love the western, road, crime, chase comedy *The Frisco Kid*, which many Jewish boys were exposed to when growing up, but can you sell it? Too many genres thrown together will not necessarily mean that the movie isn't good. Don't confuse good for marketable. I enjoyed the fantasy, action, romantic comedy *Scott Pilgrim Versus the World*. The characters were dynamic, the visual effects were spot on, the outer journey love story was crystal clear, the action was fun, and the video-game fantasy elements were clever and cinematic. The movie had fun twists, but it was infinitely difficult to sell and pinpoint a marketplace for this picture.

As the old saying goes, a jack of all trades is a master of none. This maxim applies to films; a film of all genres has an audience of none. Such movies rarely live up to box office expectations.

If you can't be clear in a commercial what the product is, who's going to buy it? Therefore, if you want to think of the studio's interests, the script should be primarily one or two genres because that's all they can effectively market in a trailer. Two is the maximum number a mass audience can be sold in a short teaser. Finding someone in the mood for one or two genres is hard enough, but, in the case of *Scott Pilgrim Versus the World*, the people who want to see a rom-com are not those who want to see a nerd-tastic action-fantasy film. Nerd culture is famously

anti-romantic comedy. Again, back to common concern number two: the genres are repelling one another.

Audiences go to movies for a feeling they hope to experience. If there is too much going on, they don't know what to make of the experience. Put simply, too many cooks spoil the broth. It's important to know exactly what you are writing, and the script should stick close to its chosen genre.

The exception to the rules

Sequels have a track record and momentum going into them that creates some marketing leeway. The rule of originality is limited in sequels to some degree. For *Star Trek* and *Lord of the Rings*, the story has to still be fresh, but the audience is paying for more of the same. They do not require a new twist on the world or genre. *The Avengers* qualifies as a genre hot mess with more than two primary genres, but it works because it's built on the joining of pre-established cinematic worlds with two genres each, which combine to include science fiction, fantasy, and action.

Summary

Audiences spend X amount of dollars to see, rent, or buy the product so that it will give them the desired feelings. It's the promise of the product. Genre is the guarantee that the audience will get what they are paying for when they pay for it. They buy tickets to experience what was sold to them in the previews. Genre affects and manipulates viewers exactly the way you promise them in the trailer. This genre promise is a double-edged sword. A writer must master the conventions of genre or risk losing the audience, having left a promise unfulfilled. When a writer violates the conventions and content an audience has come to identify with that genre, and if the writer can't create a script within the context the audience expects to see, confusion and loss of interest in the film often ensue, even if the movie is well written in a ton of other ways. These factors are why it's so important to know, understand, explore, and employ genre thoroughly and thoughtfully. Choose wisely. When the inner spark from premise meets the right tint from the rainbow color palette of genre, it elevates both of them.

Exercise 2

Write how your premise might be dramatized and proven in the genres that interest you. Select a primary genre for your premise.

Qualifications

- The genre suits the premise.
- The genre provides a mood or tone that delivers a new and specific insight to the premise.

Disqualifiers

- There are more than two dominant genres.
- The pairing of the genre and the premise feels familiar or cliché.
- The pairing of genres mesh in a way that makes it difficult to understand what kind of cinematic experience the writer is offering the audience. Make sure one genre doesn't repel the other's primary audience demographic.

The brainstorm

Figure 3.1 Jacob Redmon – When a writer brainstorms all the potential visuals specific to any singular genre, he or she might be surprised what original ideas eventually come to mind.

"Don't tell me the moon is shining; show me the glint of light on broken glass."
—Anton Chekhov, letter to his brother (1886)

Visualization

Movies are motion pictures . . . moving photographs . . . full of visuals . . . action . . . physical things . . . food for our eyeballs projected onto a giant screen, dancing larger than life before us. Many writers get stuck in plotting story beats, forgetting

to explore the rich imagery of the genre to give it the visual pop that audiences want and expect from a cinematic experience.

We work in a visual medium, and, therefore, the best and most cinematic ideas stem from the pictures in our heads. For each genre I write in, I brainstorm a laundry list of specific, physical visuals, including images, items, props, sets, actions, situations, scenes, tense moments, and characters that come to mind when I think of the genre. When I write a screenplay, I try to assemble hundreds of visual ideas (little nuggets of inspiration) before starting to plot my film. Think of the kinds of locations and settings that cinematically fit a genre, like vineyards and long walks on tropical beaches – Tahiti, Paris, Prague, Martha's Vineyard, Kyoto, Dubrovnik, Quebec, Bruges, the Swiss Alps, Venice, or Tuscany. I picture the world and put my head in it. This visualization is the beginning of the process of world-building.

You will notice that the world in which any story is set has a heightened level of stakes. There are only two things the world can agree are worth truly fighting for, which is why those are the two stakes films focus on 99.9% of the time: love and survival. This focus explains the cliché of films being all about sex and violence. So, when visualizing the world, remember to consider all the different ways in which love and death make sense within the genre.

Even the traditional lower-budget dramas listed in Chapter 2 are set behind the closed doors of the Mafia, prison, military life, world politics, biker gangs, Wall Street, insane asylums, war zones, internment camps, the ghetto, and criminal trials. The violence is palpable; the stakes are exceptionally high. Measures taken are extreme. It's hard to sell screenplays (and movies as a whole) to anyone without such palpable conflict at the center of the story. People don't often pay to see a movie about everyday life. If they wanted more everyday life, they'd save their money and stay home. So, I explore the extremes. Movies are exceptional stories about characters in exceptional circumstances. The worlds and situations of these films only get more visual, wild, daunting, and cinematic for characters in other genres.

For example, here is a starter list for science fiction:

- Outer space
- Inner space
- The first sight of something totally foreign to someone of Earth
- The visual shock of discovery
- A scientist's agony of realizing ignorance in astrophysics experiments gone wrong
- Astronauts facing the unknown
- Having a space station as a man's only chance for survival in space when his other forms of life support malfunction
- Teleportation
- Lasers
- Space travel on missions for work, survival
- Exploration and colonization of new worlds
- Aliens
- Alien society, technology, architecture, religion, needs, dreams, and fears
- Alien ambassadors verses rulers
- Wild alien military formations, weapons, talents, and tactics
- More highly evolved species
- Stuck in an airlock

- Jettisoning into space
- Punctured space suit
- Portals going two ways
- Planetary domination
- Broken moons
- Vast emptiness
- Neil Armstrong
- Space cowboy
- Space janitor
- Space ace pilot
- Space mechanic
- Interplanetary cruise ship
- Light speed
- Asteroids and asteroid fields
- Dodging comets
- Riding comets
- Black holes
- The link between time and space
- Stranded or marooned
- Dead planet
- People cannot breathe in space
- Sun kills all
- Dimensional travel
- Time travel
- Exploration
- Rift on space
- Endlessly adrift in space
- Space collision
- A tear in time
- Space tides
- Space surfing
- Space invaders
- Beings from other worlds
- Judgment of our history
- Those who put man on Earth
- Sun burns out
- A cure turned plague
- Losing gravity
- Running out of oxygen
- Losing oxygen tanks
- Oxygen poisoning
- The chill in deep space
- Isolation
- Buzz Aldrin
- Dancing on the moon
- Worlds that no human has ever seen or been
- Reversing physics
- Use of polarity and magnetic fields in space
- Naturally occurring phenomena
- Hull breach
- Genetic manipulation
- Genetic enhancements
- Genetic mutation
- Gene theft
- Genetic cloning
- Miracle cures
- Artificial intelligence
- Robots
- Machinery with a mind of its own
- Programming subroutine missions without the present crew being aware of said programming
- Amazing technology
- Flying cars
- Hover trams
- Rocket packs
- Bioweapons
- Bio-ware
- Nanotechnology
- Manufactured utopia
- Programs designed to love us
- Technology comes between humans and connectivity
- Bringing back people from the dead using their DNA
- Bringing back lost species and plants
- Harvesting organic foods inside enormous genetic plant generators
- Toxic sun rays
- Cities in space
- Cities under the surface of the earth
- Colonies on other planets or celestial bodies
- Never seeing the sky
- Atomic fusion gone wrong

- Fertility lost
- Space capsule
- Something gets into the ship from outside it
- Being locked outside of your own ship
- Charting the cosmos
- Stars
- Supernovas
- Nebulas
- Quasars
- Dwarf stars
- Burnt-out stars
- Ever-expanding, universe-consuming stars
- Constellations and what makes them hold still
- Galactic road trip
- Infinite space
- Hibernation storage of an alien world life-form unrealized until it's on Earth
- Treaties and trade with alien species
- The end of civilization
- M-class planets
- Discovering what is at the center of the sun
- Mankind uses technology to create its own destruction

The list will keep going and going ...

Funneling the light of premise through the prism of genre gives an explosion of imagery and color to your developing idea. It allows a story to start taking on a physical life beyond the conceptual. Screenwriters must illustrate the use of genre visually, or else the smart readers and executives will say your story is a better fit for a stage play or book, not a visual storytelling medium such as film, television, comic books, or video games.

The list should not include things that are specific to a preexisting franchise or intellectual property. For example, Darth Vader, the Death Star, and Jedi Knights are not on my list. Instead, let such ideas inspire you to come up with something original. Create ideas for your own supernatural-infused aliens, space stations, and alien samurai telekinetic empaths. Okay, that last one is a little too close to *Star Wars*, but you get what I'm saying.

These visuals stem from the subconscious part of genre. I'll come up with a pretty cool idea every now and then, but I don't stop when I do. I just keep expanding. Each genre has a list of hundreds of visuals. I work from lists because doing so helps me picture the mood: pages of images and ideas for each genre that I never throw away or diminish. I will build upon these lists my entire life.

Brainstorm the genre(s) you select for your premise. Each genre should have its own list, even if each list describes the same concepts and conceits. There may be some overlap in your lists; there are no rules limiting you. The visual simply needs to exemplify that genre. The contradictory irony of writing is that it's about breaking down the walls within each framework, expanding the outer walls into new ideas. So, the best writers are breaking new ground while keeping the super-structure of genre intact.

If you intend on making one genre your specialty as a writer, you will eventually have a master list of hundreds, maybe thousands of visuals. I've never

counted mine. The more, the better. This is a list from which you can begin to manufacture a script's potential conflicts, situations, and characters: 120 to 150 images, concepts, or conceits per genre is a great start for fueling ideas. By the time I reach 250 genre images, I usually have an idea of where I want to go and a story begins to reveal itself to me. This brainstorming technique will help lead you to character and story ideas perfect for your selected genre.

If you have an idea that's not visual, ask yourself what might be the most dynamic way to see that idea. Unpack the genre into what comes to mind when you close your eyes and see the genre in your head, including tropes, things worth fighting for, obstacles, triumphs, setbacks, stakes, conflict, and imagery. Nobody else ever looks at this list. There are no bad ideas, only stepping-stones to good ones. It paints a vivid, visual picture from which a writer may draw from like a well. I would keep such a genre list as a file on your computer and add to it throughout your life as a writer.

Genre-based visualization-brainstorming lists contain actual, tangible visuals a person can see and imagine realized. A writer brings genre to life with vivid pictures specific to the mood, tone, location, and highest possible stakes. Including these elements is the way in which you tell visual medium–based stories: through physical actions and images.

Mix in your list of premise-brainstormed situations with these genre visuals and see what wild concepts and ideas spawn from the combination. To help assess the story, I like to make a brainstorm list with the core premise to help flesh out the potential scenes and situations for and against the story's hypothesis. Then I put the ideas for interactive scenes and beats in order of lowest to highest stakes so that my script's conflict is always escalating from sequence to sequence.

As the list grows, go back over it and expand upon each thing where you can. The list should not simply be a slew of nouns. For example, you may start a western brainstorm with spurs jangling, a 50-paces gun-slinging duel, tumbleweed rolling through a ghost town, Civil War survivors and mercenaries, cowboy hats and chaps, Native Americans in teepees with tomahawks and peace pipes, etc. Eventually, the visuals evolve into ideas far more specific. For example:

1 Spurs jangle with each step on the dirt road that runs through the center of town.
2 The quiet stranger tips his hat and spits tobacco juice on the man's boots next to him.
3 Crowds gather along the wooden sidewalks on either side of the two men, 50 paces apart, as the men's hands suspend over the revolvers in their holsters.
4 The stagecoach roars into town followed by five horsemen firing pistols and wearing handkerchiefs over the bottom halves of their faces.
5 The woman in black with a sheriff's badge that gleams moseys into the saloon as her arms drape over the Remington rifle that rests on her shoulders.

Everything on the list of visuals needs to specifically be fitting to the genre you selected; it may not go in your actual script. The point of this exercise is for you to start picturing the genre in which you intend to tell your story. You want to make sure when you try to tell buyers you can write a western that you have a writing sample that personifies your ability to do so. Great writers can make sure they have classic imagery that fits the genre in a fresh story.

As authors of a visual medium, screenwriters need to find a way to convey the tone they wish to hit visually. If the writer wants comedy, the list may start with slipping on a banana peel, running into a glass door, or bodily function situations. If the writer wishes for less slapstick, imagine a bank robber in all black carrying a duffle bag bursting at the seams with hundred-dollar bills walking into a room to find himself surrounded by cops, dropping the bag in shock. A woman lowering the cell phone image of her date from the dating website profile to reveal the real person, 40 years older and waving her over, is funny. An airplane crashing down onto a city street and skidding to a stop right in front of a sign that says "No parking" could be amusing. The list should match the genre and tone the writer envisions for it.

Have fun fleshing out these ideas. You are breathing life into the kind of story you want to be writing, in a genre of your choosing with a message that says everything you want it to say. Let your creative mind fly free without restrictions of logical censorship. The ideas do not have to fit together yet. It's just free-association play. This is stretching out before doing creative gymnastics.

Most important, I want to end by saying that this preeminent writing tool can be implemented and expanded upon during any point in the writing process. This list is where writers can go if they ever write themselves into a corner. The list can be used to tune up a script rewrite if it feels like it hasn't maximized the manipulative power of its genre in the latest draft. When asked to make script changes, the hinge of genre guides you to where and when to set revised beats of your story. Many writers get sidetracked with what they need to change or fix about a story during rewrites. Don't lose track of the genre nor let it slip between the cracks when you do. I return to this list throughout the writing and rewriting process. It's a great, constant exploration tool I go back to if I ever want to reconsider the possibilities of any plot moment in the script. That's why I start thinking about genre so early in the writing process, right after premise, even if I don't have a story yet. Obviously, it's common to explore genre selection after the story is conceived, but not everyone knows the exploration can work in the other direction. Genre is the one thing that writers use so diversely and constantly that its gifts can be applied at any time in the writing process, from before characters are created to after the script has been rewritten. It's truly the gift that keeps on giving. This list will get you off on the right foot now and keep you there later.

Now, the stage has been set for action.

We have provided deep meaning and tone for the world of our tale. These factors need to be established before taking that big step into the outer journey of creating specific stories and action, which all stem from characters. We are ready to head into the adventure. Most people know a great deal about characters, but

I am always surprised about the details people confuse. In order to divine a story that makes sense, we need to make sure you know everything you should about characters. So, to assemble a story, we must analyze and define characters and their roles in the dramatic experience. We must take a ride on their backs in order to find the story we intend to tell. This ride will be the second act of our character-driven journey that will lead us to the distant landscapes of concept realization.

Exercise 3

Create separate visualization lists for your premise and genre.

Qualifications

- Keep your list full of actions (this is a visual medium).
- You should have a bare minimum of 120 images per genre. More imagery is always better.
- If you choose to mix and match two genres, make a complete list of images for each genre. Keep these two lists separate.

Disqualifications

- Anything that is not specific to the selected genre.
- Mixing genres into one list.

Act 2

Character creation

Character development

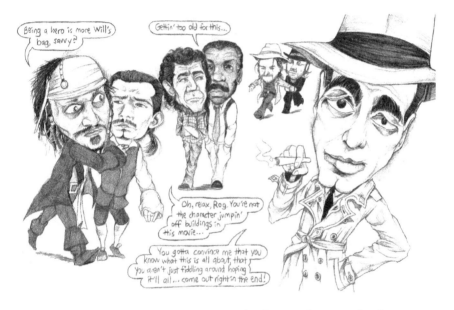

Figure 4.1 Jacob Redmon – Defining characters by design and purpose. Just because you have two leads does not mean you have two protagonists.

Character credits: Samuel Spade (*The Maltese Falcon*, Warner Brothers); Captain Jack Sparrow and Will Turner (*Pirates of the Caribbean*, Walt Disney Studios); Roger Murtaugh and Martin Riggs (*Lethal Weapon*, Warner Brothers); Dan Evans and Ben Wade (*3:10 to Yuma*, Lionsgate)

> "When writing a novel a writer should create living people; people not charac-
> ters. A character is a caricature."
> –Ernest Hemingway, Death in the Afternoon (1932)

Now that you have your premise and the genre you want, it's time to give those elements a physical life. The only way to externalize those elements is through action, and action stems directly from character. This means that in order to

develop a workable story with perspectives, willpower, and conflict, a great story must be driven by its characters. Therefore, the next major step is about understanding the role each character plays in a story to figure out and hone exactly how they contribute to and make physical the different perspectives of the premise in your tale.

The one constant throughout the history of storytelling has been characters with their perspectives and their missions. For centuries, analysts have broken down different ways to pinpoint character types and classic archetypes by their function within a play. Terms used to describe these functions include hero, villain/tyrant/destroyer, creator, the mother/caregiver, innocent youth, orphan, doppelganger, sidekick, bureaucrat, explorer, scapegoat, rebel, lover, trickster/jester/fool, sage, magician, seeker, catalyst, ruler, outlaw, everyman, bully, creature of nightmare, damsel in distress, temptress, friendly beast, outcast, survivor, warrior, martyr, or star-crossed lovers . . . The list goes on and on as ways to categorize those characters and how we see them. Many of these are personality and perspective driven. All of those things help clarify and pinpoint personality once you have a story, but I have always found them less helpful at this early point in the concept-creation process. First, a writer must know what characters need to do in the story before he or she decides how these characters will do it. Story creation is *not* about personalities or how they do things. It's about what they need to do structurally as their function for the premise. You can best decide on what personalities and perspectives fit each character only after you know what their purposes serve in the grand scheme of things.

To define and expand upon the exact situation of your story, you must understand each character's purpose in telling it and the role the character plays in proving the premise. Coming to this understanding is how you figure out exactly how the writer intends on dramatizing the hypothesis. It's done through specific actions taken and reactions had by characters. This combination of action and reaction is story, and creating these actions and reactions is our goal. We'll explore these five major roles the characters play in stories. Common, popular terminology for them includes:

1 Protagonist
2 Antagonist
3 Love interest
4 Mentor
5 Other allies and reflection characters

That's all you need to know in order to find your story. If you want to delve into all those other character archetypes, don't waste time integrating them now. Only assign them to roles once you figure out to whom you'd be giving those roles.

Most writers start off character development with the hero. Because so many people are used to using the age-old term *hero* to define a film's perspective, let's first discuss what it means to be a story's hero in a little game I want to play called . . .

Who's the hero?

Many writers face an odd conundrum when trying to understand a fantastic script that appears to have more than one central character. Have you ever watched a film and asked yourself, "Who is the hero? Which one is it?" Well, I'm going to help you find an answer by dissecting a trio of well-written, dual-protagonist films: *Lethal Weapon*, *Pirates of the Caribbean: Curse of the Black Pearl*, and the 2007 remake of *3:10 to Yuma*. All of these films appear to contain two central characters, but that's where the similarities end. To start, the members of each pair of heroes have a different type of relationship:

- *Lethal Weapon*'s duo are partners who share an external goal of solving a crime.
- *Pirates* teams two characters with different goals (treasure and saving the girl) unified by common enemies.
- *3:10 to Yuma*'s pair have external goals that are in direct conflict with one another (one character's job is to get the other character on a train to prison).

These three films are very different and vary in genre: crime, fantasy, and western. Yet, as different as they are, you will see that they share a formula. I will demystify the way in which a great two-hander is structured; all three of these character pairings are structurally identical.

We'll start with the more classical hero half of each pair: Roger Murtaugh, Will Turner, and Dan Evans. They all have their film's central love story, but that's not all . . .

- Roger Murtaugh is a family man and career cop close to retirement. He has a large, likeable family worth protecting, and he truly values his life. He also has a personal stake in solving the crime the pair is investigating (the murder of a war buddy's daughter). By his own admission, he's too old for this job, but he's still going to do it.
- Will Turner is a sympathetic orphan with respect for authority and the unrequited love of a beautiful maiden. He will risk anything to rescue the girl he loves.
- Dan Evans is a hard-working cripple who's bullied by the henchman of the west's equivalent of big business. He has a family he loves dearly and is on the brink of losing his meager farm. He risks his life to keep them safe by escorting a murderer to the prison train with the convict's posse of deadly killers on their tail.

These characters dive into the second act facing evil with everything in the world to lose. Their missions are personal as well as heroic. They have people to protect, and all of them have higher stakes than any other character. So, by all preexisting definitions and common cultural understanding, many viewers would identify these characters as the protagonists.

Each of these heroic characters has a yang to his yin with whom he is forced to pursue his goal. These other characters are never what the heroes would want for a counterpart on their mission (i.e., the outer journey). These are the unlikely heroes:

- Martin Riggs is the quintessential loose cannon, a suicidal cop with no loved ones in the world and no personal stakes in the outcome of the case.
- Jack Sparrow lives up to the term *scallywag*. He shows constant contempt for authority, no morals, no loyalty to romantic relationships, and no gumption. He's only involved with Will's rescue mission for personal gain.
- Ben Wade makes the other two look like boy scouts. He's nothing short of an escaped convicted thief and killer. The closest thing he has to family is his band of truly evil outlaws.

Two of these characters would be traditionally thought of as allies, while the third could easily be mistaken for a potential antagonist at first glance.

These latter characters are the opposite of what the heroes should evolve into during their stories, like Han Solo in *Star Wars*, Reggie Hammond in *48 Hours*, and Lazlo Hollyfeld in *Real Genius* – they are a warning to the hero. They represent the antithesis of what we hope for the protagonists. Don't become this character! The hero must be careful to not let his outer journey change him into his dubious counterpart. However, this less-than-ideal character is still needed as an ally. The hero must rely or depend upon his dark shadow during a period of crisis.

So it all makes sense – three heroes stuck on a mission with characters who mirror what they should not become. Now, here comes the reversal; it's the three unlikely heroes that are actually the protagonists of their films.

Don't forget that a character needs to have an outer journey as well as an inner journey to qualify as the protagonist. It's having an inner journey that makes those characters the protagonists. Ask yourself, which character has the character arc? Who grows? Who creates the success and battles the ultimate villain of these films, face to face? Jack Sparrow is influenced to change by Will Turner, not the other way around. Jack Sparrow turns around the boat loaded with treasure to go back and do the right thing in the end. He is the one who battles Barbosa. Martin Riggs breaks free from horrific torture, rescues his partner and his daughter, chases down a speeding car, has the final climactic fistfight, and illustrates a complete arc when he surrenders the special bullet he was saving for suicide. Ben Tate kills his band of outlaws and voluntarily gets on the prison train in order to save Dan's family from losing their home.

Before the 1940s in cinema, you will be hard-pressed to find this kind of protagonist in film, but that all changed with the birth of the antihero, Samuel Spade, in a daring and new noir genre novel turned feature, *The Maltese Falcon*.

Roger Murtaugh, Will Turner, and Dan Evans help resurrect the protagonists' humanity, awaken their consciousness, and help the protagonists achieve their character arc by showing them the way. These heroes set the example of how

the protagonist should arc during the story. Ben Wade should put others before himself, Riggs should find something to live for, and Captain Jack Sparrow must put other people above personal gain. That latter movie contends you can be a career-criminal pirate and a good man. Now, don't blame the messenger, that's what the writers wrote.

The trick question revealed

What most viewers perceive as dual-protagonist films usually are not. As for the characters we would have assumed were the protagonists, they pretty much stay the same from beginning to end. They only went on an outer journey. Upon reflection, you will realize that the heroic half of the pairing was the shining example for the protagonist to follow, helping the protagonist to accomplish his character arc. The confusion stems from two different definitions of the word *hero*. Hero can be defined as the driving force of a story, and hero can also be defined as someone with brave and heroic behavior leading to the greater good. In these stories, the two leading characters both embody one of those two definitions. The twist of this chapter is that the protagonist is not always a heroic character. The protagonist traditionally does something "heroic" by the end of the film, but that doesn't mean he or she is a hero. I would never call the central characters from *A Clockwork Orange, The Shining*, or *American Psycho* heroes. They are simply central characters.

Clarification of character classification

Like the word *premise*, the term *hero* implies to most people one concept based on its most common usage in the English language, while it actually means something else in technical terms for those properly educated within the writing community. The vast majority of people think the following three terms all mean the same thing: (1) hero, (2) central character, and (3) protagonist. Now, those three terms may refer to the same character in a single story, but that state of affairs isn't *always* the case.

 For those writers who follow the teachings of the classic structure of the hero's journey found in Joseph Campbell's *The Hero With a Thousand Faces* and Christopher Vogler's *The Writer's Journey*, you are in luck; the hero, central character, and protagonist do all mean the same thing. There is no confusion for those who follow the mythic-structural paradigm of Campbell and Vogler. That is the beautiful elegance of the hero's journey; it is probably the most widely accepted model of entertainment scriptwriting, whether you read the books or have picked up pieces of the concept instinctively by gleaning the information from watching countless movies. Most screenwriting-book authors revamp and regurgitate the teachings of Campbell and Vogler. Studios and producers hire Vogler among other structure gurus to advise on their projects because theirs are time-proven methods of effective storytelling.

Even if you desperately want to do something different and break the mold, I recommend that you study and understand what Campbell and Vogler teach. You want any decision violating those classic storytelling models to be informed, not one made in ignorance.

Obviously, not every writer has used those ancient concepts of effective storytelling, the analytical story theories of which date back to Aristotle's *Poetics*. In fact, the most basic principle of the central character still gets broken from time to time when that character dies somewhere in the middle of the story and a different character takes over that role in the plot. This switcheroo that was used in films like *Psycho* dates back to ancient Greece in plays such as Euripides' *Hippolytus*. Only if a writer chooses to follow those structural methods will the model always apply. So, whatever rules you think exist all the time, artists sometimes break those rules.

Words evolve, and their meaning changes over time. Change is the only constant in the universe. With those changes, the way a writer chooses to tell a story may change.

Now that we have established that all writers do not always adhere to common structural paradigms, I must reveal my own perversion. I don't lock the central character into being any singular character type. I define all characters by their duties in proving the premise, not the size of their parts. For me, a protagonist proves the premise, whether in a positive or negative direction. When the story is exceptionally well plotted, that proof of the premise is exemplified through the protagonist's character arc. This fact does not mean that the protagonist is always the film's centermost perspective. Writers may choose to rotate different characters into the central character position. I know that I'm engaging in rebellious thinking, but this rotation has been done successfully. I'll get more into the concept of a nonprotagonist central character during my chapter on mentors. In short, the word *protagonist* is no longer 100% synonymous with *central character*, even though 99% of the time they are one and the same.

The protagonist is often defined as one or more of the following: first character, central character, hero, lead advocate, and primary actor. Now, if the protagonist is the largest advocate for the story, that role makes him or her the champion of the writer's premise. If the protagonist is going to prove a premise's validity, the evidence mounted throughout the telling of the story should be so profound that it influences the character to change. The story shows that the world embodies the wisdom of the premise. Ironically, you can look up the term *protagonist* anywhere, but setting the example for change is never mentioned in the definition. That's right. Nowhere is it written that the protagonist, by definition, should have a character arc. Yet, for me, that's the most crucial part of proving the premise and telling the story. Illustrating the impact of the fight for and against the premise should impact the protagonist profoundly; otherwise, what's the point of the lesson? Without growth, there is no progress, and story must exemplify an attempt at progress.

Therefore, though no one else (from *Webster's* to Wikipedia) defines a protagonist in official terms by his or her character arc . . . I do. Christopher Vogler writes about the *character flaws* and *growth* of heroes in *The Writer's Journey*, and I

believe that this growth is an important part of the protagonist's role within any story. The protagonist is the *most* central character whose perspective is internally, deeply changed by their experiences within the story. It is this specific fact that makes a protagonist the most human of the characters, because he or she is flawed and still growing. That humanity is what makes it a hero's journey. Therefore, if a protagonist does not arc or refuses to change, this lack of change signifies his or her failure within the story. I try to always plot a character arc for the central character so the audience can see what is supposed to happen in the wake of realizing the premise. I want an audience to understand how things should change for the character and the world in the wake of the premise. As the writer, I lay out the arc in a leading way. Now, I do all of this whether the protagonist achieves the arc or not. Character arcs are particularly fitting for road, coming-of-age, drama, and comedy stories.

Now, I am an advocate for character arc in all protagonists, but I would be remiss if I didn't point out that some writers do not use character arcs. These writers simply have a character on a mission. In those cases, the protagonist is constant, and it is the world that faces transformation (arc). This type of story is seen primarily in films about seeking justice and right. These kinds of stories are common in action, disaster, and adventure films. Still, no matter how you slice it, the protagonist is either facing a personal or reality change. Many great protagonists have and overcome the designed character flaw, but there are these rare exceptions. For example, *Forrest Gump* is a story in which the world is flawed and changing constantly around a character who remains constant.

The four ways an arc might occur:

- The achieved character arc proves the premise (*Liar Liar*, *Almost Famous*).
- No arc is achieved, which signifies the protagonist failed to learn from the premise (*Pulp Fiction*, *Nightcrawler*).
- The world arcs (not the protagonist, who serves as a mentor to the story) (*Gladiator*, *Stand and Deliver*).
- The world fails to arc because the premise expresses a tragic reality, even though the protagonist never gave up fighting for what was right (*Chinatown*, *Night of the Living Dead*).

In the best sculpted of situations, the protagonist arcs, and his actions, as a result of the actions taken in the wake of personal metamorphosis, change the world around him.

To sum up:

- The *central character* is the character whose perspective the film follows throughout.
- The *protagonist* is the chief advocate regarding the premise, responsible for personal or world change. The story may come from the perspective of a different character, but the script is really about this character.

- The *hero* may be one or both of the above, but I do not call a character the hero if he or she is not heroic in the classical Christopher Vogler/Joseph Campbell sense of the word.

Exercise 4

- This is your first character-building exercise. Considering the brainstorm list of visuals and actions based on your premise and genre, extrapolate the list by adding to your list the types of people/characters that might commit those actions.
- Add the kinds of characters you expect to populate a film set in the genre you selected. You want characters to fit the genre because they are all part of one big movie. For example, in a crime film, you might integrate cops, hit men, thieves, mob bosses, drug dealers, parole officers, ex-convicts, conmen, thugs, loan sharks, gamblers, prostitutes, private detectives, femme fatales, etc.
- Ask yourself what other actions each of those characters might do that fit the genre and each character's perspective on the premise.

With that, let's get into talking about the first of the five major character types.

Chapter 5

Protagonist

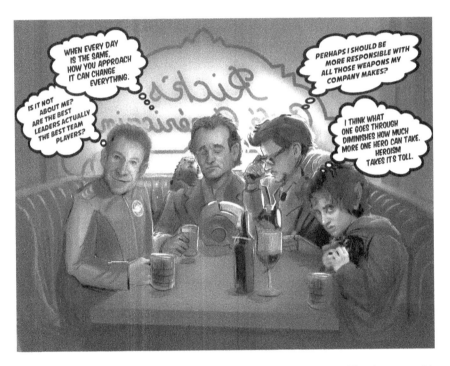

Figure 5.1 Brandon Perlow (Lettering by Denise Deems) – Protagonists: The character with two journeys, one of which unintentionally changes who he or she is on the inside.

Character credits: Jason Nesmith (*Galaxy Quest*, Dreamworks); Phil Conners (*Groundhog Day*, Columbia Pictures, Sony); Tony Stark (*Iron-Man*, Marvel, Walt Disney Studios); Frodo Baggins (*Lord of the Rings*, New Line Cinema, Warner Brothers)

> "What we achieve inwardly will change outer reality."
>
> – Plutarch

Whenever agents, producers, and executives are asked what they are looking for (regardless of genre or budgetary-scope preferences), the answer always includes

the phrase "character driven." Everything else changes with trends and taste. Therefore, since the one morsel everyone always hungers for in Hollywood consists of great characters, it's obvious that I should focus on how working screenwriters perceive, develop, and define the characters that fill our scripts. The next few chapters will focus on development of the major character types (not to be confused with character archetypes). Throughout the ages, writers and performers have crystalized character types that became extremely specific and stylized with the rise of *commedia dell'arte* in the sixteenth century. Along the way, some of the details will undoubtedly include information you already know, but it's always crucial when making a point to build upon a strong foundation.

Writers and performers have been breaking characters into quantifiable types and purposes long before film was even invented. Once fleshed out, characters are the driving force that makes ideas evolve into a full-fledged story. The characters shape everything in a script, and every one of the five possible specific purposes they serve illuminates how the story unfolds. This chapter will look closely at the most principal role of the five major characters.

The protagonist is the character through which the author takes the audience on an exploration of the premise, theme, and central question. All characters stem from the premise, a deeply rooted point that the writer wants to make or explore with the script. Often called the *hero*, even if his or her actions are not necessarily heroic, this is the character through whose eyes the writer makes a point. Every other character in the story is built and designed to challenge your protagonist in specific and unique ways. In short, using the solar system as an analogy, premise is the sun at the center of the universe around which your protagonist revolves while other characters revolve around him or her like moons.

Two personal journeys

A protagonist takes two journeys during a traditional, cinematic story:

1 The *outer journey* is a physical mission or the completion of a task, which the hero sets out on by the end of act 1. This goal is a consciously chosen undertaking by the protagonist.
2 The *inner journey* is the character arc initiated on page one in the form of the personality or character flaw with which your protagonist starts the story. This journey is entirely subconscious and exemplifies proof of the writer's premise by the end of the film.

Every scene in the script is about the protagonist's two journeys, even if that character is not in the scene. These journeys help writers focus the vision for the time frame of the story in the life of a protagonist. This focus helps define which two hours of excerpts from the protagonist's entire life are going to best fit the film's premise and subject matter. Both journeys help the writer decide what specific moments will show in the script.

There should only be one journey/goal in each journey statement. These sentences should be succinct, straightforward, and contain no compound sentences. This proscription means that if you use a conjunctive word such as *and*, you are not being clear enough. I always distill a protagonist's outer and inner journey to one thing each. That kind of clarity and simplicity is crucial when writing or pitching. I've quoted it before, and I will quote it again:

"If you can't explain it simply, you don't understand it well enough."

−Albert Einstein

Protagonist's outer journey

The outer journey answers the following question: "What is the one basic, external mission or goal of the protagonist that he or she sets out to accomplish at the end of act 1 and probably appeared to have failed in when the script reaches the end of act 2?" What is the protagonist's physical, external goal or mission? It should involve high stakes (traditionally, death or love hangs in the balance) and is something the protagonist will not give up on when the task seems insurmountable in the wake of act 2's final *all is lost* moment. The protagonist goes on this journey intentionally.

You should include no other information in this statement, not even what or whom the protagonist is up against. The most common mistake is when a writer gives the antagonist an active goal, but designs a protagonist simply to stop the machinations of the antagonist. That writerly mistake makes a protagonist *reactive* instead of *proactive*. Passive protagonists are frowned upon by the industry (and, quite frankly, are boring as hell). I urge you to create an outer journey that just happens to directly conflict with the antagonist's desires. In the 2008 film *Taken*, Bryan Mills' goal is to secure an ongoing relationship with his daughter; the human trafficking ring just happens to get in his way. In *The Patriot*, the protagonist, Benjamin Martin, just wants to raise his family in peace. In order to accomplish this end, against all his own desires, Benjamin must go to war. A protagonist should have his or her own point of view and goal for success, and this goal should not merely be to see the antagonist fail.

Whenever you think your protagonist's outer journey is to find a piece of information, you have not found the true mission yet. Dig deeper. Ask yourself, "Why is the protagonist doing this now? What physical thing is the protagonist trying to accomplish with the information?" You need to find a more finite finish line to the mission. Any visual medium of storytelling is best served and most suitably dramatized by a protagonist in pursuit of a visual goal. For example, if a character wants to know who the killer is, it's because he or she wants to see justice done in some specific way. When a protagonist wants to find his or her birth parent, it can be because he or she wants this person to attend his or her wedding, needs a bone marrow transplant, or wants an apology for the abandonment. Information may be important to the outer journey, but it is best in a visual medium when the endgame is an action.

The protagonist's outer journey needs a specific, physical goal. We need a purely physical *finish line* to the story that the protagonist can complete. The reader knows the movie is over and the character has succeeded when that mission is accomplished. For example, in *Happy Gilmore*, Happy's goal is to keep the bank from taking his grandmother's house. In most crime thrillers, the goal consists of catching a killer. In *Back to the Future*, George McFly must specifically kiss Lorraine at the Enchantment Under the Sea dance so that they can fall in love and have children. We need to be able to picture this act/deed/mission in our head, conjuring a specific image. Missions that have no end do not work. The mission can't be vague. When this goal is achieved, the audience knows that the credits will roll soon. This goal should be clean and succinct, capable of being stated in one sentence.

Consider the following generic examples of a physical goal's finish line personified with a clear visual image:

- Get home.
- Free the people.
- See justice done.
- Claim the crown.
- Avenge a loved one.
- Steal the grand jewel.
- Make the school safe.
- Get into Harvard University.
- Free the innocent man.
- Marry the dream boy or girl.
- Reveal the truth to the world.
- Become a knight of the realm.
- Get back what belongs to you.
- Help a loved one die with dignity.
- Perform at Madison Square Garden.
- Return something that belongs to someone else.
- Make sure your child lives to see another sunrise.
- Win the bet, competition, election, or championship.
- Get the real criminal arrested in order to clear his or her name.
- Scatter the ashes of a loved one from the top of Mount Everest.

Outer journeys come in many sizes and shapes. You need to be able to actually see the physical act of the finish line for your protagonist's goal on the screen.

Specific examples include:

- Martin Riggs (*Lethal Weapon*), a detective, must get justice for an innocent, murdered girl who made poor life choices.
- Jason Nesmith (*Galaxy Quest*), a washed-up actor, must become the starship captain he once played on TV, leading a gullible group of aliens to successfully achieve freedom from the genocidal alien race that wiped out their home world.
- Tony Stark (*Iron-Man*), a weapons innovator and manufacturer playboy, seeks justice upon those responsible for using his creations irresponsibly.
- Frodo Baggins (*Lord of the Rings*) must destroy the One Ring in the fires of Mordor.

- Eliza Doolittle (*My Fair Lady*) sets out to better herself enough to run her own flower shop.
- Andy Sachs (*The Devil Wear Prada*) needs to complete one year as a high-profile assistant in order to earn consideration for a job in journalism.
- Harry Stamper (*Armageddon*), a top oil driller, must join a military mission to destroy an asteroid before it collides with Earth.
- The Chosen One (*Fallout 2*, game) travels the Wasteland with the goal of saving his dying home village in a post-apocalyptic world.
- Adrian Monk (*Monk*, episodic) must catch the man who murdered his beloved wife.

This one external mission is an action triggered by the decision a protagonist makes at the end of act 1, and the mission does not change. If you do not construct the outer journey correctly, you will not be able to properly design antagonists, mentors, or allies because they are all designed to fulfill certain tasks that play a part in the protagonist's outer journey.

An outer journey will sometimes focus on the pursuit of a physical mission that is not necessarily good or right, putting the protagonist into not only difficult but immoral situations with shallow priorities. If we're working on the story about poor prioritization of material things over human beings, the goal can be a huge promotion at work (*Liar Liar*), the success of a company created in the basement (*Steve Jobs*), or the showing up of the bullies from high school at the reunion (*Romy and Michele's High School Reunion*). You must have one physical, clear and specific mission. The politician's story could be about getting elected or passing an important bill. It's crucial to make sure the outer journey fits the genre that has been chosen for the film. Now, in the case of writing assignments and adaptations, the genre has been often preselected for the writer. Otherwise, if the writer has mixed feelings about which genre to go with, selecting the most engaging outer journey for the protagonist may actually help with that decision.

The outer journey needs to provide the circumstances in which the premise can be proven. Therefore, this 100% physical mission should require the protagonist to undergo a meaningful perspective change in order to accomplish it. The situations, events, and actions that shape the hero's outer journey should become so intense that the journey triggers a major change in the heart of the protagonist and transforms him or her irrevocably forever. This transformation leads us to the . . .

Protagonist's inner journey

The inner journey is a profound change of perspective that is called the *character arc* (or *character curve* in the original stage version of the concept). This arc stems directly from the character flaw and is an unintentional result of the protagonist going on an outer journey in the physical world.

The *character/personality flaw* and *character arc* are interrelated. The flaw defines how, the protagonist changes *internally* during the story. In short, what personality flaw does your protagonist have to overcome in order to succeed in accomplishing the outer journey? For example, in the film *Liar Liar*, the protagonist must learn to be painfully honest with the people he loves if he's going to earn back their trust. This journey answers the following simple question: "What is your protagonist's personality flaw at the beginning of the script, and how does he or she permanently overcome it due to the life-changing experiences in act 2?"

Remember, the inner journey is totally subconscious; it's not an actual goal for the character. It's the result of going after something in the real world that changes the character internally; this transformation was never intended when the protagonist decided to embark upon the outer journey. It's cause and effect. The protagonist's pursuit of the outer journey causes the inner journey's long-term effects upon the protagonist psyche.

The wording of an inner journey is also exceptionally important. This character arc should be short and simple. Pick one opposite quality for each side of the equation. For example, a character can go:

- From lover to hater
- From sellout to loyal
- From slacker to worker
- From abusive to respectful
- From introvert to extrovert
- From conformist/sellout to fighter
- From impetuous to thoughtful
- From pessimism to optimism
- From procrastinator to decisive
- From distancing to welcoming
- From divisive to uniting
- From austere/tense to easy going
- From goody two-shoes to unruly
- From quarrelsome to pleasant
- From quixotic/starry-eyed to realistic/pragmatic
- From savage to cultured
- From reclusive to social
- From playing careful to daring
- From selfish to sacrificial
- From feckless to purposeful
- From skeptic to believer
- From entitlement to abdication
- From indulgent to abstinent
- From lone wolf to team player
- From conversationalist to activist
- From bigoted/judgmental/denial to accepting
- From coward/faint-hearted to courageous
- From follower to leader
- From obsession/indulgent to moderation
- From reckless to responsible
- From highbrow to lowbrow
- From braggart to humble
- From lewd to prude
- From tense/uptight to lax
- From total square/law-abiding to thief
- From conservative to progressive
- From homebody/shut-in/hermit to adventurer
- From shy/timid/bashful to bold
- From tentative to tenacious
- From a pushover to defiant
- From settler to striver
- From submissive to dominant
- From integrity to corruption
- From guilty to clear conscience
- From deceitful to honest
- From facilitator to obstructer

- From short-fused to patient
- From inconsiderate to selfless
- From self-loathing to prideful
- From dependent to autonomous
- From violent to gentle
- From abuser to guardian
- From primitive to sophisticated

- From harmless/protector to destroyer
- From rebellious/defiant to compliant
- From cowardly to heroic
- From naive to cynical

All of these transformations can be reworded to work in the reverse as well, except maybe that last one. The experiences of the second act inspire that protagonist to become more positive in uplifting stories, and the arc becomes more negative in darker stories.

You will notice that these status changes are not emotions, which do not measure an internal change of anything except temporary mood. For example, being afraid is not a flaw because anyone can feel fear, but a character being a coward is a flaw. We are looking for a permanent personality change. It is a constant problem getting in the protagonist's way at every turn, keeping him or her from realizing the premise. All of the above examples are pairings of specific and opposite personality traits. They are so opposite that they could not possibly coexist in the same persona at the same time. That's the kind of dynamic character arc we look for in a screenplay.

Each of those qualities on either side of the character arc is a polar opposite. Therefore, there is no confusion as to the fact the character changes completely in some way. These character flaws make that character appear three-dimensional and feel human/fallible. Human imperfection provides the opportunity for empathy from the viewer since we all make mistakes. Without a flaw, the protagonist simply does not feel realistic. After all, nobody is perfect; therefore, neither is your protagonist. Like real people, your protagonist is a work in progress.

Notice that arcs should have the following structure: *going from* a clear character flaw *to* a character arc that directly rectifies the flaw. Your protagonist's inner journey should be worded as clearly and succinctly as humanly possible.

Specific examples include:

- Martin Riggs (*Lethal Weapon*) goes from suicidal to having the desire to live.
- Jason Nesmith (*Galaxy Quest*) goes from self-centered to considerate.
- Tony Stark (*Iron-Man*) goes from negligent to responsible.
- Frodo Baggins (*Lord of the Rings*) goes from lively to laden.
- Eliza Doolittle (*My Fair Lady*) goes from crude to refined.
- Andy Sachs (*The Devil Wear Prada*) goes from naive to aware.
- Ebenezer Scrooge (*A Christmas Carol*) goes from stingy to generous.
- Rachel Green (*Friends*, episodic) goes from spoiled to humbled.

You should note that all these fabulous protagonists have strong, outgoing personalities, which fuel bold decisions in the face of constant confrontation.

Confrontation requires the protagonists to make tough decisions and take action. The protagonists may make poor choices and take the wrong actions supplied by the character flaw. A lot of newbie writers use self-doubt as a character flaw because they understand it, which is the opposite of what makes a compelling protagonist. Impetuousness, boldness, confidence in their ability to do something specific make for more exciting characters to watch. In short, it's better to have the flaw be something that gets the protagonist into more trouble during the story rather than something that would get him or her into less trouble. Audiences pay to see the trouble characters get themselves into and have to fight their way out of.

The character flaws are not limited to a microcosm

It's important to note that a character flaw is most effective when it is generalized, not situational. If the flaw is selfishness, the inner journey should not be that a character is selfish just regarding one specific thing. One specific thing may shine a spotlight on a protagonist's flaw more than another (which is what a great outer journey does), but flaws are best exemplified when used as an across-the-board personality issue that seeps into that character's actions in any potential situation. Showing the flaw in multiple actions and situations makes it easier for the audience to deduce what the character flaw is without exposition. So, if the flaw were selfishness, the flaw would be that they are selfish in general in the same way as being self-absorbed affects everything the character does in their actions and relationships with people and society.

As another example, a character being a collector would not be considered a flaw. However, if that character collects everything, it's called hoarding. *The 40-Year-Old Virgin* didn't just hold on to his virginity too tight; his flaw was exemplified in other areas, including the never-opened collectibles that covered every surface of his apartment.

For a split second, I thought the one exception to a flaw not revolving around a single thing might be obsession, but an obsession is also all-consuming. Obsession affects everything to such a degree that in excess it is considered a major component of a psychological condition (OCD).

This brings me to one rare piece of insight I have become familiar with during my years as a professional writer. People with psychological conditions hate it when a writer refers to his or her condition as a character flaw. It's offensive. We would never call cancer a character flaw. An involuntary psychosis does not equate to characteristics like being egotistical, greedy, immoral, ill-tempered, reclusive, and bigoted. Those latter qualities are personality flaws. So, let me remind you of Melvin in *As Good as It Gets*. He may have OCD, but his character flaw is that he's an intolerant bigot, not his condition.

Universal and perpetual flaws force characters to make the incredibly difficult decision to change their behavior patterns and who they are. That choice to make

a big change, inspired by the events of the story, is the key component in proving the writer's premise. Because the character arc demonstrates the validity of the author's hypothesis, it needs to be a big, broad, noticeable behavior alteration.

The inner journey's obstacles are external

In a visual medium, audiences need to see why characters are changing. The external situations must place the protagonist into a position to either lean into the character cure or fall back into the character flaw. The obstacles for the outer journey double as part of the learning-curve experiences that compel internal change in the protagonist's behavior. So, when a writer orchestrates an outer journey obstacle, he or she considers how the protagonist's inner journey will play into the choices the protagonist must make in those situations.

It is only through the protagonist working to overcome a series of difficult obstacles designed to exploit and explore the reasons this inner journey is necessary that a reader receives tangible proof of why the protagonist must change. The results of the choices made during the protagonist's encounter with an obstacle reveal what it will cost if protagonist does not arc as a result of each situation. It is through physical, external complications demanding decisive action that a protagonist realizes that he or she must change.

A protagonist realizes a change is necessary for one of two reasons:

1 Because the cure is for the greater or personal (selfish) good.
2 Because the flaw is wrong, damaging others or the self.

Another interpretation of these two choices are the protagonist either seeks to (1) attain pleasure by moving toward a cure or (2) avoid pain by distancing one's self from the flaw.

Sometimes, it's both.

Now, you may be asking yourself about all the work that goes into designing, setting up, and paying off an inner journey and ask if it's worth it. The movie trailers mostly sell genre and the outer journey to audiences in order to make money at the box office, so is a character arc necessary?

The answer is yes, and here is why.

The inner journey proves the premise

The inner journey should address the writer's reason for writing this story and the point it is trying to make. So, the protagonist's inner journey exemplifies whatever the premise claims. For example, if the premise's goal is that the only way to stop a genocidal regime is to kill them, you will probably want to start with a protagonist who emphatically believes killing is never the answer. The protagonist slowly learns that these radical, racist, homicidal regimes cannot be stopped without deadly force, and, in order to complete the character arc, the protagonist must

have the strength to personally pull the trigger in the end. Without the internal change the protagonist should be unable to succeed in the outer journey. The key to accomplishing the outer journey is achieving the inner journey. This duality is a huge piece of the puzzle in designing a film concept, and the pieces all need to fit together. Premise tethers to inner journey, which tethers to the love interest (see Chapter 8) because that character's job is to inspire your protagonist's arc. Story construction is a giant house of cards, and if one card is out of place, the whole thing can crumble.

Knowing all of this information about the protagonist, a writer extrapolates from the premise an inner journey that proves the premise's hypothesis. There-fore, if the premise has to do with how people now *respect material things more than other people,* you'd want to start with a protagonist whose arc begins in a place of prioritizing people, but, in the wake of the struggles that dominate the middle half of the story, the protagonist will eventually put material things above people by the end. Now, though it may be a touch cliché, a writer can also construct a story that sets out to illustrate the exact opposite perspective with a premise that argues that *people are more important than material things.* You can start with a protagonist who has always put material possessions (like a collector of some kind) above the value of his or her relationships. That protagonist's character arc will force him or her to put people above material things. It could be that the protagonist goes from indulgent to abstinent (such as forgoing completing his or her collection in lieu of doing something for someone the protagonist loves) or goes from selfish to considerate. The proof of the premise is the character arc, which would be when the protagonist sacri-fices material possessions for the sake of another person (or group of people). Notice both of these hypotheses are opposite yet accurate. Premise is about providing profound truth from a specific writer's perspective. Just as premise defines how the writer views the world, the protagonist's inner journey proves that writer's point.

Remember, the flaw isn't necessarily a good or bad behavioral trait. This means that if the premise is *greed destroys hope,* the protagonist's flaw is hope. Throughout the story greed then drives the protagonist into the opposite per-sonality trait of hope, which is pessimism. Now, if the writer wishes to prove the opposite sentiment, *hope destroys greed,* the protagonist's character flaw is greed. Because love is hope's most idealized form, love would inspire the protagonist to arc from greediness into its opposite form, benevolence. This illustrates how the character flaw of the inner journey can be a positive or nega-tive trait.

It is common for one of the key words in the premise to be used as one of the behavioral qualities used in the protagonist's inner journey. A personality flaw is often the part of a premise that is being disproven and discredited, or the word that signifies the answer for success in the premise is the end goal/cure of the character arc. When the writer finds a way to do one of these two things, the premise and the protagonist's inner journey find perfect harmony.

Another thing one must realize when designing an inner journey to fit the premise is that even good traits taken to extremes can birth strong character flaws. If the premise centers on how decent people cannot get ahead in politics to do what's right for the country, you'd want to start the protagonist's inner journey with the flaw of a total inability to compromise his or her belief system in decency. You can take something that most would consider a positive trait to a negative extent. Yes, strict decency can be a flaw if one must compromise in order to work with others who have a different idea of what is decent in order to succeed. This morphing of a positive character trait into a negative extreme is an important part of building drama.

The last thing I want to say about the character flaw that inspires the character arc is that it can often supply the writer with a character's greatest attribute or skill. There is a yin to every yang. For example:

- Deceitfulness means someone can be an extremely convincing salesman.
- Cowards are excellent at diverting blame.
- Inconsiderate people get what they want because they don't wait for permission.
- Codependence makes someone feel important and loved.
- Shyness will keep a character from putting a foot in his or her mouth.

- A skeptic can see through a scam.
- Impetuousness can lead to heroism.
- A lone wolf can fend for him- or herself.
- Victims can elicit sympathy.
- Suicidal tendencies result in fearlessness.
- Naiveté leads to a happier disposition and an optimistic outlook.
- Spoiled people can afford to be generous.

This skill is something a writer will use to establish the protagonist along with his or her flaw at the beginning of a well-written story. Laura Mixon has said that part of the joy of fiction is watching a really seasoned professional at work. Protagonists are almost always good at what they do. Therefore, establishing the flaw can play a large role in illustrating what they are excellent at doing at the beginning of the story.

The three elements below should all reflect one another. They are as interrelated as three sides of the same triangle.

1 A *premise* is the unique reason why a protagonist must arc from where he or she starts the story, evolving as he or she confronts the premise's statement.
2 The character's *inner journey* proves the premise, whether happy or tragic.
3 An *outer journey* is a physical endeavor that allows the writer to question all logical arguments for and against the premise, putting the protagonist in the position to be changed by the sequence of events this mission requires.

These three things together make up the holy trinity of the story foundation. Everything else sprouts from these three things.

For example, if the premise is *a mother's love has its limits*, the mother's character arc will be from pushover to aggressor or giver to taker in a story where the outer journey is to keep her addict child safe from the local crime organization. If the premise is *secrets are essential to a happy marriage*, the inner journey goes from honest to liar, and the outer journey is for the child to save his parents' marriage. If the premise is *life is really about how you treat the people in your life*, you may have an ensemble film about college students that have character arcs going from selfish to varying degrees of considerate with an outer journey being to have a killer Christmas party without their families.

Humble origins

Starting the protagonist's journeys from humble origins is the key to generating awe, the greatest of all emotions to cultivate in a cinematic experience. A bright writer introduces his or her protagonist through an easily comprehensible situation (or crisis) that an audience can identify with, often starting from the most normal of possibilities (even in the most fantastic of stories). It is common to begin with a protagonist who truly appears average (but has personality). For example, let's look at the wild worlds of fantasy and science fiction: the blockbuster classics *Star Wars* and *Harry Potter*.

It boggles the mind to think of all the possible wild, outlandish lifestyles the creators of these sagas could have chosen for the protagonists in these universes. Yet, for such fantastic realities, their origins are anything but. Luke Skywalker starts his journey as a simple farm boy who wants to go off to the academy (college) with his pals, but he has to stay on the farm to help his aunt and uncle. Harry Potter starts even lower, forced to sleep in the closet under the staircase at his nasty aunt and uncle's house.

It's not a coincidence that Harry and Luke were both orphans, which helps build sympathy for the central characters. This sympathy building is done on purpose so that typical audience members can empathize with a deeply human situation in an abnormal reality. Because protagonists and the audience are in the dark about such entities as the Force or Hogwarts when they enter the movie theater, the audience can experience shock and awe of all the imaginative concepts and exploits to come in tandem with the heroes. This technique puts the audience directly in the protagonist's shoes.

It's no wonder that Dorothy Gale's story begins on a small farm in Kansas before the tornado sweeps her off to Oz. Humble beginnings help each escalation, revealing new experiences and allowing them to have a greater impact on the protagonist (and the audience in his or her shoes). Through innocent, humble eyes, the protagonist's breath can be swept away. Genuine awe is the greatest

emotion to create in characters, and that awe felt by the protagonist translates directly to the audience members if they share the same perspective. The creation of awe allows the writer to generate visceral and emotional responses in protagonists with which the audience can empathize as they experience world-changing events. This empathy makes for a truly visual and emotionally dynamic rising action, one scene at a time.

The antihero

Before we conclude our first character model, we should address the one last potential version of the protagonist – the *antihero. Merriam-Webster* defines it as, "A protagonist or notable figure who is conspicuously lacking in heroic qualities," such as common decency, altruism, idealism, courage, nobility, fortitude, and moral goodness. In short, the antihero can be a total jackass (*Bad Grandpa*), idiot (*The Jerk*), drug dealer (*Scarface*), drug-addled jerk (*Inherent Vice*), pimp (*Hustle and Flow*), gigolo (*Midnight Cowboy*), hit man (*The Professional, Pulp Fiction*), hit woman (*Kill Bill, Vol. I & II, The Long Kiss Goodnight*), thief (*The Thomas Crown Affair*), dirty cop (*Bad Lieutenant*), egomaniac (*Citizen Kane*), sociopath (*Nightcrawler*), mob enforcer (*Get Shorty*), bank robber (*Dog Day Afternoon*), con artist (*The Sting*), convicted criminal (*Cool Hand Luke*), hacker (*The Girl with the Dragon Tattoo*), porn star (*Boogie Nights*), gangster (*Goodfellas*), alcoholic home wrecker (*Young Adult*), despicable lawyer (*Liar Liar*), smuggler (*Blood Diamond*), hustler (*The Color of Money*), degenerate gambling addict (*The Gambler*), homophobic bigot (*Dallas Buyers Club*), or split-personality terrorist (*Fight Club*). The antihero can range from a highfalutin, multi-millionaire, stock-trader (*Wolf of Wall Street*) to the lowly and unimpressive, adult, useless, lay-about slacker (*The Big Lebowski*). Now, the protagonists are all supposed to have flaws, but these are more major than one might expect.

The history of cinema is filled with protagonists with human qualities and jobs that no reasonable, logical person would think should carry the role of a film's hero. How do writers get away with this?

A character's point of view, which is where personality meets perspective, can bridge the shocking gap between the character we would normally see ourselves rooting for and the protagonist in the story. Through point of view, the writer must find a common ground rooted in the nasty attributes of an antihero and an everyday moviegoer responsible and good enough to pay for movie tickets in this age of digital piracy and BitTorrents. So, the writer takes the character-designing concept of generating a personality flaw that makes a character believable to the audience as a real person and reverses the math on it.

Now, instead of looking for a flaw to insert into a hero, the writer searches for the right redeemable quality to plug into an extremely flawed protagonist.

These qualities can include attributes that build sympathetic, empathetic, and endearing respectability through a personal moral code or duty that engages us enough to suck us in as story lovers. These antiheroes share a common goal with someone you would associate with being heroic. This commonality elevates the character beyond his or her disreputable outward qualities. Traditionally the "anti" in antihero has to do with how the protagonist takes action. Either they do bad actions with some type of moral code (like criminals, killers, conmen, or womanizers), or they do upstanding deeds with a lousy point of view (think shallow lawyers, habitual liars, total jerks, and extremely offensive characters like racists). By today's standards, Huckleberry Finn would be an antihero.

In short, from the outside, the antihero takes actions that do not fall within the Judeo-Christian understanding of moral boundaries and good, law-abiding behavior, but there is something we see inside the antiheroes that makes the moral corruption redeemable in some way. *The Professional* is about a contract killer who spends the movie trying to save an innocent little girl who witnessed a murder. Dirk Diggler in *Boogie Nights* is desperately looking for the love and the belonging afforded by a family, which he never had, only to find it in the San Fernando Valley's pornography industry. Sonny Wortzik in *Dog Day Afternoon* robs the bank in order to get his desperate gay lover the sex change operation he cannot afford. So, outwardly, antiheroes do bad things, but these characters' motivations allow us to empathize with even the most unlikely of protagonists. These characters tether themselves to us, engage us, and endear us to them through sympathy and the possession of a unique moral code or a goal that is entertaining and compelling enough to suck in us story lovers.

There are a slew of reasons to utilize antihero protagonists. The antihero is often sculpted as a comment on the society and times in which the story is set as well as having current relevance. In its subtext, this kind of character raises the implicit question, "How does society create somebody like this?" Maybe the antihero implicitly questions the existence of heroism in the first place, or perhaps the antihero calls into question the structural conditions that give rise to these kinds of people. Antiheroes are so popular because it's a vicarious walk on the wild side. It's common to have a morbid fascination with dangerous people and lifestyles we'd never get close to in reality, but that curiosity can be satiated for the price of an admission ticket. Lastly, let's not forget that it can be comforting to see a story that illustrates how even a bad person can be likeable and empathetic. Everyone has felt like they were bad at some point in their lives. If someone can be *truly* bad and *still* earn our sympathy, then we must not be so bad.

Now, there are rare stories with an antihero who is challenged the entire film to undergo a meaningful inner journey, and he or she fails to achieve a character arc the end. I call those characters *failed protagonists*. This is most common in antiheroes that act like full-blown antagonists. Therefore, I explain failed protagonists in Chapter 7, where I thoroughly answer the

question that many new writers inevitably ask, "Can the protagonist be the antagonist?"

The questions

Once the writer has an inner journey that proves the premise and an outer journey set firmly in the world of its argument, it's time to brainstorm again. Start listing all the physical obstacles and situations facing the protagonist. List all the things that can get in the protagonist's way:

- What are the temptations involved on these journeys and in that world?
- What is important enough to sway the protagonist?
- What are the worst examples you have seen happen in regards to this character's flaw?
- What would be even worse than that?
- Where would all the pressure that the protagonist is feeling come from?
- What uncomfortable things would be said when he or she is pressured?
- What trouble would the character flaw, in that world, put the protagonist in a terrible position of physically doing?
- What no-win scenarios might the character create?
- What extremely uncomfortable decisions might the character have to make?
- Who wants/needs the protagonist to succeed and why?
- Why does the character care so much?
- Why do we care if he or she succeeds or fails? What does it mean about the world we live in either way?
- What actions dynamically exemplify the different sides of the character arc?

- How does genre show itself visually during the inner and outer journeys? What are those situations that fit the genre and environment?
- What is the best argument in the world for the protagonist to not arc?
- What is the "greater good" or utilitarian thinking for each argument?
- What does the protagonist stand to lose if he or she does not arc?
- How far is this character willing to go to achieve his or her goal?
- What situations might achieving the achievements create with each bold choice?
- What could be the ramifications of taking those risks?
- Will it cost love? A life? Multiple lives?
- Who stands to benefit most from the failure of achieving the inner or outer journey?
- Who is in a position of influence and power over the protagonist given his exterior goal?
- How do those characters personify the counterargument to your premise?
- Which one of those counterarguments is the best, most common misconception that explains why you need to tell this story? (Note: the answer to this question is the spark for creating an antagonist.)

- What character arc (inner journey) would prove the premise of this story?
- What physical tasks would a character need to undertake, and what goals would a character have to achieve in order to result in such a character arc?

This last question should be a mission that, once complete, logically inspires the reader to think the following: "Oh, the character reached the finish line. The credits will soon roll."

None of these questions is about delving into the specific person this character will wind up being, like race, gender, nationality, hair or eye color, weight, height, hometown, day job, etc. Now, those things might come up as result of answering unrelated questions, but all those qualities are secondary. This entire process really concerns the different questions you can ask with one goal in mind: story creation.

You can see how, even though we are not outlining, beat sheeting, or even structure building, all these questions will start to fall into those places for you. You don't have to wait for those ideas to come to you if you just ask yourself the right questions. The last few questions obviously will help lead to the next story-driving character, the antagonist.

Exercise 5

1 Inspired by the premise the writer is attempting to prove, where should the protagonist of your story start and end his character arc? This is the protagonist's inner journey.

The wording for the protagonist's inner journey should be as follows:

- The protagonist's inner journey goes from _____ (*single-word character flaw/personality trait*) to _____ (*single-word cure for the flaw, an opposite behavioral trait*).

You fill in the blanks.

Qualifications

- The inner journey proves the premise to be true. So, make sure the premise and character arc are going in the exact same direction. The inner journey ends with a cure to the flaw that matches what the premise says will be proven at the end of the film.
- It's an across-the-board, permanent personality and behavioral change due to what the protagonist has been through during the second act of a three-act structured script.

- This character arc is the embodiment of the protagonist's perspective shift due to fully realizing the truth of the premise. It personifies and exemplifies that the premise has been proven.

Disqualifications

- Making it an educational arc about learning a piece of information. That's not a behavioral or personality change.
- The words on either side of the *to* can coexist in a human being.
- Emotional changes are not permanent. Therefore, emotions should never be in an inner journey.
- There should only be one thing (traditionally a single word) on either side of this character arc. Therefore, there should be no conjunctive words in the outer journey statement such as *and*.

2 Inspired by the genre and the goal of the premise, what is the protagonist attempting to physically accomplish during the story? This is the protagonist's outer journey.

The wording for the protagonist's outer journey should be as follows:

- The protagonist's outer journey is to accomplish _____ (*a mission with an exceptionally clear, specific, visual, 100% physical finish line for the outer journey*).

You fill in the blank.

Qualifications

- It fits the genre.
- It's a proactive pursuit.
- It should be described in only one sentence.
- It establishes a physical finish line for the protagonist to cross in the climax so the reader knows the story is reaching its end.
- It is what the protagonist will be attempting to accomplish throughout act 2 of a traditional three-act structured film.

Disqualifications

- Reactive missions.
- Compound sentences.
- There should only be one journey, so there should be no conjunctive words in the outer journey statement such as *and*.

3 Consider how an antihero might lend him- or herself to proving your premise.

4 Make a list of at least 20 difficult situations that would visually and dramatically illustrate the potential steps in the selected protagonist's outer journey. Obviously, you will not use them all in a script; this is just a brainstorming list.

5 Make a list of 10 situations that would inspire a protagonist to revert toward his or her character flaw of his or her inner journey.

6 Make a list of 10 situations that would inspire a protagonist toward the character cure of his or her inner journey.

7 With two sentences per idea, explain five situations that could affect both the inner and outer journey. For each situation, write one sentence for the outer journey obstacle, and a second sentence explaining how it affects the inner journey.

Chapter 6

Antagonist

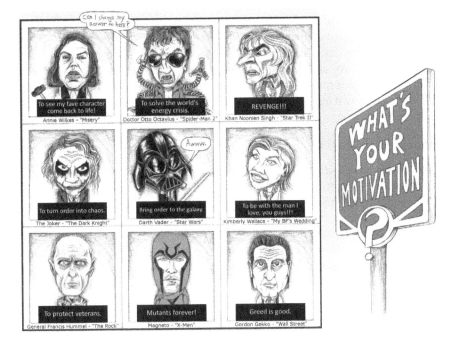

Figure 6.1 Jacob Redmon – Antagonists: The obstacle to the central character's physical mission that everyone loves to hate.

Character credits: Annie Wilkes (*Misery*, Castle Rock Entertainment, Columbia Pictures); Doctor Otto Octavius (*Spider-Man 2*, Columbia Pictures, Sony); Kahn Noonien Singh (*Star Trek II: The Wrath of Kahn*, Paramount Pictures); The Joker (*The Dark Knight*, Warner Brothers); Darth Vader (*Star Wars*, 20th Century Fox, now Lucasfilm, Walt Disney Studios); Kimberly Williams (*My Best Friend's Wedding*, Columbia TriStar Pictures, Sony); General Francis Hummel (*The Rock*, Hollywood Pictures, Walt Disney Studios); Magneto (*X-Men*, 20th Century Fox); Gordon Gekko (*Wall Street*, 20th Century Fox)

"Tut, I have done a thousand dreadful things
As willingly as one would kill a fly,
And nothing grieves me heartily indeed
But that I cannot do ten thousand more."

—William Shakespeare, Titus Andronicus

We now move on to the second of the five major character types that drive an idea toward a full-fledged story. To the working screenwriter, each character type serves a specific, unique purpose in the exploration of a script's premise. Deep under the text and between the lines, we set out to examine what is often the most certain-minded character of all: the antagonist.

Newton's third law of motion teaches us that for every action there is an equal and opposite reaction. Without action being met by reaction, there is no conflict. Without conflict, a writer has no story. Therefore, our reaction to the protagonist (personifying the writer's premise) is the personification of the counterargument to that premise. An antagonist must be both engaging (forcing a protagonist to take action) and formidable (because the greater the challenge, the greater the victory). These two qualities form the context from which sprouts our antagonist.

Motivating the antagonist

You cannot have clarity on an antagonist until you have clarity on the protagonist, because you design the antagonist specifically to demolish the protagonist's outer journey, which forces that protagonist to undergo change (the character arc). All characters serve the protagonist's two journeys. The antagonist achieves his or her primary purpose as the main obstacle to the hero's quest (outer journey) because he or she is motivated by a conflicting goal. That goal is something an antagonist is determined to accomplish for a very good reason. His motives can be self-serving or community serving. For some characters, such as Magneto in the *X-Men* movies, both motivations exist. He defends his fellow mutants from mankind at any cost in an allegorical tale of racism.

The motivation of a well-written antagonist is something the audience should be made to understand (be it selfish or altruistic). It could be anything, so long as it's clear and means the world to the antagonist. This character's reasons for doing what he or she does can often be the most emotionally compelling part of the story. Audiences understand the antagonist's motivation and, ideally, can relate to it. These motives fall generally under those two classifications of personal gain or communal gain. Writers think in those terms because doing so helps both quantify and identify the core values of the antagonist and best show how the antagonist's brain works.

For example, here are some personal reasons for an antagonist's actions:

- Pride (Apollo Creed in *Rocky*)
- Sustenance/survival (*Dracula*)
- Glory (Shooter in *Happy Gilmore*)

- The ultimate thrill (Bodhi in *Point Break*)
- Recognition (Buddy Pine/Syndrome in *The Incredibles*)
- Love (Kimberly in *My Best Friend's Wedding*)
- Entitlement (Commodus in *Gladiator*)
- Power (Miranda Priestly in *Devil Wears Prada*)
- Revenge (Jennifer Spencer in *Sudden Impact*)
- Inappropriate familial desires (Noah Cross in *Chinatown*)
- The highest of standards (Anton Ego in *Ratatouille*)

Others have communal motives:

- Justice (Little Bill in *Unforgiven*)
- World peace (Ozymandias in *The Watchmen*)
- Safety of our nation (Col. Jessup in *A Few Good Men*)
- Protection of our military veterans (General Hummel in *The Rock*)
- Upholding a code of conduct (Ed Rooney in *Ferris Bueller's Day Off*)
- Keeping the streets clear of undesirables (Sheriff Teasle in *First Blood*)
- Solving the Earth's energy problems (Doctor Octavius in *Spider-Man 2*)
- The preservation of a small community in the face of modern, corrupt influences (Edward Walker in *The Village*)

Traditionally, the antagonist's perspective on communal gain or method of pursuing it is terribly misguided. Whatever the antagonist's aspiration is, his or her actions must be grounded in an incontrovertible conviction until the end, and this goal comes into direct conflict with the protagonist's mission throughout the story. Yet opposing the protagonist is not all that the antagonist does . . .

As the electric bumper against which the writer bounces his or her premise off of, the antagonist must have the fight and tenacity to be the best counterargument the scribe can fathom. The antagonist's actions should constantly comment on the writer's premise and central question. How?

The antagonist's actions can:

1 Provide a popular conception or misconception regarding the premise.
2 Personify the antithesis of the author's premise (and always challenge it).
3 Prove the premise (which is how we create tragedies in any piece of literature).

Whatever perspective the antagonist portrays, it should carry weight, sincerity, and, most of all, truth. Making a counterargument does the writer no good if the audience doesn't buy it. Now, just because an antagonist makes a good point, that doesn't mean the character needs to make that point in a nice way. For example, once you see it, you will find it hard to forget Al Capone's lecture on the importance of teamwork in *The Untouchables*. Ozymandias' explanations for his actions make horrible yet perfect sense at the end of *The Watchmen*. Homicidal maniac The Joker in *The Dark Knight* tries to prove the point that we all lie to

ourselves if we think the world isn't chaos and selfishness underneath all our societal niceties constructed by the weak to protect themselves. For how long has mankind asked the question as to whether man is born good or bad? Even a total lunatic character's argument needs to be a fair and real one worth making, and it has strong points to make. An antagonist's perspective may be warped, cruel, and morally and philosophically reprehensible, but it needs to make sense to the audience. Otherwise, the premise has nothing worthy to fight against.

The independent antagonist

Like protagonists, antagonists need to be proactive, not reactive. That means the antagonist's goal needs to exist independently of the protagonist, but that singular antagonist's goal must conflict with the protagonist's outer journey. As an example, if the writer says the protagonist's outer journey is to get justice for a loved one's murder, the antagonist is not simply trying to keep his murderous secret from only the protagonist. The killer wants to get away with murder in general. Antagonists are driven to take action and complete their mission regardless of the protagonist's determination to subvert it, as is the case in the protagonist's outer journey.

Giving the antagonist an independent goal allows the story to read as though it takes place in the real world. When a writer thinks that a character is only there to battle one person, that character stops acting and thinking like a real person. People fight other people because there is a larger reason for fighting, be it honor, reputation, respect, or power, for example. Writers make stories feel realistic and engaging by writing characters who act like real people. We are talking about providing self-sustaining motivation for the characters so they live and breathe regardless of the other characters.

Providing characters with human, real-world motivations gives those seemingly two-dimensional physical missions and goals deeper meaning. A great writer makes a story about more than two characters who each want to stop the other. In a great script, the subtext of any conflict between the characters is about warring ideologies, and the ideology each character represents helps make the character read and feel more human to the reader because each character is given a specific point of view that reaches beyond the other characters. That's individualism, which makes the characters feel more realistic.

The ideology of each character in the war, which every character fights, is in service of proving the premise through heated exchange. The only way to put up a fight for each ideology battling for supremacy is to allow each character to own that ideology. An antagonist fights for a belief system against all other belief systems, not just the writer's premise. The antagonist has a powerful point of view, and it exists not merely to disprove the protagonist's.

Characters with clear ideologies are especially important for television-character writing because the stories and conflicts keep changing. Consistency of character stems from (1) consistency of independent goals regardless of what character comes across their path and (2) how that character goes about achieving the goal.

So, pen a proactive antagonist, not a reactive one, and make sure the antagonist's goal conflicts with the protagonist's outer journey.

Here are a few fantastic examples of antagonists that have independent goals from the protagonist, but those goals clearly conflict with the protagonist's outer journey:

- In *Skyfall*, the antagonist's goal is to use the stolen information to bring down British Intelligence, which makes the protagonist's outer journey to retrieve the stolen drive to save British Intelligence impossible to achieve.
- In *Happy Gilmore*, the antagonist's goal is to win the golf championship, which makes the protagonist's outer journey to use that prize money from that championship to save his grandmother's house from foreclosure impossible to achieve.
- In *Star Wars*, the antagonist's goal is to wipe out the rebel base with the Death Star (a weapon of mass destruction), which makes the protagonist's outer journey of delivering the stolen schematics for how to destroy that weapon to the rebels impossible to achieve.
- In *The Wedding Crashers*, the antagonist's goal is to marry Claire Cleary, which makes the protagonist's outer journey to date Claire impossible to achieve.
- In *The Princess Bride*, Prince Humperdinck's goal is to murder Buttercup and frame another kingdom for it so he can start a war, which makes the protagonist's outer journey to marry Buttercup impossible to achieve.

The courage of conviction

A strong antagonist is the key to making the premise clear to the audience as the protagonist struggles with every fiber of his or her being to achieve his or her contrary goal. After all, if antagonists do not wage a hard-fought war against or for the writer's premise, nobody will buy into the final analysis of the premise because that analysis will not have been earned. Any literary scholar worth his or her salt could argue that the antagonist is by far the most important character in any story because the antagonist is the embodiment of a strong, constant counterargument to the protagonist and the script's premise.

The antagonist may be referred to as the villain or "bad guy," even though his or her motives should be grounded in a strong morality-based belief system of right and wrong that simply comes into direct conflict with the protagonist's outer journey. It's often forgotten by writers (which is a mistake) that the protagonist does not have a monopoly on morality. The best antagonists get our empathy because we relate to them on a human level.

Compelling drama comes when a great writer humanizes an antagonist and then puts the audience in a position to be emotionally invested in that character's failure. The motives that I used as examples above are not necessarily evil. In fact, depending on their context, the same incentives can just as easily work for a protagonist. Look at such characters as General Hummel in *The Rock*, Javert

in *Les Misérables*, or Sheriff Teasle in *First Blood*. Few concepts are more emotionally engaging than a character willing to do something that we might consider bad for what they consider to be "the greater good." The climax of *The Watchmen* is so engrossing and compelling because the antagonist kills so many innocent people in the name of world peace. The moral high ground that motivates an antagonist's actions may not align with the Judeo-Christian concept of morality, but the antagonist obviously holds these positions devoutly and sees them as concrete.

An antagonist's confidence in his or her beliefs may crumble under scrutiny at the close of a script (as with Doctor Octavius in *Spider-Man 2*), but to provide your protagonist with a strong nemesis, the antagonist's capacity and strength of conviction should not be diminished (nor should he or she show a diminished capacity to do harm) until the climax (final showdown) of the story is in full swing.

It is an important distinction that the antagonist does not need to change; no character arc is required. Just as the antagonist does not have to "change," the nemesis does not need to be "conflicted." In fact, it's an antagonist's conviction that gives him or her such power. When the antagonist questions his or her own actions, he or she begins to unravel and crumble. When Mr. Takagi refuses to give up the vault's access codes in *Die Hard*, can you imagine Hans Gruber turning to his men and saying, "You know what . . . Maybe this isn't such a good idea, guys. Is money really worth killing anyone over?" Lord Voldemort in the *Harry Potter* franchise never turns to his Death Eaters for approval of his plans. At no point does he say, "Hey, Lucius, old pal. That Harry was just a baby when I murdered his mum and dad. Am I overthinking this whole prophecy thing? I mean, the kid is still in high school. Maybe he's suffered enough. Hey, what do you think, Wormtail?" The Sheriff of Nottingham never says, "You know, maybe this Robin Hood fellow is right. Perhaps we should take care of our poor and hungry whilst we attempt to steal the throne from our absentee king." An antagonist's single-minded surety is one of the things that makes him or her such an unstoppable force.

It makes sense to model an antagonist after a kamikaze pilot or suicide bomb–wielding terrorist. These two kinds of people show unwavering determination by voluntarily sacrificing their own lives for their ideals. In many genres where life and death are at stake, a worthy antagonist is often willing to make the ultimate sacrifice to achieve his or her ambitions. An antagonist can (and should) be driven enough to go to that extent if needed. To make any journey as heroic as possible, a villain must be so fully committed to his or her goal that it forces the protagonist to go to lengths never gone to before in order to succeed. That sheer drive and will are at the core of any antagonist. For example, John Doe has no intention of surviving his own meticulous plan in *Seven*.

A great, relentless nemesis can be on his last leg and willing to anything to achieve his or her goal's ends, and refuses to give up. No one can forget the riveting, revenge-driven antagonist in *Star Trek II: The Wrath of Kahn*; his finger is on the proverbial button that could kill everyone aboard the *Enterprise-C* as he dramatically quotes the final words of Captain Ahab from the literary classic

Moby Dick. A superior, genetically engineered Kahn (defeated, outthought, and outmaneuvered by Captain Kirk), commits suicide to accomplish his goal with his dying breath. He is well written with awe-worthy power, horrific intention, and gravitas right up until (and through) his dramatic demise.

Darth Vader mutilates his son before offering him one last chance to work together and rule the galaxy far, far away in *The Empire Strikes Back.* Antagonists are not faint of heart.

The antagonist (not the protagonist) must have the greatest willpower, which makes him or her the most powerful character in your story. Let me explain how we know this fact. Protagonists are traditionally reluctant and refuse the call to action at first. In fact, I suspect that most protagonists would have never started the outer journey if they knew in advance what was in store for them along the way. They make a choice that will change their lives irrevocably at the end of act 1, but they are usually ignorant of the sacrifices the choice will cost them in the final analysis. It's only once they get to the low point of the film (at the end of the second act, structurally) that they truly understand how far they will be pushed, how much they will lose, and how far they will have to go in order to succeed. The same cannot be said for the antagonist, whose conviction is often set and determined long before the hero enters the conflict. All the drama and conflict of the entire story arise from an antagonist's predetermined decisions and determination to succeed.

Antagonizing love

Now, not every film involves life-and-death stakes. The other possible thing that hangs in the balance is love. The reason love is an equally compelling objective or pursuit in storytelling is because other than life, it is the one other thing (no matter where you are from anywhere in the world or what language you speak) that people might agree is worth dying to save. Since all films pretty much boil down to love or death as the stakes, these stakes explain film's obsession with "sex and violence." In an instance in which a story is about love, the antagonist need not put his or her own life on the line, but he or she must always be totally driven to succeed. In order to give the antagonist that extra motivation, writers will sometimes have more than love at stake in the event of an antagonist's defeat.

Because greed is the antithesis of love, there is usually an element of such selfishness involved in an antagonist's motivations when dealing with a love-centered story. Romantic love could mean the object of affection's parent won't leave the antagonist the family business anymore. The problem could be another romantic suitor. If we're dealing with the love of family, inheritance could be at stake (such as the film *Greedy*, starring Michael J. Fox). If the love of money is involved, a financial empire or an extravagant way of life that hangs in the balance. Just watch any film about Wall Street. Gordon Gekko preaches the value of greed. Greed puts jobs and livelihoods on the line in all types of films that do not focus on mortal stakes, whether it's Edward Lewis' hurtful business practices in *Pretty*

Woman or *Norma Rae's* fight with employers who refuse to take care of fellow employees. Marquise Isabelle's desire to control even the most lecherous of men inspires her to manipulate the hearts of even the most unlikely duped playboy in *Dangerous Liaisons*.

The point is that even if the stakes are not those of life and death, the antagonist must be fully motivated and totally driven to succeed, willing to go to drastic and excessive measures. Only then is the antagonist worthy. During stories in which the protagonist is in the wrong, the antagonist has a superior, deeper, and truer adoration for the love interest than the protagonist does. In *My Best Friend's Wedding*, Kimberly Williams was far more sympathetic than the protagonist, Julianne Potter. In any case, the antagonist is often more motivated or has more at stake than the protagonist does. *That* higher level of motivation makes for better conflict.

What doesn't kill you makes you stronger

Without a great, chief obstacle that pushes the hero to extremes, no story can be completely satisfying or fully realized. If the antagonist will do anything to succeed, only then must protagonists challenge themselves to stand in the way of this force. Only then are they truly challenged to supersede anything they have done before. The obstacle demands that a protagonist rise to new heights like a phoenix from the ashes in the wake of act 2's apparent defeat. In short, your protagonist can only be as amazing, daring, and heroic as your antagonist pushes him or her to become in order to succeed. Your protagonist is nothing without a formidable antagonist. This reminds me of the quote attributed to Henry Ford that says, "When everything seems to be going against you, remember that the airplane takes off against the wind, not with it."

The defiant nemesis should also have the upper hand, making the protagonist's goal virtually impossible to achieve. How exactly that superiority is manifested is in the hands of the writer. The antagonist could:

- Have a better skill set (from fighting skill to cleverness).
- Be more accomplished.
- Be more powerful (be that power supernatural, physical, or influence based, as in the case of a leader of a mighty army).
- Be better equipped (via wealth, training, breeding, education, experience, invulnerability, or tactical advantage).
- Be more dangerous by not playing by the same rules (audacity, daring, and their moral code differences are categorized here).
- Be more dangerous by not playing by any rules due to the drive to achieve his or her goal (willing to go to any length for success, illustrating a relentless passion to succeed).

Some antagonists can run the gambit on the attributes of a challenging antagonist, such as Longshanks (King Edward I) in *Braveheart*.

Whatever combination of these attributes of superiority you choose, this combination should stack the proverbial deck against your protagonist. This deck stacking makes the hero easier to sympathize with because the nemesis turns your protagonist into an underdog fighting an uphill battle. By definition, that situation forces your central character to be heroic, just by waging a war with the odds stacked against him or her.

In any case, the nemesis is a powerful device that helps the writer challenge and question the point of the film, not just the central character. Metaphorically, the antagonist is not only the battle-ready antithesis of the protagonist but of the writer as well. Let's not forget that the premise comes from the heart of the writer, and the antagonist is the relentless force waging war with that premise throughout the script. A fantastic antagonist is constantly trying to rip out the writer's proverbial heart. When I write a "villain," I imagine that I have to go toe-to-toe with that character, and this character is so formidable on the page that I have to fight him or her from here in the real world on my laptop. Antagonists push their creators around from inside their own brains and on the pages they write. That's how strong an antagonist can be in a script.

I use the voices of every bully and person who has ever doubted me. Those voices still echo inside us all. On the page is where we can finally stand up to them and stage our comeback. Only now, we get to take our time to mount a well-conceived fight. You know how we always think of the right thing to say hours after the moment happens? In a script, we can plan out and make the point we wish we had made when we were face-to-face with those kinds of people: the people who use, abuse, anger, shame, or humiliate others they think are below them. We can also be bolder and fearless in this world of the imagination. We can do and say the things we never could in real life. It is both cathartic and a bit horrifying to unleash that energy. Then the writer sets the battle in a cool place.

In what's become an industry-insiders' cult classic, *Swimming with Sharks* sets that exact kind of story in the most self-effacing location of all, a Hollywood film studio. Buddy Ackerman pushes his protagonist, Guy, to extraordinary measures. Remember, when it comes to protagonists against antagonists, it's not the size of the dog in the fight; it's the size of the fight inside that underdog. A well-written antagonist can justify taking shocking, outrageous action.

During the plotting and designing of the antagonist, the writer will need to decide on the antagonist's relationship with the protagonist. The conflict between them can be personal or situational. In some cases it's both. For example, the throne sought by Loki in *Thor* and the gold depository robbery by Simon Gruber in *Die Hard: With a Vengeance* both include a personal comeuppance to the protagonists in the process of pursuing their goals. That said, the relationship might simply be situational. Hey, sometimes the protagonist is just in the wrong place at the wrong time. If that is the case, I always make sure any and all coincidences only happen in the first act; otherwise, the sudden left turn in the middle of a script reads as if the writer didn't properly plan his or her own plot escalations.

The necessity of a strong antagonist boils down to the nature of conflict and directly relates to a litany of questions I have been asked repeatedly by new writers revolving around potential antagonists:

- Does the antagonist need a personality?
- Does the antagonist have to be a person?
- Does the antagonist need to have a motive?
- Does the antagonist have to have a brain?
- Does the antagonist have to have a conscience? Okay, some humans don't have that, but you get the idea.

Therefore, the last major consideration regarding identifying different kinds of antagonists usually falls into the category of nonpersonal conflict because an antagonist need not be human.

Inhuman antagonists

Figure 6.2 Brian Lathroum – The inhuman antagonists.

Character credits: *Godzilla* (Toho Company); *Predator* (20th Century Fox); *The Mummy* (Universal Pictures); *Creature from the Black Lagoon* (Universal); *Jaws* (Universal Studios); *The Birds* (Universal Studios, Alfred J. Hitchcock Productions); Xenomorph (*Alien*, 20th Century Fox); Pennywise the Dancing Clown (*It*, New Line Cinema, Warner Brothers); Megatron (*Transformers*, Paramount Pictures, Hasbro); Spike (*Gremlins*, Warner Brothers, Amblin Entertainment); Audrey II (*Little Shop of Horrors*, The Geffen Company, Warner Brothers); Martians (*Mars Attacks!* Warner Brothers); Indominus Rex (*Jurassic World*, Universal Pictures, Amblin Entertainment, Legendary Entertainment); various disasters (fire, tsunami, volcano, earthquake, nuclear explosion)

We have seen the creature antagonist a million times, including:

- Animal (*Jaws, Cujo, Anaconda, The Birds*)
- Earthly monster (*Creature from the Black Lagoon, King Kong, Gremlins*)
- Aliens from outer space (*Cloverfield, Independence Day, The Last Starfighter, Little Shop of Horrors, Attack the Block*)

Other antagonistic forces don't even have a brain. Such an antagonist simply has a powerful skill and will. For example, this kind of antagonist can be:

- Weather (*The Perfect Storm, Twister, White Out*)
- Natural disasters (*Dante's Peak, Pompeii, Avalanche, San Andreas*)
- A damaged structure or vessel (*The Poseidon Adventure, Unstoppable, Airplane!*)
- Inhospitable conditions (*Castaway, Gravity, Alive, Vertical Limit, The Martian*)
- Medical issues, including disease, epidemic, injury, or addiction (*The Fault in Our Stars, Outbreak, I Am Legend, The Diving Bell and the Butterfly, Still Alice, Requiem for a Dream*)
- A cataclysm (*Armageddon, 2012, The Core, Interstellar*)
- A prophecy (*Gabriel, The Seventh Sign, End of Days*)
- Technology (*WarGames, Terminator, Eternal Sunshine of the Spotless Mind, iRobot*)
- Supernatural event (*Poltergeist, Shaun of the Dead*)
- A human trait (or internal conflict) like mankind's inability to show restraint (*Wall-E*)

The above antagonists have neither consciousness nor the ability to be reasoned with (if the protagonist so desired). They are, in the simplest terms, relentless, overpowering, driving forces with neither vested interests nor motives to cause harm to the protagonist specifically. There is no mercy, only a protagonist's will to fight for life and beliefs. When a protagonist fights a force far greater than he or she could ever hope to wield, it's heroic.

Stories with inhuman antagonists often have what one might want to call a *secondary antagonist*. This person or organization humanizes the conflict on an interpersonal level. These characters are not the main obstacle to your hero's survival/success, and they are, therefore, not the antagonist to your protagonist. There can only be one antagonist. These other characters (such as Dr. Jonas Miller in *Twister*, Carter Burke in *Aliens*, Eddie Brock "Venom" in *Spider-Man 3*, or Gollum in *LOTR*) serve an important purpose that will be explained in more detail in Chapter 9. For now, I will simply say that just the mere fact that a character becomes an obstacle to the protagonist's mission does not make that character an antagonist any more than a typical henchman is. These characters are simply misguided manifestations of the pitfalls our protagonist must overcome like any obstacle.

How antagonists unhinge protagonists

Lastly, it is important to give a quick explanation of how a well-designed antagonist works. Great villains should exploit a protagonist's personality flaw in order to gain the upper hand. The personality flaw is at the core of the protagonist's character arc and often is the key to understanding the script's premise. That fact means that an antagonist preys upon the protagonist's personal weakness throughout the film's conflict. This constant pressure and hardship force a protagonist to change.

In a film many people don't realize is structured from the mentor's point of view, the protagonist in *Back to the Future* is George McFly, not Marty. George is the one who undergoes the major character arc. Biff the bully is a perfect weapon to assault George's personality flaw of cowardice. In the end, George overcomes his flaw, defeats the bully, and gains a forever-changed life. Without Biff, George never changes; without George's arc, there is no happy ending. It all ties together, and that's how antagonists function to change the protagonist when the script is well structured.

I hope this shines a light on how this screenwriter sees different types of antagonists, the fuel that propels them forward, and the way in which they work.

The questions

This is where we ask a few more brainstorm questions:

- What are all the different ways someone may personify the antithesis for your premise?
- What might the antagonist do to prove his or her point?
- What's his or her concept of fair play?
- What's out-of-bounds to him or her?
- What would he or she say?
- Why is the antagonist so damn convinced of his or her perspective?
- What is his or her version of the greater good? The antagonist should have a perspective on this question that makes perfect sense and can almost convince us.
- How are the protagonist and antagonist alike?

- What moment might this character (with a flaw he or she could have in common with the protagonist at the top of the film) endear him or her to the protagonist?
- What might indenture the protagonist to this character?
- What bold choices might the protagonist make to get the antagonist's respect or turn his or her head?
- How has the antagonist turned his or her flaws to his or her benefit?
- What about this antagonist is incredibly alluring?
- In what way do we see the attraction to those choices?
- What can the antagonist hold over the protagonist?

- What's this character's idea of respect?
- What's his or her idea of failure?
- Why does the antagonist care so much? Where is his or her heart invested?
- What's his or her weakness?
- What is his or her most admirable quality?
- How will we know this character has been pushed too far?
- What does this character want at the beginning of the film?
- How exactly does the antagonist's desire conflict with what the protagonist wants for his or her outer journey?
- What does this character want more than anything in the world?
- What does the antagonist stand to lose if he or she does not succeed?
- What situations might this antagonist create with each bold choice?
- How far is the antagonist willing to go to get it? What might this character do if and when pushed to it?
- What could be the ramifications of taking those risks?
- What are the specific stakes? Will it cost love? A life? Multiple lives?
- Other than the protagonist, who stands to benefit most from the failure of achieving the inner or outer journey?
- Who is the antagonist stepping on to get what he or she is planning along the way?
- Who or what could get this character to change?
- Has this character pushed something away or did this character let this something go?
- Can he or she still change?
- If not, why can't he or she change?
- What motivation could the protagonist have for changing that the antagonist does not?

Once in a long while, an antagonist's action may help the protagonist, but it should be clear how that action: (1) helps the antagonist to a far greater extent and (2) dramatically illustrates the antagonist's formidability. For example, the antagonist eliminates mutual competition in a tournament. The more ideas a writer has for the antagonist's goal advancement that actually setback your protagonist, the better.

The last few questions above will lead you toward the qualities needed for a love interest, but first, I will answer the question that plagues so many writers: can a protagonist be the antagonist?

Exercise 6

1 The wording for the antagonist's goal should be as follows:

- The antagonist's goal is to _____ (*a specific, measurable accomplishment*), which makes the protagonist's outer journey to _____ (*write the specific outer journey here*) impossible to achieve.

You fill in the blanks.

Qualifications

- The goal is proactive.
- The goal fits the genre.
- This should be only one sentence.
- It directly conflicts with the protagonist's outer journey to such an extent that if the antagonist succeeds, the protagonist cannot achieve his or her outer journey.

2 Make a list of at least of 20 things the antagonist might do to achieve his or her goal/mission, and consider how each would adversely affect the protagonist's outer journey.

Chapter 7

Can the protagonist be the antagonist?

Figure 7.1 Robert Carrasco – In some stories, people start to think protagonists are their own antagonists.

Character credits: Rudy (*Rudy*, TriStar Pictures/Columbia Pictures, Sony); Mark Watney (*The Martian*, 20th Century Fox); Larry Talbot (*The Wolfman*, Universal Pictures); Ben Sanderson (*Leaving Las Vegas*, MGM/UA); Tyler Durden (*Fight Club*; Fox 2000 Pictures, 20th Century Fox); Alex (*A Clockwork Orange*, Warner Brothers)

"How wonderful it would be if everything could always be as clear and simple as it used to be when you were twelve years old, or twenty years old. If there really were only two colors in the world: black and white. But even the most honest and ingenuous cop, raised on the resounding ideal of the stars and stripes,

> has to understand sooner or later that there's more than just Darkness and Light
> out on the streets. There are understandings, concessions, agreements. Inform-
> ers, traps, provocations. Sooner or later the time comes when you have to betray
> your own side, plant bags of heroin in pockets, and beat people on the kidneys –
> carefully, so there are no marks."
>
> – Sergei Lukyanenko, Night Watch *(1998)*

I am flattered when new writers try to pitch me their ideas, and I often hear them say that their protagonist is also the antagonist. Let's address that possibility. Is there a case for man being his own worst enemy in a script? We all know a fatal flaw can do a character in, but does that make him the villain?

There are four ways in which one might consider a protagonist to be his or her own most antagonistic force. They are:

1 When something or someone from inside the protagonist creates the film's conflict
2 When the inner journey dominates the visual story (focusing on a character's personality flaw)
3 When nobody else is there to oppose them
4 When the protagonist is just plain wrong or evil

Let's take them one at a time.

I The antagonist inside the protagonist

The first example stems from a situation where there are two sides to a leading character (for example: *Dr. Jekyll and Mr. Hyde* or *Fight Club*). Having written a werewolf film, I see those "beast within" stories as an allegory for one person's dark battle with impulse control. As a classic example, *The Wolfman* can easily be seen as a metaphorical struggle with alcohol abuse. At night, Wolfie indulges in base, raw, uncensored actions while being under the influence and not in his right mind. He wakes the next morning disoriented with no clue of the violence he committed the previous night. I am going to put the kibosh on this one right out of the gate. This carnal beast is actually inside the protagonist, but the beast is not the protagonist any more than a patient with cancer is his own villain. The inner beast acts independently from the protagonist without his or her consent or influence; therefore, protagonist and antagonist are not one in the same. These antagonists are totally separate characters even though they share a body with the protagonist.

2 Personality flaw as the antagonist

Second, many dramatic films center on inner journeys instead of outer journeys, which might bring a young writer to believe that a personality flaw can be an

antagonist. Speaking of acting under the influence, let's look at *Leaving Las Vegas*. Don't be fooled by first-blush thoughts; alcoholism is not the antagonist. This is the story of Ben's slow battle with suicide in the wake of extreme loss. It is a personal battle with the will to live. Through his love interest in the film (Sera the prostitute), the script revolves around the big central question: can new love ever replace the void left by a broken heart? The answer is no. We never get over certain traumas, just ask anyone with post-traumatic stress disorder (PTSD).

PTSD might bring to mind *Born on the Fourth of July*, in which Ron Kovic struggles with the ideology of blind patriotism in wartime. What antagonizes heroes who face an inner struggle is something outside of themselves. Ron is guilt-ridden and full of self-loathing over the war, which fuels his rage as he battles the ideologies of a patriotic nation with a superiority complex since the country had never lost a World War (or any war for that matter). When a protagonist cannot reconcile with the actions he has already taken, a fight begins. But in a film, that fight must be shown and exemplified by elements outside of himself with an antagonist and other obstacles. He is fueled by his experiences, not fighting with them. Only by taking the war outside of himself and battling an external nemesis (the societal thinking that he bought into in his youth and that put him in that wheelchair) can he start to heal and forgive.

I have heard the argument made that the Rudy Ruettiger's own limitations are his antagonist in the film *Rudy*. Rudy has his share of personal obstacles, but does the presence of these obstacles mean he's his own antagonist? Again, we're asking if a trait or flaw can be a nemesis. This film is the true story of one man's struggle to prove anything is possible with enough heart. He faces the one antagonist that is the opposition to all dreams – reality. In order to go to Notre Dame, Rudy needs money and a solid GPA. To play football, he needs size and strength. Rudy has none of those things. He fights endlessly against the realities of his poor socio-economic background and physical limitations, but he is still not fighting himself.

This may be hard to grasp, but there is a big difference between obstacles and antagonists. Obstacles are things a protagonist must overcome, while an antagonist is something with an iron will to accomplish something that renders your protagonist's outer journey impossible. Cancer spreads; fire consumes; storms rage. Whether personified though human characters or not, antagonists act. They do something. Rudy fights almost everyone else to overcome the obstacles, but his limitations have no will of their own to directly oppose him. Rudy is battling society. He refuses to accept labels, opinions, and misconceptions of what he is capable of accomplishing. The admissions board, the coaches, his own family, societal thinking on body types, and how far someone can rise due to socioeconomic position are the antagonist. Rudy's willpower overcomes a world that is constantly saying, "No. Be realistic. Stay where you are and don't bother." That no-hope philosophy is the enemy.

Whether it's Ben proving that "life goes on" is a lie, Ron's battle against blind patriotism, or Rudy's personal battle to exceed expectations, a common misconception turns out to be the nemesis. These common misconceptions are personified by characters that surround and affect the protagonist, who has to prove them

wrong. So, when an inner journey is in the spotlight, the antagonist can be equally intangible and elusive. These protagonists fight beliefs or ideologies that do not hold true under the scrutiny of these protagonists' specific conditions. The ideology is best described as a publicly held, common misconception. Yet it's never enough to only have an inner journey and inner conflict.

The antagonist is the role that directly opposes the protagonist's outer journey. It takes a physical force to stage that external battle of wills with a hero. Each of these movies has separate characters who engage in battle with the protagonist. For example, Rudy's external, outer journey is to play football for Notre Dame. He must fight with every fiber of his being to get the coaches to let him play in a season game. So, no dice on the protagonist also being the antagonist in an inner journey–based script because there is still always an outer journey. That mission requires an antagonistic force in the physical world working against the protagonist's goal (even when that outer journey is not the film's primary focus).

3 When there is nobody else to oppose them

Third, we might wonder about films where there is nobody around to oppose the protagonist: films like *Castaway*, *The Towering Inferno*, or *The Martian*. We can dispel this wondering quickly. The protagonist is fighting a situation every step of the way. Whether trapped on an island, a burning building, or in outer space, the antagonist keeping them from their goal is the situation. That situation is a powerful, external force threatening their goal of survival or reunion with loved ones, just like a battle against the elements or a disease.

4 When the protagonist is just plain wrong or evil

Finally, let's discuss movies where the central character is clearly a bad guy. Such characters can be horrific people, but they still have their own antagonists (opposing forces), often represented by the law:

- The violent and demented Alex in *A Clockwork Orange* faces off against rehabilitation as represented by his probation officer and the Minister of Interior.
- In *Falling Down*, a film about a family man who has snapped, William Foster's goal of reuniting with his family is thwarted by Sgt. Martin Pendergast.
- Detective Donald Kimball is never able to arrest serial killer Patrick Bateman in *American Psycho*.

So, even then, the protagonist is not the antagonist. As I stated in the chapter on antagonists, the physics of Newton apply. Every action has an equal and opposite reaction.

These often-sociopathic characters, whether they survive or die, like most antagonists, have no character arc. If the central characters do not arc, they are

not a straight-up protagonist. This quality makes them the rare-breed characters known as *failed protagonists*. This concept is nothing new either. For example, Shakespeare's *Richard III* and *Macbeth* fall into this category. So, even in the rare situation where it seems at first blush that all rules are off, and the leading character acts like an antagonist, he or she still has an external opposing force outside him- or herself with which he or she must do battle.

We live in an edgier world now, so unlike the good, old, Elizabethan era, such central characters do not always die at the end of a tragic story. Shakespeare measured tragedy through the eyes of the central character, so his or her death was the very definition of tragedy common to that era. Today, tragedy is sometimes measured by the audience's reaction to it.

A writer like me says that some of these characters continuing to live unpunished is actually a greater tragedy than if they die. Getting away with horrific acts is even more tragic to an audience in some cases. That said, this book is not about the changing landscape of tragedy in storytelling.

Let me just wrap up this final attempt at explaining the protagonist/antagonist-in-one-body theory. Whether the script centers on a likable, failed protagonist who dies (like Vincent Vega because he refuses to arc and follow the good advice presented by his partner, Jules Winfield, in *Pulp Fiction*), or the downright nasty failed protagonist who lives to kill again (like Patrick Bateman in *American Psycho*, Lou Bloom in *Nightcrawler*, and Tom Ripley in *The Talented Mr. Ripley*), each protagonist has external adversaries that he or she must face. Those antagonistic characters do have the will to stop the protagonist and serve as counterarguments to the premise on a visual, external basis in order to be clear to an audience.

Summary

In every great, cinematic story I can conjure up, the protagonist wages war with something that personifies the premise's counterpoint in order to make the writer's point clear. *The Deer Hunter* wrestles with the question, "Does anyone actually come out of a war?" Film is not a book in which we can spend the whole time in someone's thoughts, listening to an endless barrage of inner monologues. Doing so would be boring. We must see the fight unfold in order to understand it. Actually witnessing ideals being put on trial as battles wage engages viewers and allows them to observe the internal conflict in a tangible way. This engagement allows an audience to understand the application of the story's premise in real terms that they can see and touch and triggers an actual catharsis, which takes place within the moviegoer when done extremely well.

Think about it logically for just a second. If the protagonist were the antagonist, what would that situation look like? It's important to be able to picture something in a visual medium. Stories are about conflict. No separate, outside opposing force means there that is no external conflict, which in turn means that there isn't much of a story to watch. Protagonists wrestle with something outside themselves just as Jacob wrestles with another unspecified being in *The Bible*

before he finally faces his brother as an adult. Yes, the antagonist may represent an inner struggle, but the antagonist must be a separate entity. Why? Films are a visual medium, and a separate personification of the enemy is the only way to visually show a struggle.

Hundreds of years before movies, Shakespeare always tried to give the protagonist's enemy a face. Iago defeats Othello through manipulation of man's paranoid tendencies toward romantic jealousy. You can call this character a provocateur if you prefer, but he does the antagonizing.

Don't get me wrong, I can totally understand why so many writers keep trying to pitch the script in which the protagonist is the antagonist. The concept sounds so tormented, pithy, edgy, and cool. It just doesn't work logistically or cinematically. So, in the final analysis, for at least this writer, the answer to the question of whether the protagonist can also be the antagonist is a constant and unequivocal no.

In my next character study, I leave the character we "love to hate" behind and explore what is most frequently the worst conceived and most poorly designed character by amateur writers – the love interest.

Exercise 7

Because the antagonist is a separate entity from the protagonist, you should make a list of the different ways in which your antagonist might externally conflict with your protagonist. This includes asking yourself the following questions:

1 What might the antagonist do in order to stop or tear down your protagonist?
2 How might this antagonist attack either physically or psychologically?
3 How do these attacks play into the protagonist's character flaw, bring that flaw into the spotlight, and put the protagonist's flaw through a trial by fire?

Chapter 8

Love interests

Figure 8.1 Lauren Maria Gruich – The love app: a motivator for change.

Character credits: Rhett Butler (*Gone with the Wind*, MGM, now owned by Warner Brothers); Belle (*Beauty and the Beast*, Walt Disney Studios); Cheryl (*The Sessions*, 20th Century Fox); Vanessa (*Deadpool*, 20th Century Fox); Amanda Jones (*Some Kind of Wonderful*, Paramount Pictures); Edward (*Pretty Woman*, Touchstone Pictures, Walt Disney Studios); Neytiri (*Avatar*, 20th Century Fox); Tom (*Broadcast News*, 20th Century Fox); Sally (*When Harry Met Sally*, Castle Rock Entertainment, Columbia Pictures, Sony); Lisa (*Weird Science*, Universal Pictures); Edward Cullen (*Twilight*, Summit Entertainment, Lionsgate); Dorothy (*Jerry Maguire*, TriStar Pictures, Gracie Films, Columbia Pictures, Sony)

"To love is surely to support and to encourage – but not necessarily to approve. Quite the contrary! If we love one another we will help one another fight against our evil dreams."

–William Sloane Coffin, Credo *(2004)*

The ancient Greeks believed there were eight types of love, and each type of love has its own unique emotional connection to the subject of that affection. It is the emotional connection between these two characters that makes this the most engaging relationship of the story, and it has the most significant impact on your protagonist's inner journey. The vast majority of these powerful relationships are romantic. A protagonist who rebuffs love also rebuffs change (i.e., the character arc), laying the groundwork suitable for a failed protagonist. Therefore, this character plays a crucial part in story construction, which will allow a writer to prove his or her premise.

If there is a common tragedy in the relationship between my fellow screenwriters and their five major character types, it often is in the poor amount of forethought and development that seem to go into the character every writer should most adore. It hurts to admit that the most poorly conceived character in a script is so frequently the one that should be the closest to our hearts. We writers love to write a beautifully flawed protagonist because we identify with him or her. Writers can't wait to sink their teeth into that nasty antagonist that's inspired by a person we've been dying to fight from the safety of sitting behind our laptops. Are lackluster love interests the result of wallflower writers who seem to witness life more than partake in it as extroverted participants? Perhaps many writers have not found a person that rips their soul apart and also mends it, romantically, all at the same time? Maybe it's the opposite situation, where writers have been so deeply heartbroken that the terrain is too sensitive to approach for mere entertainment properties. Yet this approach is exactly what great writers must do, or they utterly fail at creating the essence of beauty that only love can bring to any story. As a professional writer, I refuse to fail love.

The love interest is far too often written as a trophy for the protagonist, which is the polar opposite of how the role should be designed. To simply make the romantic character something to "win over" is to demean the words "love" and "romance" entirely. Novelists Stephanie Meyer and E. L. James know how to sculpt fascinating and complex love interests like the protective vampire Edward Cullen in *Twilight* and conflicted Christian Grey in *Fifty Shades of Grey*. How they did it is no secret. They made us see them through the eyes of Bella Swan and Anastasia Steele.

Because we experience stories from a protagonist's perspective, when writing a character that performs the love-interest function, I remind myself that this character should inspire the same feeling in the audience as it does in the protagonist: awe. Everyone should grow to *love* this character when they read it. If audiences can fall for a bodiless computer operating system in the film *Her*, this goal is

possible to achieve. Any actor or actress should drool at the idea of playing the part. A love interest is so much more than six-pack abs or a writer's ideal amount of cleavage (which the director will change to his or her own ideal when casting anyway).

Beauty is in the eyes of the protagonist

We all know how Hollywood works. They are going to cast someone in this role who looks great next to the protagonist. A writer never need write the role just as eye candy. The director and casting people will be shallow for you. Our job as writers is to create a character so dynamic, exciting, invigorating, fun, savvy, intelligent, or perfect in his or her own way for the protagonist that the sexiest people in Hollywood will fight for that part. Look at the wonderfully ironic role of Cheryl in *The Sessions*. She's a professional sex surrogate in an unsatisfying marriage being paid to help an amazing, romantic, paralyzed man make love for the first time. Writers must pour their heart and soul into the love interest because they expect the protagonist to do exactly that. Therefore, this character must not merely be skin deep; he or she actually has a specific, structural purpose in the big picture.

Every character should speak to something in the grand design of your story. Just as the antagonist personifies the antithesis of the script's premise by challenging the protagonist's outer journey, the love interest should speak to the character arc and push him or her to grow with regards to the protagonist's inner journey. This arc relates to the lesson, core value, or point of the protagonist's evolution. Therefore, when writing this role, I don't just ask myself, "What is attractive?" Instead, I ask, "What is it that my protagonist truly needs as a counterpart to complete and round him or her out as a person?"

Audrey in *Little Shop of Horrors* reflects Seymour's complete inability to speak up due to low self-esteem. Only because Seymour sees the value in Audrey that she fails to see in herself does he arc into a leading man. Seymour develops a real backbone to stick up for someone he does see value in, even though she may not necessarily see value in herself. Only love can fill the gap created by a character flaw between the person the protagonist is at the beginning of the film and who he or she is at the end of it. Yes, the famous *Jerry Maguire* line says it all; the love interest "completes" the protagonist.

Serving the inner journey

The love interest is the personification of the ideal mental and emotional balance the writer hopes for the future of the protagonist. This character helps shape a new life for the future of the protagonist by the end of the story. He or she represents everything your protagonist's personal journey is about and everything your protagonist aspires to be worthy of when the film is done. Anything less than that, and you will sell short the dream Hollywood is based on – that anyone can

find, realize, and achieve their dreams. For what is love if it is not a dream? Now, whether that dream should be realized or shattered is up to the writer. That is the deeply disquieting question all writers must give serious consideration to every set of lovers since *Romeo and Juliet* broke our hearts.

The romantic interest often serves as a gauge of how close the protagonist is to achieving his or her character arc. This arc also means they are obviously a source of commentary on the protagonist's humanity (character flaw) as they challenge him or her to rise above it. Rita is a perfect example of this for Phil in *Groundhog Day*. The audience knows Phil will not get the girl until he has truly, completely changed. So, the protagonist is the yang to this character's yin. No character is ever perfect, but they are perfect for each other in a way the reader/audience must be able to fully see and comprehend.

Like a muse of ancient Greece, this character:

1 Should motivate (provoke, challenge, inspire, or push) the protagonist.
2 Force the protagonist to earn our respect and appreciation by the end of the story.
3 Is one of the reasons we deeply hope the protagonist comes out on top – with the love interest.

The love interest is the answer to our hero's inspiration and aspiration. There's an old adage that women try to change the men they love into the men they want to be with – the man they believe he is capable of becoming. In animation, Wyldstyle is the reason an ordinary Lego construction worker becomes a hero in *The Lego Movie*. Naytiri sets Jake Sully's heart on the right path in *Avatar*. Belle changes the heart of a cursed prince in *Beauty and the Beast* just as it takes Madame de Tourvel to finally break Vicomte de Valmont of his lecherous proclivities in *Dangerous Liaisons*.

A good writer allows art to imitate life, but the writer does not limit art to a sexist, gender role–playing cliché. It's important to note that this rule applies to male and female characters, which means it can be reversed. It works in epic, male-driven fantasies (like *Avatar*) just as it works in romantic, female-driven fairy tales (as when Prince Charmont gets Ella in *Ella Enchanted* to break the curse of obedience through love). In *Twilight*'s slowly escalating lion-and-lamb romance, Edward Cullen both challenges and facilitates Bella Swan's emotional growth and confidence level throughout the film series as she finds her place in this new world among the vampires and werewolves.

Even when others have written a romantic character as little more than a trophy for the protagonist, writers have innately known that love is the impetus for growth and change. Love emboldens us. Writers and audiences understand this. That's why the damsel in distress has been such a commonly trod path. Whether consciously or subconsciously, writers know that the key to inspiring a protagonist to make a huge character arc and fulfill an inner journey is love. It may have never been explained to writers in this way before, but that's the logic

behind putting the love interest in jeopardy. The purpose is to inspire the protagonist to break the mold. Now, there are other characters you can do this with in any script, but it's important to note that the logical cliché of a love in distress exists because this is what love does best for your protagonist. It's an inner journey motivator. It has worked that way since our first steps into the world of filmmaking.

In a visual medium like filmmaking, a great love interest inspires the protagonist's inner journey by taking physical actions. I recommend planning at least three deeds that provoke the character arc. For example:

- In *Black Panther*, the love interest, Nakia, inspires the protagonist, T'challa, to think globally instead of communally by having left the comforts of Wakanda to help those outside the kingdom, not accepting the role as queen because she has work to do in the outside community-driven culture, and only kisses the protagonist once he makes bold efforts to act in global instead of communal interests.
- In the modern Dickensian *Christmas Carol*–inspired *Scrooged*, the love interest, Claire Phillips, inspires the protagonist, Frank Cross, to become generous by reminding him their happiest times were when they were poor, being an example of generosity by feeding the homeless at a shelter on Christmas Eve, and showing how stingy she could become because of his example.
- In *Dangerous Liaisons*, the love interest, the virtuous Madame de Tourvel, inspires the protagonist, Vicomte de Valmont, to become a true lover by refusing to trust his sweet words because of his reputation as a womanizer; remains chaste (resists advances) once she develops feelings for him; illustrates her high morals as a god-fearing woman (reading books like *Christian Thoughts Vol. 2* and unable to eat when contemplating sin); and, when temptation becomes too much, flees the estate to get away from Valmont until he has fallen in love with her.
- In *Galaxy Quest*, the love interest, Gwen DeMarco, inspires the protagonist, Jason Nesmith, to become considerate by chiding him for taking jobs without his fellow cast members, refusing Jason's romantic advances due to his attitude, and, in the end, kissing Jason once he's changed, having proven himself a team player.
- In *Pretty Woman*, the love interest, Edward Lewis, inspires the protagonist, Vivian Ward, to finally realize her self-worth by providing her the opportunity to show up the snobs of Rodeo Drive that snubbed her, treating her far better than a typical street-walking hooker, and protecting and standing up for her against his long-term business partner, Philip Stuckey.
- In *Star Wars*, the love interest, Princess Leia Organa, inspires the protagonist, a mopey, whiny Luke Skywalker, to become an action hero by providing missions to return the stolen plans to Alderaan, rescue her from the detention area of the Death Star, and, just when Luke could take the reward money and run

off to the academy like he once wanted, join the dogfight against insurmountable odds in a final assault on the Death Star, which he personally destroys, saving the galaxy.

Conflict in love

Now, just because the love interest inspires greatness in the protagonist doesn't mean the protagonist and the love interest have to get along. The protagonist doesn't have to even like the love interest at the beginning of the story; he or she just merely needs to be engaged by him or her. *The Cutting Edge*, the 1992 ice-skating, romantic comedy, is a perfect example of this. As the story unfolds, the love interests provide a metaphor for success and a deeper understanding of what it means to achieve the character arc – an arc that brings a beloved character into the protagonist's arms. This trick of adversarial romance was used to great effect in Shakespeare's plays *The Taming of the Shrew* and *Much Ado About Nothing*.

It is important to note that for conflict to thrive in scenes with a strong and competent love interest, a writer should not fall into the habit of allowing that love interest to turn the protagonist into a pushover or Melba toast. Remember the rules of physics for creating smoldering fire; sparks fly from the friction created between two solid objects, not limp fibers. That's why *Much Ado About Nothing* and *Taming of the Shrew* have stood the test of time. A fantastic love interest does not weaken a protagonist but instead revs him or her up.

Nothing worth having in any story should come easily for the protagonist. Struggle and conflict are the adhesives keeping an audience's butts glued to their seats. Therefore, romance should be earned through personal growth, and not given over easily. Even if the love relationship is that of a married couple, there should be strife between them until the protagonist becomes the spouse they should be after they have reached their arc. Maintaining any long-term relationship takes effort, patience, understanding, sacrifices, compromise, and prioritization (and that's before adding children, financial pressures, and work schedules into the mix). Movies like *The Family Man, The Story of Us*, and *This Is 40* exemplify the effort involved in maintaining a relationship. There are many areas in which characters can arc that would affect a relationship that began long before the first frame of story was shot.

There should be conflict between your protagonist and every character in the story, including the love interest (or else the character needs to be redesigned). Without conflict, there is no story to watch. Even when the two characters alone in a scene together share a mutual goal, they should disagree on how to achieve that goal.

Putting love on the line

The romantic interest serves the protagonist's journey by highlighting how much better off the protagonist will be if he or she succeeds in attaining the goal and

earns the love (or saves the life) of the one person who completes him or her emotionally. Without this love interest, the hero can never be happy, content, or fulfilled. This is why the love interest is so often the character tied to the proverbial railroad tracks (or worse). Clarence Whorley gets into a huge whirlwind of trouble to free Alabama from her pimp in *True Romance*. His entire journey begins because he decides to save the girl he loves. These lovers try to stay ahead of the train roaring down the tracks after them, and it catches up to Alabama in the form of a brutal, sadistic thug named Virgil.

If a hero fails to fulfill his or her character arc and rise to the challenge, it is literally the protagonist's ideal future that hangs in the balance. Let's not forget how things turned out in the film *Seven*. Everything the protagonist could become if he or she is successful, and the one person who makes our hero a better (and more complete) person, who personifies all of this, should be on the line.

Should love conquer all?

The difficult question to answer is if the protagonist is going to end up with the love interest. Often, the most engaging movies end without a union. Look at *Casablanca*, where the girl finds meaning in her life with a man who stands for something (as opposed to Rick, who often only stands to make a profit from it). Look at how Michael Corleone in *The Godfather* discovers the kind of woman he wishes he could be with is murdered in Italy brought about by his arc from soldier to murderous criminal. Later, he loses Kay Adams to a divorce. Who gives a damn when Rhett walks out at the end of *Gone with the Wind*? We all do. Look at every crime noir movie ever made, from the great classics *Double Indemnity* and *Chinatown* to *The Maltese Falcon*. Or how about the majority of the great Gothic horror films of years past. Or even going all the way back to love stories such as *Romeo and Juliet*. If the history of cinema has taught us anything, it is that just because the reader may want the hero to succeed does not mean he or she gets everything he or she wants. Many of the greatest films of all time in any genre do not end well for the love story.

That said, alas, it is so wonderful and satisfying when it does. A successful conclusion to a difficult and trying love story that forced the protagonist to change his or her ways is life affirming. Such a conclusion gives viewers a sense of hope, a sense that dreams do come true, and a sense that one day each of us stands a chance of finally finding our true love and ending up together. This kind of hope is delivered by movies such as *The Princess Bride*, *Sabrina*, *Roxanne*, *Taming of the Shrew*, *The Philadelphia Story*, *Working Girl*, *It Happened One Night*, and, a personal favorite, *An Officer and a Gentleman*.

When love interests have character arcs

Now once in a while, we have a love interest that is more than simply a love interest. Sometimes the romantic experience changes both parties involved so both

of them have character arcs. This dual arc happens most noticeably in romantic comedies. Look at the two films *When Harry Met Sally* and *Pretty Woman*. Both are wonderful films and quintessential examples of their genre. When comparing the two movies, both films appear to be a co-protagonist situation. That apparent state of affairs is not the case, though. As I explained in the section in Chapter 4 on "Who's the Hero?" many people do not understand the difference between the protagonist and a central character or hero. A protagonist has a character arc and changes profoundly on the inside. Sally falls in love with her best friend, but her belief system never changes. She teaches Harry that a woman can be a best friend and a lover. Harry is the protagonist.

In *Pretty Woman*, both central characters change dramatically and have profound arcs, exemplified by their major course-of-action shifts at the end of the film. Vivian gets off the street corner, and Edward decides to build something out of a company instead of dismantling it and selling it for its parts to make a quick buck. Both are metaphors for being ready to do something with their hearts and their lives beyond flitting them away for money. Despite their own financial best interests, two characters realize they can do the things they have been doing for money for love instead. Both arcs are about investing from the heart instead of from a money-driven head. Both have arcs reflecting the film's premise, yet only one of them is the central character. Why? At the end of act 1, it's Vivian who makes the major decision to accept a longer-term relationship. She's the one who accepts the offer. Edward wants to kiss her on the lips several times, but it's Vivian who decides when it happens. She triggers the changes and story escalations with her choices. Those choices then trigger the changes inside him. The character who pulls the trigger on a script's major escalations is the story's central character.

There is a long history of romantic comedies featuring dual character arcs with love interests, going back hundreds of years. Shakespeare's *Much Ado About Nothing* is a strong example of this dual arc. Benedick and Beatrice exemplify that perhaps nobody has ever written such challenging, spirited love interests as the master of love stories, William Shakespeare.

In *When Harry Met Sally*, it's Harry who triggers the story's escalations. Sally wanted to be friends with Harry from the beginning, saying he was the only person she knew in New York. It wasn't until years later when Harry finally agreed to be friends that their relationship began. Just as is the case in *Pretty Woman*, the love interest gives the green-light for the first kiss with a look of teary doe eyes when she's emotionally vulnerable, but the kiss doesn't happen until Harry decides. The love interest opens the door, leaving it to the protagonist to make the decision whether to walk through it, defining who is the lead protagonist and the central character of the film.

Now, just because the love interest affects the inner journey as this character's most major contribution to the story design, don't think that he or she doesn't have to be a part of the outer journey as well. The inner journey makes the outer journey possible. After all, it's the character arc that brings about the protagonist's ability to achieve the physical goal. Therefore, a good writer keeps the love interest actively involved in the outer journey.

The lust interest

Now before we wrap up, let's not forget that there are two types of love interest. The one we automatically think of, and the second is one we sometimes forget. This character can be subcategorized as the *lust interest*. This character serves one main purpose, which is to exemplify exactly what we don't want for our hero. They can be a blast to write if you look at the well-constructed examples in films such as *True Lies* (Juno Skinner), *Jerry Maguire* (Avery Bishop), *Peter Pan* (Tinker Bell), *The Devil Wears Prada* (Christian Thompson), *Teen Wolf* (Pamela), *Tootsie* (Sandy and Les), *Wall Street* (Darien Taylor), *Arthur* (Susan Johnson), *Beauty and the Beast* (Gaston), *Twilight* (Jacob), and most romantic comedies.

Some Kind of Wonderful shows us that just because the "other woman" is a lust interest, that doesn't make her a bad person. Amanda Jones is simply what the protagonist thinks he wants. On the opposite end of the scale, Jane Craig cannot help her attraction to Tom Grunick even though he is the antithesis of everything she believes in *Broadcast News*.

Lust interests are also used to create the all-too-popular "love triangle." This triangle is another way of creating conflict, putting the proverbial stumbling block between the two people who belong together. We see the deployment of the triangle all the time in the form of "the other suitor" in Gothic thrillers, including *The Phantom of the Opera*, *The Hunchback of Notre Dame*, *Dracula*, and *The Creature from the Black Lagoon*. We can also see the opposite extremes in romantic comedies such as *The Wedding Singer*, *Bridget Jones' Diary*, *While You Were Sleeping*, *Wedding Crashers*, *French Kiss*, and *The Runaway Bride*. The list is endless.

In many romance-based films, the lust interest can turn out to be the antagonist as well. In the Disney classic *Beauty and the Beast*, Gaston is a handsome suitor revealed to be the true monster.

The key to understanding what the lust interest is designed to do is at the core of your protagonist's character arc. Obviously, the arc plays into the right love interest, while the lust interest is where our heroes might wind up if they do not stay the proper course and achieve their arcs. This lust interest is a warning sign with one of three traditional approaches. They personify one of the following:

1 The fate the protagonist is trying to avoid (*Arthur*, *Wayne's World*, *Beauty and the Beast*, *Shakespeare in Love*).
2 The fate the hero actually wants but cannot see is the wrong choice (*Some Kind of Wonderful*, *Something's Gotta Give*, *Lars and the Real Girl*).
3 Temptation from the right path (*Indecent Proposal*, *Fatal Attraction*, *Wall Street*, *Broadcast News*).

Any way you slice it, both types of love interest reflect the character arc when designed properly.

One last point . . .

Our little secret: this character is about love, not romance

Now, what I am about to say defies the conventional definition as explained by some of the most respected and published screenwriting teachers in the world, but the love interest doesn't have to involve a romance or sex. Don't get me wrong. Ninety-five percent of the time, the love interest is romantic, but, from the standpoint of this character's duty in a script, romance isn't necessary. Characters change because of love, and love is not always romantic in nature. The ancient Greeks categorized two of their eight types of love to be without physical romance, which included *Storge* (familial love built upon familiarity and dependency) and *Philia* (the most virtuous friendship between equals with shared sacrifice, emotion and loyalty), and it is those types of love I refer to here.

Here are a couple examples of what I mean:

- Marlin changes his cowardly ways for his son in *Finding Nemo*.
- Leon goes from killer to protector for a young girl, Mathilda, in *The Professional*.
- In *E.T.*, Elliot grows because of the pint-sized alien that he found in his backyard.
- Though he has a wife in this story, Richard Hoover actually changes because of his daughter, Olive, in *Little Miss Sunshine*.
- John grows into a responsible man as a result of facing the death of his own father in *Dad*.
- A vengeful *Maleficent* changes her ways as she develops motherly feelings for Princess Aurora.
- The brotherhood that develops amidst the 54th Massachusetts Volunteer Infantry in the film *Glory*.

Nonromantic love inspires those protagonists to achieve their character arcs, and, for my money, this power of inspiration is what makes a character the love interest. It's all about an emotional connection between this character and the protagonist that creates a tether, drawing the protagonist forward. These emotional influencers have the power to lure the protagonists' hearts onto an inner journey. While love interests provide inspiration, it's important that the protagonists make their own choices on how to advance in ways that are unique to their own personality.

Nonromantic characters do the job of love interests (using their own emotional connection to inspire change) when the subject of the premise is about familial relationships or friendships. Otherwise, writers typically stick to romance.

Romance works best for most stories. Other types of love relationships are not always emotionally accessible to all audiences. The members of the largest movie-going demographic don't have kids of their own yet, and a lot of people did not have wonderful relationships with their parents. Romance is a relationship

people can choose to invest in, unlike familial circumstances. People believe anyone can fall in romantic love. Therefore, the most common way to inspire a character to grow is through romance.

Most of us do know the feeling of doing something astronomically out of character for love. Romance is one thing that most audiences know can be powerful, moving, devastating, and fragile. By fragile, I mean temporary, unlike familial relations. We know what it's like to lose romantic love, how painful it can be, and how at some point we would have done anything in the world to stop from losing it. This is good for motivating change because (unlike a fight with lifelong friends or family), if you lose a romantic love, that relationship is more likely to be permanently lost. As a childhood friend and family member, you can never be replaced, but lovers find another romantic love. The risk of losing romantic love is palpable and common. Therefore, there are a lot of reasons to use the romance angle as most teach it.

My only point is that you don't need a romance to serve the purpose of a love interest as so many insist. Thus, some films appear not to have a romantic character; instead, they have someone who does fulfill his or her duties in providing another type of love to inspire internal growth of the protagonist. A script needs something to inspire the protagonist's character arc, even if there is no romantic angle to the script. That's why I call this device the *love interest* and not a romantic character. It's the emotional connection (love) that is needed to accomplish this task.

This is deeply important to understand because this means two things:

1 Not every love interest is romantic.
2 Not every romantic character does the job of a love interest.

This might take a little mental gymnastics to understand, but it's crucial to proper character design. The best way to explain this is with a cinematic example. In *Liar Liar*, Fletcher is a divorcee and lousy father because he cannot keep his word about anything. He's never there for the big moments and always lets his son down. In this story, Audrey Reede, the ex-wife and romantic character, is the constant role model of a dependable, honest parent. She is the mentor who teaches and pushes him to be a better man and gives him the opportunities (which holds his feet to the fire) to succeed in fulfilling his outer journey goal of being a dependable, honest parent. If you look at all that Audrey does, she serves as a mentor character. Meanwhile, it's Fletcher's desire to be a good father that serves as his inspiration for his internal change. Fletcher is not trying to win Audrey back; he knows that ship has sailed. It's the love of his son that inspires Fletcher's inner journey. Even though he wins back Audrey when he learns to be a good father, throughout the center of the film, Max (the son) is the love interest that inspires the inner journey. Audrey, the romantic character, serves as his mentor for the outer journey.

By now you're asking, "Why is this our little secret?"

Nobody else will understand, and it would take too long to explain.

So, I *never* pitch a nonromantic character as a love interest in a meeting. Ever. Doing so will only confuse your potential buyers. The phrase "love interest" has romantic connotations. If you pitch a love interest to an executive, agent, development person, or even most writers, they automatically think romance. Don't confuse them. If you don't have a romantic character in the story, tell them that the key emotional relationship in this script is between a mother and son, a daughter and her grandfather, two brothers behind enemy lines, or whatever relationship inspires the protagonist to internally change.

The point is that a nonromantic character may fulfill the function of a great love interest when needed (even if he or she is not what others would call a love interest). This character touches the protagonist's heart, whether that love is romantic or not. The important thing is that there is a character inspiring the inner journey, and *you* understand that the duty of this character may fall to any character with which meaningful love exists. This is why film scripts do occasionally work without romance.

The questions

Here are some brainstorming questions for developing a love interest:

- What inspires me, the writer, to be a better person in the real world?
- Who inspires me and how? Who do I want to impress for love?
- What and who would motivate the protagonist to fulfill the character arc?
- How can this character provide that motivation?
- What provokes the protagonist?
- Who challenges the protagonist?
- What might push the protagonist's buttons, given his or her flaws?
- How can this character see through the protagonist?
- How might this character be inspiring proof of the premise?
- How might this character urge or push the protagonist?
- What test does the protagonist fail?
- Why is this character so able to see through the protagonist?
- What in this character's past has made him or her feel and act this way?
- How can the protagonist earn this person's respect?
- What different ways can this respect be earned?
- Why will the protagonist appreciate this character and vice versa at the end of the story? The answer can't be just simple love. What acts from the other character earn that love?
- How does he or she personify the premise?
- What means the most to this personification of the premise?
- What does the protagonist love about this character? Why?
- What would be hardest thing for this character to overlook and forgive? This one thing should relate to the love interest's personal history. Give the protagonist a good reason for doing exactly that thing that would alienate the love interest.

- Who does the love interest care about most in the world when we first meet this person?
- What does this character expect, want, or demand of the protagonist?
- Considering that some love interests are not in love at the beginning of their movies, for what reason might the protagonist want to impress (or do good by) the love interest (that has nothing to do with love)?

- With regards to the protagonist and love interest, what is it about each character that drives the other crazy or gets him or her frustrated with the other? How does this factor into the premise?
- Does the antagonist have the love interest fooled? If so, why would the love interest respect the antagonist? What's the appeal? What ability does the antagonist have that the protagonist does not? How does the antagonist show it?

The next chapter focuses on the fourth character, which is the second half of your protagonist's inspiration for success. If the love interest is the heart of your protagonist's goal, then character number four is the brain. Whether the story is about saving a love, a life, or an entire universe, a hero must look up to and admire someone who provides inspiration in the execution of his or her deeds. That character is none other than the mentor.

Exercise 8

1 How is the love interest going to challenge your protagonist to grow as a person? Make a list of at least of 20 ways the love interest might inspire the character arc (inner journey) through his or her actions.

2 The love interest should be defined as follows:

- The love interest inspires the protagonist to become _____ (cure of the inner journey) by _____ (three specific examples on how the love interest inspires the protagonist to achieve his or her arc through action).

You fill in the blanks. Just remember with the supporting character roles that you provide the *how* they do their job, not just that they are doing it. You wouldn't just say the love interest inspires the protagonist to grow from (flaw) to (cure). That is a given. You need to add the how, giving specific actions that *this* love interest would do that inspire a character arc.

Qualifications

- This should be only one sentence.
- The protagonist loves this character enough to change permanently for him or her.
- It shows audiences *how* the love interest inspires the completion of the character arc and inner journey.
- The *how* this character inspires the protagonist's character arc fits the genre.

- This happens during the heart of your film, which is the second act in traditional three-act structure.

Disqualifications

- It focuses on the outer journey.
- The protagonist does not care deeply about this person.
- Any of the three actions taken by the love interest are merely advice and hot air. They should be actions, not words.

3 How would a *lust interest* inspire the protagonist *not* to grow/arc?

Chapter 9

Mentor

Figure 9.1 Jacob Redmon – This teachers' lounge is for true mentors only.

Character credits: Katharine Parker (*Working Girl*, 20th Century Fox); Wade Garrett (*Roadhouse*, United Artists and Silver Pictures); Gandalf the Grey (*Lord of the Rings*, New Line Cinema, Warner Brothers); Albus Dumbledore (*Harry Potter and the Half Blood Prince*, Warner Brothers); Mickey (*Rocky*, United Artists); Agent Kay (*Men in Black*, Columbia Pictures and Amblin Entertainment); Mr. Miyagi (*Karate Kid*, Columbia Pictures)

> "He was always so zealous and honorable in fulfilling his compact with me, that he made me zealous and honorable in fulfilling mine with him. If he had shown indifference as a master, I have no doubt I should have returned the compliment as a pupil. He gave me no such excuse, and each of us did the other justice."
>
> – Charles Dickens, Great Expectations *(1861)*

A mentor (sometimes referred to as the *guardian*) serves the purpose of providing physical training and/or wisdom to the protagonist in his or her efforts to

achieve the outer journey of the story (the physical mission). Some brilliant script gurus lump the mentor in with other types of ally characters, but I think it's important to see this character as separate and independent. So, even though a mentor is considered by many to be an ally of the protagonist, like toads are a subset of frogs, the role of mentor is special among all the allies. The mentor character is superior to the protagonist in mindset, rank, reputation, or experience with regards to pursuing the external goal. That combination of traits makes the mentor unique. In his or her own right, the mentor is *the* hero of many films, not just *a* hero.

The role model

Any number of characters may reflect, coax, or inspire a protagonist to act differently than in the past, influencing his or her course of action. The mentor is the one major character type who has already fought the battle the protagonist is about to fight. This means that the mentor has the ability to train the protagonist to do what he or she sets out to do in both mind and mission. It takes a character like Morpheus in *The Matrix* to mentor both the body and spirit of a protagonist.

This singular character sets the example and provides inspiration by "living the path" the protagonist hero chooses to take at the end of act 1. It's this important thing that distinguishes this character from any other ally who may reflect the hero's specific predicament. This character is the role model leading the protagonist onto that right path. The mentor can be as hands-on as Jedi masters to a padawan in the *Star Wars* saga or as subtle and understated as the character of James Morse, who gently mentors Edward in *Pretty Woman*. A mentor suggests the best way forward through providing an example, not merely comments and opinions. The mentor is chiefly responsible for mentally and physically arming the protagonist for that rocky road to facing the antagonist.

To write mentors who live up to their purpose, ask yourself some specific questions (yes, we are hitting the ground running with brainstorming for the mentor early in this chapter):

- Who do I, the writer, look up to and admire in my life (people you know personally and those you may not)?
- Why do I admire those people?
- What qualities inspire me to be better than I am?
- What gives me personal conviction?
- What inspired (mentored) me to make a film about this premise?
- What qualities in mankind led me to believe this?
- How does this mentor relate directly to the premise of the script?
- Who would the protagonist look up to at the beginning of his or her journey and why?

- Who would the protagonist look up to at the end of his or her journey and why (if that changes)?

- What life experience(s) qualifies this character to mentor your protagonist's outer journey?

All of these factors should be taken into account when sculpting the mentor to a protagonist. A mentor is an example of what the writer hopes the hero will personify and believe at the end of the story.

The mentor's sacrifice

It is common for a mentor to not only train the protagonist, but also to make an enormous sacrifice (sometimes his or her life) for the premise the writer poses to the audience. That sacrifice personifies the value of the script's premise. Now, obviously, this sacrifice is not always made for the protagonist. Not all mentors sacrifice themselves, but such a sacrifice is a key and memorable moment in any script if they do. Such sacrifice reminds the audience of what is at stake (usually death or a life without love) if your protagonist fails to achieve their goal.

Even in enormously budgeted, special effects–driven films, the most memorable moments are often the mentor's sacrifice; for example: Gandalf in *The Lord of the Rings: The Fellowship of the Ring*, Morpheus in *The Matrix*, Albus Dumbledore in *Harry Potter and the Half-Blood Prince*, or Ben Kenobi in *Star Wars: A New Hope*. All the special effects in the world can't provide the jolt of emotional impact a properly written mentor sacrifice gives the audience. The sacrifice is powerful. The example the mentor sets for your protagonist is that the goal (and the truth of your premise) is one worthy of the ultimate sacrifice. Such self-abnegation serves as a cue or reminder for the protagonist to start living up to the promise of the mentor's example. Structurally, a mentor often dies so that the protagonist is forced to face the antagonist without him or her as a crutch at the climax of the story.

The teacher

The protagonist's inner journey starts with a personal character flaw that paves a path toward self-destruction, unless he or she does something to fix the problem. As a script doctor, one would diagnose the character flaw as a preexisting condition coming into the story. In this respect, the mentor may not be the one to trigger or inspire the protagonist to change (that job belongs to the love interest), but the mentor is the example that will help the protagonist to turn toward change. The mentor may also serve as an external conscience for the protagonist, designed to point out and guide the hero. The mentor attempts to keep the hero "on the straight and narrow." So, think of the mentor as the proverbial life coach of the protagonist with regards to (1) mission, (2) mindset, or (3) sometimes both.

So, the love interest provides the *why to do something*, whereas a mentor provides *how to get it done*.

Mentors exist in all genres; here's a list of examples of top mentors:

- Mr. Miyagi in *The Karate Kid*
- Viper in *Top Gun*
- Jim Malone in *The Untouchables*
- Don Diego de la Vega in *The Mask of Zorro*
- Auguste Gusteau in *Ratatouille*
- Father Merrin in *The Exorcist*
- Professor Charles Xavier in *X-Men*
- Shug Avery in *The Color Purple*
- Pai Mei in *Kill Bill: Vol. 2*
- Mickey in *Rocky*
- Elvis in *True Romance*
- Proximo in *Gladiator*
- Whistler in *Blade*
- Skeeter Phelan in *The Help*
- General Bache in *Taps*
- Nigel in *The Devil Wears Prada*
- Harry Hart "Galahad" in *Kingsman: The Secret Service*
- The Giver in *The Giver*
- Katsumoto in *The Last Samurai*
- Captain Pike in *Star Trek* (2009)
- Nobody in *My Name Is Nobody*
- Lester Bangs in *Almost Famous*
- Uncle Ben in *Spider-Man*
- Juan Sanchez Villa-Lobos Ramirez in *Highlander*
- Splinter in *Teenage Mutant Ninja Turtles*
- Patches O'Houlinhan in *Dodgeball: A True Underdog Story*
- Santa Claus in *Rise of the Guardians*
- God in *Bruce/Evan Almighty* and *The Ten Commandments*

Obviously, mentors can be found in any genre. In *The Karate Kid* (1984), Ali (the love interest) motivates Daniel Larusso (the protagonist) to arc on his inner journey. Meanwhile, Mr. Kesuke Miyagi plays the role of the quintessential mentor, providing Daniel with more than physical training for facing his bullies. Miyagi also provides the perspective. It is this mental side of the mentorship that separates Mr. Miyagi from the bullies' martial arts sensei, John Kreese. Miyagi is the whole package, a master mentor of both mission and mind.

Great mentors exemplify their role as the educator in the protagonist's outer journey in at least three, physically active ways during a film. For example:

- In *Grandma*, the mentor, Grandma Elle, teaches/trains the protagonist, Sage, how to stand up for herself against boys, right-to-lifers, and her controlling mother, without which the protagonist cannot accomplish giving herself a promising future in the wake of an unplanned teen pregnancy.
- In *Jurassic World*, the mentor, Owen, teaches/trains the protagonist, Claire, how to track, stand up against, and protect people from the terrifying dinosaurs by making her understand and respect their nature, without which the protagonist cannot accomplish containing the threat of the genetically modified super-predator.
- In *Nocturnal Animals*, the mentor, Bobby Andes, teaches/trains the protagonist how to find, confront, and punish a criminal, without which the

protagonist cannot accomplish revenge for his raped and murdered loved ones.

- In *The Blind Side*, the mentor, Leigh Anne Touhy, teaches the protagonist, Michael Oher, that to succeed in sports he must make getting his grades up a priority, defend his team like his family, and never give up on himself just as she never gives up on him without which the protagonist cannot accomplish playing for a top college football team.

Mentors get immersed in the protagonist's outer journey

One of the most important things one needs to consider about these mentors is that they are immediately involved with in the pursuit of the outer journey, not just commenting on it or providing advice. The mentor becomes involved in the mission that the protagonist has set out to accomplish. I'll use some of the mentors I mentioned above to illustrate the performance of this mission:

- Gandalf is a member of the fellowship on a mission to destroy the ring.
- Dumbledore helps Harry Potter discover the secrets of the horcruxes so Harry can stop Lord Voldemort.
- Morpheus battles against the machines with Neo.
- Obi Wan helps Luke get the schematics for the Death Star to the Rebel Alliance.
- Mr. Miyagi protects Daniel from his bullies and is at his side every step of the way in their mission for Daniel to stand up to them all at the karate tournament.

It's important to remember that when one designs a strong mentor, that character goes on the outer journey with the protagonist until the mentor becomes unable to continue. One of my favorite examples of this is the older, experienced beat cop Jim Malone, who schools young and eager Detective Elliot Ness on how to bring down Al Capone in *The Untouchables*. This mentor is not a random, advice-wielding character that the protagonist visits in a location that has nothing to do with his mission/goal. If the writer does not design the character to be involved, the mentor will read as if the writer is trying to make the protagonist do something that is not motivated by the plot, so he or she will sound like an unnatural and forced creation, superfluous or random.

Nobody's perfect

Because this role of mentorship can be blatantly obvious, serving a transparent purpose in your story, the mentor is one of the more difficult characters to write well. The character must be sculpted with the same care as is taken with the

protagonist and antagonist, or the character will read terribly cliché. The mentor as "the perfect person" is what to avoid here. I am not sure if mentors such as Obi-Wan and Yoda would be as compelling to a modern audience because they are, frankly, a touch one-dimensional. As a huge *Star Wars* fan, I am pained to make the following point. Ask yourself who is a more compelling mentor to watch, either of the above-mentioned *Star Wars* saga mentors or (1) Jim Malone in *The Untouchables*, who teaches Elliot Ness he must be willing to break the law to enforce it; (2) Morpheus in *The Matrix* whose blind faith defies reason; (3) Jonathan Kent, Kal El's adoptive father in the film *Man of Steel*, who sacrifices his life because he has no faith in humanity; or (4) Shifu in *Kung Fu Panda*, who exemplifies a troubled mentor when he's told to train a Dragon Warrior in whom he has no faith. It's no secret that flawed characters are simply more compelling to watch.

Just as you design the protagonist to have a flaw to overcome, it's a good idea to provide the mentor a flaw to make him or her more three-dimensional. So, while giving mentors a character flaw is not strictly necessary, doing so helps elevate the character and the material. That personality flaw keeps the mentor from being two-dimensional. For a prime example on doing this, watch Douglas Day Stewart's *An Officer and a Gentleman*. Drill Sgt. Emil Foley, forced to train whatever soldier the military gives him, is determined to push the protagonist he dislikes to the breaking point so he'll quit.

When assigning a flaw to the mentor, I ask myself questions that will help me to hunt for the right problem:

- Is there an identifiable reason the mentor doesn't want to work with this protagonist?
- Has the mentor lost so much that he or she cannot show love (for fear of losing it)?
- Is the mentor selfish, teaching the hero strictly for selfish motives (a personal agenda)?
- Is the mentor all courage but void of dignity and good character?
- Is the mentor all talk and no action now, or does he or she still have the courage of his or her convictions?
- Is the mentor too physically feeble to do what the protagonist is trying to do?
- If so, how does that handicap hold the mentor back?
- It all boils down to this question: what makes your mentor deeply human?

A mentor can be frail, dissipated, and ravaged from his or her own journey yet can help the protagonist accomplish more than he or she is capable of doing for him- or herself. You get the idea. Assign the mentor specific personality attributes or weaknesses that go along with his or her personal flaw. Such attributes make the mentor more than just a purpose but an actual person. Just remember, when a writer provides the mentor with a character flaw, this flaw does not mean that he or she requires a character arc. Only the protagonist needs an arc. The

mentor may not overcome his or her flaw because the story is not about the mentor's arc, unless . . .

Mentors as central characters (i.e., the central mentor)

As stated in earlier chapters, some characters can serve more than one of the five purposes. Sometimes mentors are the protagonists (a form of leader), which means that they do have a character arc. Mentor protagonists often exist in an environment in which they play a leadership role in their jobs. These can often be in an educational or military capacity in the form of teacher or commanding officer. In short, mentoring is in that character's actual job description. For example, look at every slacker's favorite English teacher, Freddy Shoop, in *Summer School*, the pool hustler "Fast Eddie" Felson as he trains a young pool shark in *The Color of Money*, and *Gandhi*, who teaches the world about passive resistance in his biopic.

Marty McFly is the hero and mentor to his own father, George, in *Back to the Future*. Ferris Bueller spends all of his day off teaching Cameron Frye to live fearlessly.

The last two examples illustrate the way in which sometimes the mentor can be the central character of the film. It's important to note that the central character is not always the protagonist. This possibility is one that many do not grasp. The central character drives the action of a film, while the effects of those actions internally change the protagonist. Central characters and protagonists are usually one in the same but not always. A perfect example of mentor as central character is Jaime Escalante, an inner-city high school math teacher, who turns potential dropouts into college prospects in *Stand and Deliver*. In such situations, his students have an inner journey. Other examples of mentors in the central role (and sometimes arcing in the shared role of protagonist) include:

- Captain Miller in *Saving Private Ryan*
- Coach Norman Dale in *Hoosiers*
- Patton in *Patton*
- Principal Joe Clark in *Lean on Me*
- Bill Rago in *Renaissance Man*
- Louanne Johnson in *Dangerous Minds*
- Alex Hitchens in *Hitch*
- Dewey Finn in *School of Rock*
- Sister Mary Clarence in *Sister Act 2*
- Mary Poppins in *Mary Poppins*

In the end, you are identifying a mentor by the outer journey of the protagonist.

When examining the above characters, you will find half of them have no arc. Yet there is no question that these mentors are the central characters of their perspective films. Those without arcs lead by example for those characters who do have an arc. So, here's proof that a central character is not always the protagonist. These are also not "failed protagonists" because they were not meant to change. Mentors are simply heroes until they're not.

Figure 9.2 Kaitlin "Katt" Cassidy – Beware the false mentor.

Character credits: Harry Potter mentor Remus J. Lupin keeps out Gilderoy Lockhart, Barty Crouch Jr., Professor Quirrell, and Severus Snape (Warner Brothers).

False mentors

Because the antagonist and mentor are the two character types who enter the story in a superior position to the protagonist, due to experience, knowledge, or power, it's an interesting thought that an antagonist is a mentor gone wrong. Many films feature moments where the antagonist is actually trying to *teach* the protagonist what the antagonist thinks is the right way. The story's antagonist that thinks he's a mentor is a great trope we've seen in many films.

Let's not forget that not all mentors turn out to be good or right. Just as you can have an antihero or false love interest (lust interest), you can also have a false mentor. Those can be fabulous, juicy roles for an actor to play. J. K. Simmons won an Academy Award for playing iconic and volatile Terence Fletcher in *Whiplash*. Some mentors are downright abusive to the protagonist for whatever reason, be it personal dislike or a personality flaw. True mentors never take credit for the

protagonists' successes, even though without the mentors, the protagonists don't stand a chance in hell of accomplishing their outer journey. A false mentor can do the exact opposite.

A powerful false mentor can, in a split second, rob a protagonist of everything he or she has fought to achieve throughout the film. When this twist of fate is executed correctly, the reveal of this character's true nature (or the moment of double cross) blindsides the protagonist. This betrayal usually comes right on the heels of a moment in which the protagonist thinks that the worst of his or her outer journey is past. Therefore, this betrayal provides a jolt in the story.

As a popular example, in *Harry Potter and the Goblet of Fire,* the character disguised as "Mad-Eye" Moody appears to be the protagonist's most vigilant ally until it's revealed that his help was only given in order to guide Harry into a trap designed to kill him and revive the murderer of his parents. Dr. Manhattan, one of the greatly confused superheroes, supports a horrific massive death toll and murders a member of his own team to cover it up at the end of *The Watchmen.* In *Working Girl,* just when Tess McGill gets everything she's worked for since the end of act 1, Katherine Parker (her boss) swoops in and steals everything right out from under her, misappropriating her assistant's ideas and then taking credit for them. This creates the worst of all possible situations for the protagonist at the end of act 2.

This faux mentor appears to be a model of success for the protagonist at the outset of the story: someone with the skills the protagonist believes he or she must master in order to achieve his or her goal. Along the way, at a moment that proves devastating, the hero either: (1) discovers this person was not the icon in whom he or she had originally put his or her faith in because the mentor fails to live up to the ideals and promises he or she extolled or (2) realizes this ideal leader is actually leading our hero down the wrong path. This is sometimes an interesting way of discovering who the antagonist is going to be in the story. In fact, it is quite common for the false mentor to turn out to be the antagonist.

False mentor as antagonist

In some cases, over the course of a script, a character actually starts as a mentor and crosses a line that triggers a transformation from a mentor into a villain right in front of our eyes. In *L.A. Confidential,* Police Captain Dudley Smith, who has no fear of getting his hands dirty, mentors the protagonist (Detective Edmund Exley) and turns out to be the antagonist. Aspiring to become "top cop" and get a promotion when Dudley runs for commissioner, Exley hopes to crack a famous case.

The mentor-turned-antagonist often appears in cinema. Examples of this kind of mentor include such famous characters as: Detective Alonzo Harris in *Training Day*, Gordon Gekko in *Wall Street*, Tyler Durden in *Fight Club*, Ernesto de la Cruz in *Coco*, Doctor Otto Octavius in *Spider-Man 2*, John Milton in *The Devil's*

Advocate, Bodhi in *Point Break*, Henri Ducard in *Batman Begins*, Deak in *Broken Arrow*, "Long John" Silver in *Treasure Island,* and, perhaps one of my favorite false mentors because his character was so emotionally convincing, Lawrence Fassett in Sam Peckinpah's *The Osterman Weekend.*

I must stress that it was difficult to find quality female mentor characters in mainstream larger-budget films. I found plenty of male mentors to female protagonists, but can you think of 10 female mentors to male protagonists? Can you think of even one such mentor without doing an online search? And, most important, the female cannot turn out to be the love interest; I'm talking about a man looking up to a woman without romance as the endgame. Just think about it. I challenge my fellow writers to consider creating more original, strong female mentor characters.

The questions

You should ask yourself:

- Given the outer journey, who would be in a position to teach the protagonist how to achieve that goal?
- How is this person accessible?
- Has he or she taught others before?
- If the mentor has taught others, does the mentor feel that he or she has been successful?
- Why does this character not want to teach the protagonist how to achieve his or her outer journey? Has or does he or she:

 - Given up?
 - Lost faith?
 - Feel incapable or worthy of training others? Have too much to lose?
 - Have nothing to gain?
 - Not care?

 - Possess hatred for the protagonist?
 - Want it for him- or herself?
 - Not think it can be done?
 - Lost a previous pupil?
 - Seen what this pursuit has done to his or her own mentor?

- Why would this character teach? What would make this person take up that responsibility?
- Where did this character fail that he or she thinks the protagonist may succeed?
- How does this character feel about his or her own lack of success and the potential success of the protagonist?
- Does the mentor have different goals or standards than those of the protagonist with regards to the outer journey?
- What does the mentor get if the protagonist succeeds in the outer journey?
- What is the mentor's position in the hierarchy of the world/place, workforce, or situation?
- What might the mentor stand to lose by working with the protagonist?

- What might the mentor lose if the protagonist fails?
- What will the mentor personally sacrifice to help the protagonist succeed?
- What are the personal and global stakes of the protagonist's success as seen through the eyes of the mentor?
- How does the mentor know so much?
- What is the mentor blind to?
- How extreme are the mentor's opinions? Do they change as the antagonist continues? What kind of action might it take to change them?
- Who convinces whom? Does the mentor inspire the protagonist to take on this physical mission, or does the protagonist convince the mentor to help?

Now, in a situation that may feel all too familiar for those with divorced parents, I'm going to explain the uses of *dual mentors*, each fighting for what he or she thinks is best.

Exercise 9

1 What is the mentor teaching the protagonist to do that will help the protagonist achieve his or her outer journey? Make a list of at least 20 ways the mentor might physically teach or train the protagonist to achieve his or her specific outer journey. Any ally can give advice, but remember, the mentor is special because he or she also teaches the protagonist how to do the physical actions that are needed to cross the outer journey's finish line.

2. The mentor should be defined as follows:

- The mentor teaches/trains the protagonist how to _____ (*three specific physical actions*), without which the protagonist cannot accomplish _____ (*the protagonist's outer journey*).

You fill in the blanks.

Qualifications

- This should be only one sentence.
- It illustrates leadership of mindset or mission or both.
- This mentor is a teacher (not merely a helper or ally) that is clearly your protagonist's personal trainer in executing the outer journey.
- This prepares the protagonist for his or her specific outer journey. It shows specifically how and what your specific mentor physically and actively teaches the protagonist to achieve his or her physical, external goal.
- It sets an example for how the protagonist needs to live the path in order to succeed in the outer journey.
- This is a superior-ranked or more-experienced character to the protagonist in the qualifications to pursue this mission.

- The teaching allows the protagonist to achieve the outer journey under his or her own power.
- It teaches the protagonist how to achieve the outer journey in a way that fits the genre.

Disqualifications

- Focuses on the *inner* journey or character arc.
- Does the job that *any* ally or friend of the protagonist could do, such as simply lending a hand or giving advice.
- Being *vague*, simply writing the mentor teaches the protagonist to accomplish the outer journey. We know that's what a mentor does; we want to know what *this* mentor does. *How* your mentor does it needs to be specific.

Chapter 10

Dual mentors

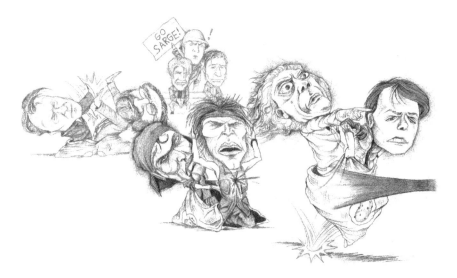

Figure 10.1 Jacob Redmon – The mentors of mind and mission sometimes work well together while others do not.

Character credits: George McFly, Marty McFly and Dr. Emmett Brown (*Back to the Future*, Universal Pictures); Chris, Sgt. Barnes, Sgt. Elias (*Platoon*, Orion, MGM); Will, Sean, and Dr. Gerard Lambeau (*Good Will Hunting*, Miramax, Walt Disney Studios)

> "Our chief want in life is somebody who will make us do what we can."
> —Ralph Waldo Emerson (1872)

When a script has two separate mentors, these two mentors usually personify the two aspects of learning how to complete the outer journey: mission and mindset. That duality always sits at the core of differentiating two mentors. These two characters always boil down to one of three potential scenarios, which I will explain in this chapter. The first two require a false mentor. The dual-mentor approach makes the most sense when the character is divvied up into one false and one true mentor. If the mentor sometimes acts as the guardian angel on one of the protagonist's

shoulders, the false mentor appears to be an angel but is later revealed to be a little devil. Now, just because one of the two mentors is false, it does not make him or her a bad person. The false mentor isn't always bad; he or she is just wrong.

1 One mentor of the mind versus one mentor of mission

Movies are about tough decisions. The conflict between the protagonist's original outer goal and the inner journey yields dissent among mentors in this first category. Stories are about those times in life when one's mission (physical task) and mind (the right way to do things) don't mesh. How much the mentor of mission and mentor of the mind conflict with one another about the best way to succeed is in the writer's hands. The key to any conflict between dual mentors should revolve around what is best for the protagonist, keeping him or her at the core of all conflict in the story.

The dividing of mentor duties is perfectly exemplified by Sean Maguire and Professor Gerard Lambeau in *Good Will Hunting*. Professor Gerard Lambeau finds a genius serving as a janitor at his university, and the professor endeavors to provide this brilliant, ungrateful young man with a far more viable future. Lambeau is Will's external mission mentor who can put the protagonist in a place to utilize his tremendous brilliance in the world of complex mathematics. Too bad the protagonist is incapable of being a productive member of society due to the demons of his childhood. Lambeau enlists the aid of a psychiatrist (Sean) to help with mentoring Will's mind. A protagonist cannot succeed in his mission if his mind is not right.

Professor Lambeau proves that the false mentor does not have to be a bad man; he just needs to provide the wrong path for this protagonist. A false mentor usually personifies a public misconception that relates directly to the writer's chosen premise. *Good Will Hunting* focuses on how best to measure one's success, whether through career or personal life. Lambeau has no wife and no family. He stays up late working on math problems. He's internationally recognized and has earned the respect of everyone in his life. He has found great career respect and success (this is the mission of the outer journey), while the other mentor has lived and loved with all his heart (because his mind is in the right place – in touch with his heart). Sean mentors the psychology of Will's outer journey.

In the end, the protagonist will have to choose which of the two paths to follow. The writer is showing and asking what is more important: mission or mentality? Each possesses drawbacks and benefits. The film still makes me wonder sometimes if it was better to have loved and lost than to have dedicated that time toward a field of study that would always be there. Meanwhile, math can't hold you at night. Not without the help of some serious hallucinogenics. Perhaps Professor Lambeau might make the counterpoint that mathematics also won't take half of your assets in a divorce. This struggle shows how a protagonist can fulfill the character arc of the inner journey while not accomplishing the goal of the

original outer journey. This conflict provides an emotionally satisfying yet unpredictable ending to the story.

It's no surprise that these two mentors' lives and personalities reflect their roles as mentors. You will notice that Professor Lambeau (pompous and impatient) and Sean (emotionally drifting at sea) are both flawed. The movie asks who is most successful. Professor Lambeau considers Sean a failure in many ways because he never received recognition. This lack of recognition is blamed on the tragic loss of a wife that he loved more than anything in the world. When Will chooses love over career in the end, the writers make their point. In short, by delineating the mentors' responsibilities of preparing the protagonist in mission and mind, a writer can make a statement about which is more important: action or wisdom.

It's important to recognize the character parallels between the protagonist and Sean, the mentor designed to be Will's true guide to success. The writer makes a point of the fact that they are from the same neighborhood, and it is later revealed that Sean even has the same exact problem as Will (an unwillingness to trust others in new relationships, although Sean's reasons for mistrust differ from Will's). Will was brutalized in his youth, while Sean hasn't gotten over the loss of his wife. Sean has a history of success in relationships and is trying to help Will overcome his issues so that he can have successful relationships in the future. What's wonderful about this symbiotic relationship is that Will turns right around and mentors Sean at the end of the movie to open his heart to love again. It makes sense that the completion of the protagonist's character arc in the third act may inspire mentors and other allies to change. Now, you will notice that we do not see Sean find love. No arc is actually shown for Sean. The mentor does not have to actually achieve the arc unless he or she is also the protagonist. It's enough to know that one inner journey inspires change in others.

The double mentor of mission (action) and mind (psychology) is not a new concept. In the quintessential mafia film, *The Godfather*, the two mentors are Tom Hagen and Don Vito Corleone. Vito teaches his son, Michael, about the importance of family and wants him out of the dangerous family business. The counsel provided to Michael is Don Vito's idea of protecting his family. Meanwhile, when the family comes under attack, Tom puts the gun in Michael's hand and gives him the mission he needs to follow through on if his family must come first. Tom teaches Michael about the action necessary to defend family while Vito counsels with wisdom.

Calvin (the dad) is the mentor of mission who tries to salvage the family in *Ordinary People*, while Berger is Conrad's guide on how to mentally succeed in getting over loss.

The genres that utilize both true and false mentors span the playing field (not just the Academy Award–nominated, dramatic screenplays). In romantic comedies like *Nine Months*, you have Marty and Sean. Marty is the example of the guy who got married and settled down to have a family, and Sean stayed a single swinger. Both characters are totally committed to their lifestyles. Sean appears to be the mentor for the first half of the film, but the story evolves. These roles become reversed as the story drives toward its climax.

The same happens with the Professors Stromwell (the mindset to succeed) and Callahan (the mission to become a working lawyer) in the comedy *Legally Blonde*. Once Elle Woods gets to Harvard, Stromwell embarrasses Elle and kicks her out of the class on her first day of school. Meanwhile, Callahan shows interest in the lovely blonde, takes Elle under his wing, and gives her an internship at his prestigious law firm every student wants. This internship allows her to work on a high-profile legal case. One professor seems unnecessarily hard on Elle, while the other offers a highly coveted opportunity for practical training. That's when the writer plays three-card-monte and switches the mentors on us.

It isn't until after the midpoint that Callahan reveals his true colors by trying to get into Elle's pink miniskirt. Meanwhile, during the protagonist's personal low point at the end of act 2, when she is ready to drop out of school, the writer reveals Stromwell at the salon, where she encourages Elle to stay and rise to the challenge. Setting the reveal at the salon is critical because it actually draws the thin red line of connective tissue from protagonist to true mentor (just like Sean and Will's similar backgrounds in *Good Will Hunting*). Without on-the-nose dialogue, it's made clear to the audience in this moment by visually revealing Stromwell at a beauty salon that the tough teacher Elle thought hated her is also a blonde, well-built woman (probably having had to face that same sexist behavior Elle is facing). This shared experience explains why Stromwell was so hard on Elle. Stromwell knew Elle needed to be able to step up and not let her looks speak for her. Otherwise, she'd never be anything but some rich, sexist lawyer's inside joke at a law firm. In the wake of the second act low point, Stromwell inspires Elle to stay in law school and rise to the challenge of becoming a lawyer in act 3. This reveal exemplifies one of my favorite mentor-writing tricks.

The flip-flop

This old-school switcheroo happens when one character appears to be working against the protagonist and another appears to be guiding or helping the protagonist. Then something happens in the plot that reveals those characters' true nature, and they switch sides. The reveal of the false ally plays a huge part in revealing the other's hidden loyalty. The unveiling of a false mentor sometimes forces a true one into the light.

In *Harry Potter and the Sorcerer's Stone*, the character who seems to be frail, unthreatening, and stuttering, Professor Quirrell, is supposedly teaching Harry how to defend himself against dark magic, and the intimidating Professor Snape, always draped in all black, dogs Harry every chance he gets. When Harry Potter walks in on Professor Snape cornering Professor Quirrell, arguing in the shadows about loyalty, most audience members would naturally assume that Severus Snape is up to something nefarious. Yet, in the end, it is revealed that Snape has been protecting Harry while Quirrell has been trying to kill him. The flip-flopping device thwarts predictability at the major escalations of a story.

Being unpredictable but logical is a huge part of keeping a script engaging. This unpredictability is probably one of the many reasons that J. K. Rowling used dual and false mentors in virtually every *Harry Potter* book leading up to *The Deathly Hallows*. Look at characters like Gilderoy Lockhart in *The Chamber of Secrets*, Sirius Black in *The Prisoner of Azkaban*, and "Mad-Eye" Moody in *The Goblet of Fire*. All of them are the opposite of what one expects in the end. In the one case she didn't use a false mentor, she instead flip-flopped the perceived antagonist into a beloved ally. This specific brand of shapeshifter is a fabulous wrench to throw into any decent writer's toolbox.

On a brief side note, this flip-flop between two characters can be done outside the dual-mentor paradigm. As an example, in *Terminator 2: Judgment Day*, the audience is predisposed to believing the Schwarzenegger terminator from the first film is evil and that the other character traveling back through time has been sent to protect the heroes. Therefore, it's a shock when the roles are reversed upon catching up to John Connor.

Structurally, the surprise of one character's betrayal traditionally triggers the reveal of the true mentor's decency. This reveal clears up our misconceptions regarding which character was working against the protagonist.

Platoon's Sergeant Barnes starts out as the no-nonsense, stand-up, tough soldier and role model, while Sergeant Elias is a drug-addled, similarly higher-ranking officer to the protagonist, who gets high in the foxholes of Southeast Asia. Later, the truth about who has the moral high ground comes to light as it's revealed that Elias is the educator of mindset and understands how screwed up this whole situation is at every turn. With these flip-flopping mentors, we come across the second way to differentiate between dual mentors.

2 Two mentors with one mission but two minds

Another way to explore the conflict of two mentors is when they both have the same mission, but the true mentor is only revealed after revealing the difference in mind. In my favorite example of this revelation of difference, *Platoon*'s outer journey is the mission of how to survive Vietnam. This film features one of the most memorable pair of dual mentors on the same side of a conflict, yet they are at total odds with one another. These two strong men are deep in the jungles of Vietnam during a war neither believes in, armed with machine guns. They literally have to put their lives in each other's hands on a daily basis regardless of being at heated odds with one another. They vie for the protagonist's soul as he struggles with how to compartmentalize and mentally digest the situation. These two opposing mentors physicalize and epitomize everything Chris is wrestling with: what they are doing there and how to behave in a violent world in which they do not belong. Sergeant Barnes starts as the badass mentor, but he reveals himself to be a false mentor through his actions in the second act. These motifs play out again and again in films. How Sergeant Barnes pursues the mission of survival during

war is wrong, revealing Sergeant Elias as the true mentor of mindset. Obviously, once this difference is revealed, the true mentor must be somehow removed from the equation so that Chris has to face the false mentor turned antagonist.

A modern, cinematic example of the Sergeant Barnes and Sergeant Elias conflict between dual mentors can be found in *Avatar*. James Cameron practically clones this exact technique. Colonel Miles Quaritch and Doctor Grace Augustine are both on the planet at the service of a joint military–corporate venture in mining for a valuable and precious mineral. The two mentor figures are united in mission, brought in by the same people, trying to find a means to a singular end, but these characters are differentiated by their philosophies on how best to achieve the end. You could not find two more polar opposite mindsets. Many nonwriters are shocked when they realize the tools are all the same regardless of genre, from Vietnam War to sci-fi fantasy film. They all employ the exact same plot devices; only the tone changes.

3 Unified mentors: a mentor of the mind aligns with a mentor of mission

Now, just because a screenplay has two mentors, one of them doesn't have to be a false mentor. A good writer knows there's always another way and that our options are limited only by our creativity. In *Harry Potter and the Prisoner of Azkaban*, Albus Dumbledore deals with the mission (goal oriented) while Remus Lupin trains the mind (providing mental training and perspective in several situations). They are never at odds. Yoda trains the mind of a Jedi, and Obi-Wan focuses on the mission to prepare Luke for his inevitable confrontation with evil in *Star Wars, Episode V: The Empire Strikes Back*. Both mentors appear to fail in unison when Luke abandons training to save his friends. As Luke flies off in his X-Wing fighter, they seem to wash their hands of him. So, clearly, the dual mentors are not always at odds with one another in the middle of the journey, as is the case in *Good Will Hunting* and *Platoon*. In *Star Wars*, both mentors want what's best for the protagonist.

Now, in a medium in which the most engaging element of storytelling is the conflict between characters, one might wonder why a writer would design two mentors who are on the same side. There's one reason: the writer is specifically trying to make a point that mind and mission should not conflict when it comes to doing the right thing. You see this technique employed mostly in large-scope, good-versus-evil-themed stories.

The mentor's mentor

A unique example of two mentors in a single movie is when the protagonist's mentor requires a mentor. This inclusion of a second mentor makes a lot of sense for a story that deals with multiple generations or with the passing forward responsibilities and traditions. Such is the case in *Kung Fu Panda*, where Oogway must

mentor Shifu to see beyond his preconceived notions of Po. In *Back to the Future*, the central character of the film is Marty McFly, the mentor who gets his own father, George McFly, to his character arc. All the while, mentor Marty has his own mentor, Doc Brown, who teaches him how to handle the intricacies of altering history.

So in all, there are three types of dual-mentor situations:

1 Mentor of the mindset versus mentor of mission
2 Mentors of a single mission differing in mind
3 Two mentors on a unified front (mindset aligns with mission)

In any event, when written well, these two mentors always differ from one another in mindset, mission, or both. Otherwise, you wouldn't need two of them.

The questions

Ask yourself:

* What are the different approaches to achieving the mission of the protagonist's outer journey?
* What are the different mental point of views a mentor could have to get our protagonist there?
* Is there a point of view for accomplishing the physical goal in line with the antithesis of your premise?
* What would make a character a fantastic mentor for the mind but not for the mission? How might characters for each of these roles differ?
* If the mentor of mission is not coming from a good mental place, who keeps the mentor in line and helping the protagonist?

The mentor is the fourth major character archetype of the big five. Our fifth and final major character type is the most overlooked and underutilized of all character purposes in any script. For my money, this type serves one of the most important purposes any character can have in your story. The last (and definitely not least) important of the five major character types is the ally.

Exercise 10

1 How will your mentor of *mindset* teach your protagonist to think differently?
2 What will your mentor of *mission* teach your protagonist to physically do?
3 Which of the above mentors best suits your premise?
4 Ask yourself if a singular mentor should possess both qualities (mind and mission).
5 What would a *false mentor* for this protagonist's outer journey look like and what would he or she do?

Chapter 11

Allies

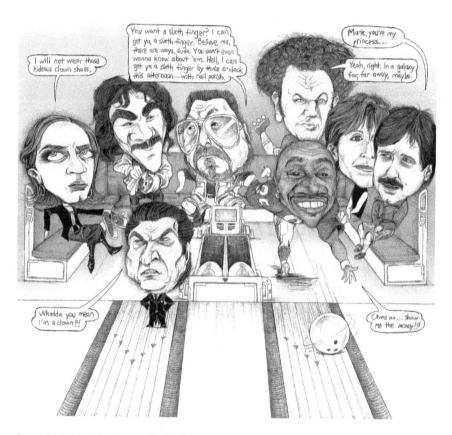

Figure 11.1 Jacob Redmon – Each of these wildly unique characters reflect and support the protagonist's outer journey. Walter would take them all bowling.

Character credits: Emily (*The Devil Wears Prada*, 20th Century Fox); Inigo Montoya (*The Princess Bride*, Act III Communications, 20th Century Fox); Tommy DeVito (*Goodfellas*, Warner Brothers); Walter Sobchak (*The Big Lebowski*, Polygram Filmed Entertainment, Working Title Films, Gramercy Pictures, Universal Studios); Rod Tidwell (*Jerry Maguire*, TriStar Pictures, Gracie Films, Columbia Pictures, Sony); Reed Rothchild (*Boogie Nights*, New Line Cinema, Warner Brothers); Marie and Jess (*When Harry Met Sally*, Castle Rock Entertainment, Columbia Pictures, Sony)

"A friend is one who aids with deeds at a critical time when deeds are called for."

—Euripides

An ally is far too frequently, especially by less experienced writers, the most underutilized of the five characters. Like the other four previous character types (protagonist, antagonist, love interest, and mentor), this character serves as a crucial component in the process of creating drama, foreshadowing, high and ever-rising stakes, conflict, and tension. Without well-constructed allies, the audience has no reminders of the physical and emotional impact or risks involved with the protagonist's choices and goals. This key role illustrates the importance of success and the cost of failure throughout the story. Allies remind the audience of what the protagonist is trying to accomplish, illustrate the cost of achieving the goal, and define the uniqueness of the protagonist. If the story's stakes are important (and they should be, or why would any writer bother writing the story in the first place?), you cannot overvalue the importance of allies.

Many classify the mentor as an ally because he or she fulfills many of the same dramatic functions in the story, including establishing the stakes involved, and serves as someone to hold the protagonist's proverbial feet to the fire, but it's important to differentiate them. All mentors are a form of ally, but not all allies are mentors. It's like the old parable that every thumb is a finger but not every finger is a thumb. A mentor's job is to literally instruct the protagonist; he or she is the protagonist's teacher, guidance counselor, or commanding officer. On the other hand, a protagonist may glean wisdom from other allies within the trenches together in various ways through any method, mainly verbal advice or as a living example.

The soldier right next to the protagonist, who pops up to see if the coast is clear from the trenches and gets his head blown off by the opposing soldiers, is a form of ally. He reminds the audience in a powerful way of what the stakes are for the central character if an error is made in the situation. In the analogy where the mentor is a teacher, any other ally is a student, while the protagonist is either a fellow student or somewhere in between as the teaching assistant. There is a formidable difference in perceived rank between mentors and other allies, so I do classify them separately, just as thumb is defined separately from fingers.

Allies align with the protagonist and hold his or her feet to the fire. The ally takes the protagonist to task or questions his or her actions. The ally is a category of character type that includes a protagonist's friends, partners, coworkers, teammates, and sidekicks. He or she comments on the protagonist's outer journey and is often along for the same ride.

In modern cinema, to avoid the cliché of the love interest being tied to the proverbial railroad tracks at the climax of a film, it's common now to use an ally for that role instead. In such situations, the ally dies more often than a love interest in the same situation because the ally's death delivers a powerful blow to the

protagonist, and the happy ending for the protagonist doesn't depend on these characters ending up together.

Death in the mirror

Fellow WGA writer and MFA teacher Garrick Dowhen calls this type of character "the ghost" or "the conscience" of the story, because he or she frequently reminds protagonists of when they are screwing up. In *Basic Instinct*, Detective Nick Curran's partner, Gus Moran, repeatedly warns and asks him, "What the hell are you doing?" This character points out when the protagonist veers off course; this ally attempts to help the protagonist stay on the straight-and-narrow path toward his or her goal. An ally doesn't necessarily have any dog in the proverbial race outside of the protagonist's welfare. An atypical ally has the best interest of the protagonist at heart. Nick does not heed Gus' warnings, and his actions/indiscretions result in many unforeseen, direct consequences, which lead to Gus' murder. This type of action is commonplace among partners in cop, crime, and caper films, including Harry in *Speed*, Charlie Vincent in *Black Rain*, Pappas in *Point Break*, Jack Vincennes in *L.A. Confidential*, and Agent Oscar Wallace in *The Untouchables*.

An ally provides the audience a clear understanding of the stakes and meaning of the hero's journey. Allies are all about the way in which they are aligned with the central character. The ally sets up the pitfalls and/or can personally fall prey to them. The ally exemplifies the struggle and cost as a warning, foreshadowing, or example to the protagonist of what success or failure may look like. So, a writer designs an ally's participation in the plot by using this character to ask and answer (in dialogue and through actions) the following questions about the protagonist's situation regarding risk versus reward:

- What does the protagonist stand to lose?
- What does the protagonist stand to gain?
- How does the antagonist treat the people who oppose him or her? The answer leads to an important, stakes-oriented question . . .
- Exactly how dangerous is the antagonist and the obstacles before him or her?

Every ally must serve the story and protagonist in this way, or else you need to rethink how (or even why) you have chosen to use them. Allies are a key element in establishing:

1 What can go wrong.
2 The promise of the potential reward and success for the protagonist.

Remember the old adage: "The enemy of my enemy is my friend." This means that not every ally needs to be what most people might consider a friend of the protagonist. If the story is about a competition, an ally might be someone

else that is positioned to face-off against the antagonist before the protagonist. Because the antagonist is the biggest threat to success, these characters might align in that way as well. Every contestant in *The Hunger Games* is Katniss' potential ally, all of whom were forced into the same situation by the antagonist, Snow. Allies don't have to like one another; they're simply in a similar position.

Allies are necessary to help illustrate and build fear as well as tension earlier in the story. That said, if the main ally is killed during the story (usually at a major structural turning point), the question of whether your protagonist can change grows direr.

All cop partner and buddy movies are essentially ally-based stories because the lead characters are a pair that serve as a living, external mirror to the goal and outer journey of the other.

Here is a list of nonmentor allies who pay the ultimate price as a warning to the protagonist of the stakes involved:

- Brooks in *The Shawshank Redemption*
- Spock in *Star Trek II: The Wrath of Kahn.*
- Goose in *Top Gun*
- Tommy DeVito in *Goodfellas*
- Fenster in *The Usual Suspects*
- Manny Ribera in *Scarface*
- Sonny Corleone in *The Godfather*
- Miles Archer in *The Maltese Falcon*
- Bubba in *Forrest Gump*
- Louis Dega in *Papillon*
- Sandy "The Sandman" in *Rise of the Guardians*
- Clifford Worley in *True Romance*
- Riff in *West Side Story*
- Doc in *The Marathon Man*
- Seth in *Looper*
- Cleopatra Sims in *Set-It-Off*
- Jackie Flannery in *State of Grace*
- Richard Gecko in *From Dusk Till Dawn*
- Johnny Cade in *The Outsiders*
- Tommy in *At Close Range*
- Rorschach in *The Watchmen*
- Nick in *The Deerhunter*
- Sid Worley in *An Officer and a Gentleman*

When an ally dies, this death raises the questions:

- Can the protagonist rise to the challenge without the outside help of the deceased ally?
- Can the protagonist develop this conscience without that character to help or guide him or her?

The ally is commonly used in order to escalate the stakes. After all, the typical ally often is used to portray the story's conscience (i.e., the writer's conscience and premise).

Allies across genres

Now, not all movies involve life-and-death stakes, so death isn't always what threatens allies. The allies only experience the threat or the reward of what is at stake for the protagonist as a way of establishing potential outcomes for him or her. Without these characters, the protagonist and his or her audience never get a clear picture of what each step of the journey means because there's nobody to comment or be an example for it. Sometimes they simply provide verbal reminders, but these characters reflect the journey and comment on it through dialogue or example. Now, just because this character is an ally, that doesn't mean the ally always agrees with the protagonist. To make sure conflict occurs in every scene, they may share the same goal but often disagree on how that goal should be achieved.

The quintessential ally character for me is DC Comics' Dick Grayson (Robin) in the *Batman* stories. Dick reflects Bruce Wayne's journey from a child unjustly orphaned by criminals to crime fighter, becoming the truest of allies. If you read the *Harry Potter* books, you would see a similar personal history pattern between Harry and Neville Longbottom, who was also robbed of his parents by Voldemort

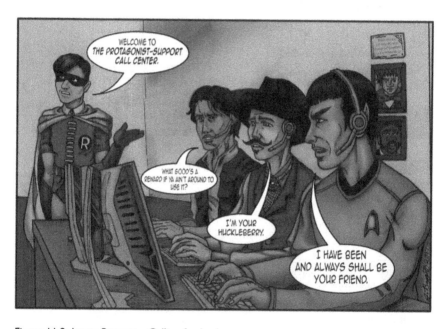

Figure 11.2 James Baggett – Calling for backup.

Character credits: Robin (*Batman*, Fox Television, 20th Century Fox, Warner Brothers); Han Solo (*Star Wars*, released by 20th Century Fox, owned by Lucasfilm, Walt Disney Studios); Doc Holliday (*Tombstone*, Hollywood Pictures, Walt Disney Studios, Cinergi Pictures); Spock (*Star Trek*, Paramount Pictures); Samwise Gamgee (*Lord of the Rings*, New Line, Warner Brothers); Jules Winnfield (*Pulp Fiction*, Miramax, Walt Disney Studios)

when he was merely a baby. Now, an ally character's personal history is rarely that paralleled. Here is a laundry list of more common allies by the traditional definition in various genres:

- Dr. John Watson in *Sherlock Holmes*
- Emily in *The Devil Wears Prada*
- David in *The 40-Year-Old Virgin*
- Walter in *The Big Lebowski*
- Reed Rothchild in *Boogie Nights*
- Chuckie Sullivan in *Good Will Hunting*
- Rod Tidwell in *Jerry Maguire*
- Paulie in *Rocky*
- Rex in *Swimming with Sharks*
- Melanie Hamilton in *Gone with the Wind*
- Hamish in *Braveheart*
- Athos in *The Three Musketeers*
- Will Scarlet in *Robin Hood*
- Wamba in *Ivanhoe*
- Norm Spellman in *Avatar*
- Dr. Ian Malcolm in *Jurassic Park*
- The Scarecrow in *The Wizard of Oz*
- Claudio in *Much Ado About Nothing*
- Itzhak Stern in *Schindler's List*
- Cosmo Brown in *Singin' in the Rain*
- Chloe in *Pitch Perfect*
- Kenickie in *Grease*
- Doc Holiday in *Tombstone*
- Ned Logan in *The Unforgiven*
- Dick Greyson in *Batman & Robin*
- Miles in *Risky Business*
- The Geek in *Sixteen Candles*
- Stiles in *Teen Wolf*
- Peeta in *Hunger Games*

They do this in film after film, genre after genre, in many different ways.

If the story is about love, allies illustrate what the protagonist stands to lose if he or she does not succeed in love, from heartbroken and alone to miserably married. You can specifically design allies to make the points you wish to make. In any love story, the old spinster, the cat lady, the aging gigolo, the long-suffering family guy with too many kids and too little sex, the eternal swinger who has nothing to come home to at the end of the day except a shallow existence, and so on, all reflect the potential fate of your protagonist. They foreshadow or warn protagonists of the stakes if the love story does or does not succeed. The older married couple in a romantic comedy (whether they finish each other's sentences, sacrifice to care for one another when one has lost his or her faculties, or can no longer stand one another) reflects the film's potential marriage. The romantic interest's latest lover or exes are also reflections of the protagonist's potential situation. They can have similar or opposite goals, reflecting the protagonist's inner journey. Those goals can make the most interesting love stories: from positive examples, like Marie and Jess in *When Harry Met Sally*, to antithetical allies to the protagonist's fate, like Kit De Luca and Philip Stuckey in *Pretty Woman*.

In pulp noir films, you can look at Private Investigator Sam Spade's partner Miles Archer in *The Maltese Falcon* or Jules Winnfield in *Pulp Fiction*. In the first case, Archer gets murdered in a deadly game of deception, lies, and betrayal, establishing the stakes early on. Jules continuously tries to convince Vincent Vega to make better choices. Jules warns Vincent about the stakes involved in taking

out Mia Wallace as well as attempting to get him to change his ways in the light of a "miracle." By the end of the movie, Jules lays out the example for Vincent to arc before it's too late for him. Not listening to Jules results in a lot of volatile situations and leads to Vincent's untimely demise.

In a horror film, a protagonist will attempt to escape some horrific fate as a series of allies meet the terrible end that your protagonist is threatened with as a form of foreshadowing.

In comedy, look at Chazz Reinhold in *Wedding Crashers*, who starts as a legend and is known as a mentor. He exemplifies what happens if the protagonists refuse to change. Lazlo Hollyfeld in one of my favorite college comedies, *Real Genius*, is the character who was the genius of geniuses. He cracked under pressure, and now he lives in a basement he accesses through their dorm room closet.

In the action genre, think about Sergeant Al Powell, who is the constant moral support system that helps John McClane keep going at his low points in *Die Hard*. Goose in *Top Gun* constantly reminds Maverick of the stakes, holding him accountable for the cost of each reckless move. Tony Stark keeps Bruce Banner's feet to the fire, pushing for his involvement as a superhero in *The Avengers*.

Science-fiction/fantasy films have some of the best-written allies with Spock in the iconic *Star Trek* series, Han Solo in *Star Wars*, and Samwise Gamgee in *The Lord of the Rings* saga. In the swashbuckler fantasy genre, one of the most quoted allies, Inigo Montoya, reflects Wesley in *The Princess Bride*. He sets an example for Wesley regarding courage, determination, loyalty, and the pursuit of a worthy quest involving unrelenting love (be it romantic or familial). In return, at the end of the film, Inigo is offered Wesley's alternate identity, the Dread Pirate Roberts. That's a brilliantly structured ally. The two characters start the film at odds with one another, but they end up storming the castle as allies in the film's climax, both on a mission to do right by those they love.

Great allies exemplify their role supporting the protagonist's outer journey in at least three, physically active ways during a film. For example:

- In *Hell or High Water*, the ally, Tanner Howard, provides backup for or reflects the outer journey to financially support their family's financial needs by helping his brother plan, execute, and escape the bank robberies.
- In *Pitch Perfect*, the ally, Chloe, provides backup for or reflects the outer journey to win the a cappella singing group championship finals by recruiting Beca to sing with them, training/singing with Beca, and arguing to keep Beca in their group when she has a falling out with its leader.
- In *Hidden Figures*, the ally, Dorothy Vaughn, provides backup for or reflects the outer journey to play a major role in computing the launching of America's first astronaut into space and back by driving Katherine G. Johnson to work every day, recommending Katherine for the job that would make her a NASA legend, and telling everyone to give Katherine space

when she needs to run the final numbers for John Glenn's trajectory just before his launch.

* In *The Big Short*, the ally, Jared Vennet, provides backup for or reflects the outer journey to prove the banks are screwing over the common man by bringing Mark Baum the theory to prove big banks are lying to everyone, helping Mark investigate those banks' financial improprieties, and partnering with Mark Baum in betting against the entire real estate market, proving it was a huge bubble and holding all the financial institutions responsible for their lies.

Allies and the protagonist's character arc

There are two characters against whom a protagonist measures him- or herself during the escalating story (usually at some point in the second half of the story): an antagonist and the ally. You all know the typical scene I'm talking about with the nemesis. The villain monologues and tries to convince the protagonist they are the same, deep down. That moment always sticks out like a sore thumb. Yet what many writers do not notice is that on the other side of things there is a similar moment with a well-drawn ally who defines the protagonist as a hero. In fact, the character arc's transformative moment occurs when the protagonist realizes his or her similarity to the antagonist and difference from the ally.

When audiences witness the difference between the guts (intentional fortitude) of the ally and measure this fortitude against that of the protagonist, audience members learn a lot about who is truly heroic. Protagonists often get practical advice from the ally and break away from it. The moment when the protagonist takes dramatic action despite all present dangers and advice is the point at which the protagonist's character arc can occur and the status of "hero" is earned. The protagonist establishes him- or herself as uniquely extraordinary. A perfect example of this occurs in *Star Wars* when Han plans on abandoning the rebels in the face of impossible odds, asking, "What good's a reward if ya ain't around to use it?" Meanwhile, this moment personifies Luke's enormous character arc from a reluctant farm boy, who originally insists he would like to help but has chores to do, into a full-blown hero. Then Han reflects Luke's example, changes his mind, and comes to Luke's aid during the climax.

In Aaron Sorkin's script for *A Few Good Men*, Lieutenant Sam Weinberg (co-counsel and a traditional ally) tells Lieutenant Daniel Kaffe (the protagonist) that he (nor Kaffe's famous lawyer father) would risk putting Colonel Nathan Jessup on the witness stand. No moment better personifies this departure point, separating the protagonist from everyone else, as when Sam points out that it's irrelevant what anybody else would do in this situation. The question is "What will the protagonist do?" This question, in turn, suggests the major discerning questions that quantify how heroic your protagonist has become: (1) how bold is the hero, and (2) how far will that character go to attain his or her goal? Differentiating the protagonist

from others, Kaffe's decision to put Jessup on the stand triggers the completion of Kaffe's character arc by having him stand up for something with all his guts.

There are two ways to see this moment, and either works. It all boils down to the writer's personal perspective on the concept of character arc. Either Kaffe is (1) changing who he is in this moment, or (2) he is finally finding the strength within himself to be the man he has always been but somehow lost along life's journey. This pinnacle moment in the script signifies the character arc, whether you see it as an internal growth into a *new self* or a return to his *true self.* The later sentiment is best stated by Shakespeare in Hamlet when Polonius advises his son before a long journey: "This above all: to thine own-self be true, and it must follow, as the night the day, thou canst not then be false to any man."

This ally–protagonist shared and character-defining moment in *A Few Good Men* is all about a character living up to his true or new self. In this moment, the protagonist must make a decision based on his identity, his values, his core, his belief systems, and knowing what he must do or risk never being able to look in the mirror again. Kaffe cannot be the man he wants to be (or is, depending on your perspective) without taking this drastic action. He *cannot* avoid his destiny. He must fulfill his fate and take the extraordinary step in front of him and bite the proverbial bullet. This beat is about having the courage to do what the protagonist knows is right, regardless of the forces aligned against him. Obviously, a lot of tragic heroes have to make this choice with dire consequences.

Kaffe's inner journey focuses on the question of whether this settlement-happy, paper-pushing attorney who has a reputation for cutting deals without ever going to trial will ever be a real trial lawyer like his legendary father. Will he live up to his true/new-and-better self? Kaffe's actions and life both center around the philosophy that anything is negotiable, right up until the end of act 1 when he passes on a remarkable plea deal. Act 2 begins the character arc of standing up for something, raising the question of whether he will relent and buckle as the stakes and pressure rise.

Kaffe has an enormous transformation, and it is the ally character that makes this transformation crystal clear to the audience. Sam's role is crucial in (1) clarifying how far the protagonist has come since act 1, and (2) showing how the protagonist differs from other worthy trial lawyers as truly heroic. These are important functions. A second ally, Lieutenant Commander JoAnne Galloway, served the function of holding the protagonist's feet to the fire at the major plot points. The writer reminds us of this function right in the middle of his showdown, when Colonel Jessup is on the stand. It looks like the witness will not crack under pressure. Sam and even the staunchest of defense attorneys, JoAnne, shake their heads for him not to continue. Kaffe's hands shake as he takes a sip of water. Nobody else would continue at this point, but Kaffe does. Daniel Kaffe becomes a hero because of the way in which he differentiates himself from his allies.

Allies must be different from the protagonist

It's integral that allies are different from the protagonist because every character needs to be unique. Their goals may be the same, but these characters have to differ in other ways. In *Legally Blonde*, there are numerous allies; each serves a purpose. Paulette is an example of what can happen to Elle if she does not succeed in becoming a lawyer as an attractive woman who has gotten older and was recently dumped by a lousy boyfriend. It's important to realize Paulette is different in ways that comment on Elle's journey by being older and not having the financial resources that Elle has. Elle's gal pals from L.A., Margot and Serena, reflect what she could be like as well if she decides to revert to the person she was before Harvard. These friends do not appear to have Elle's tenacity for success even though they do have the resources. Look at Dorky David Kidney, Brooke Taylor Windham, and the different law professors mentioned in the mentor chapter – none of them have Elle's perkiness and gusto. Every one of the protagonist's allies holds Elle's feet to the fire and supports her, but they are all different from her, which provides Elle with different perspectives. That support distinguishes the ally from all the other character types in one important way.

How allies may be similar to the protagonist

Outside of supporting the protagonist's outer journey, allies may look similar to visually accentuate their parallel fate, whether they share a common military uniform or sports team jersey. If the protagonist has to dress as the opposite gender, the ally may have to do the same, illustrating their unity like in *Some Like It Hot* and *Nuns on the Run*. It's a striking moment in *Rain Man* when Charlie dresses Raymond in a matching suit for their gambling run in Vegas. They might even have mirroring gestures, like the moment Biff walks into the diner in *Back to the Future* when Marty and George both duck their heads and stroke their hair in unison as a means of hiding from his view. So, while it is important to create different characters for each character, it is also important in a cinematic medium to remind the audience they are on the same side with subtextual, completely visual ques.

There is no limit on the number of allies in a script

Now, most writers design a script with one specific ally in mind by design, and good writers know better than to dilute a great ally character's potential by chopping it into many characters. Yet it is undeniable that, unlike the case for the previous four character types, at the end of the writing process, there are often many more than one or two characters in a script that can function as an ally. Sometimes different allies serve different functions: holding the protagonist's feet to the fire, or illustrating what is at stake (what can be lost or what can be gained), or bringing perspective on the protagonist's individuality. These characters all reflect the protagonist's outer journey and possible outcomes.

I am aware that stating that more than one character can fill any singular character purpose goes against many screenwriting gurus' philosophies. These writers often say that a script can have only one protagonist, one antagonist, one love interest, and only one ally. I say go and look at any story with a team of people following a protagonist, and you will find several allies: some more integral than others, some I would consider separately as mentors, others as partners or allies, but multiple allies nonetheless. There's a whole team of allies in *The Matrix* (the most symbolic of Neo's options being the ally who betrays him, Cypher), *Planet of the Apes* (George Taylor's fellow astronauts are killed or lobotomized), *Ocean's Eleven* (with a crew of 10 supporting conmen), and *Harry Potter and the Order of the Phoenix* (Dumbledore's Army). They are all allies of the protagonist's outer journey in one way or another.

The questions

In considering potential allies, a writer asks:

- What exemplifies the pitfalls of this protagonist's outer journey?
- What exemplifies the successes of that outer journey?
- Who would the protagonist trust most?
- Why would he or she trust someone?
- Who would he or she be advised by?
- What examples might someone set?
- Who else is going after what the protagonist wants?
- How are that person's motives different from those of the protagonist?
- What does the protagonist have that no ally can have?
- What does the protagonist do that no ally would?
- What is that special, unique skill that separates him or her from every other ally?
- Why would the protagonist go through with the climactic confrontation?

- Why would the ally not go through with this confrontation? How is this character less heroic?
- Does this character believe in short-cuts and cheating? Where is the moral difference?
- As a possible sidekick, why does the protagonist need this character? What does he or she offer to the outer journey?
- This point need not be selfish, but why might this character care if the protagonist succeeds?
- What makes this character and the protagonist alike outside of the situation?
- Does this character share a belief system with the protagonist?
- How does this character illustrate or point out the protagonist's shortcomings?
- How far is this character willing to go for the outer journey goal?
- How far will this character go for the protagonist?

- Does this character support the outer journey or the protagonist? Which is the priority?
- What's this character looking to find, and why does he or she do it?

- What are the different ways someone could do what the protagonist is trying to get done?

The next chapter takes the character definitions and expands upon them in new ways, twisting some old theories and redefining others in our final reflection on character creation.

Exercise 11

1 State at least 10 different ways how your ally (excluding mentors) will exemplify the protagonist's stakes (either for good or bad).
2 State at least 10 different ways how your ally (excluding mentors) will hold the protagonist's feet to the proverbial fire when the going gets rough, helping the protagonist achieve his or her outer journey.
3 The defining statement for this character can read as follows:

- The ally provides backup for or reflects the outer journey to _____ (*state the outer journey here*) by _____ (*list three specific ways in which this character supports and takes action that inspire the protagonist to carry on in his or her pursuit of the outer journey*).

You fill in the blanks.

Qualifiers

- This should be only one sentence.
- This character is an ally and a helper.
- The ally supports the protagonist's outer journey in a way that fits the genre.

Disqualifications

- It focuses on the inner journey.

Chapter 12

Final reflections on characters

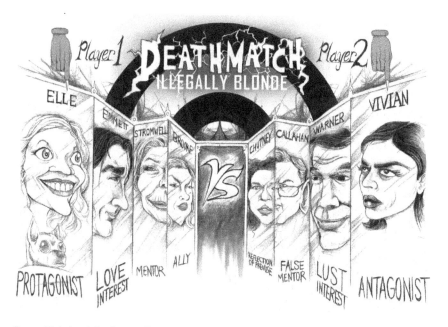

Figure 12.1 Jacob Redmon –The hall of mirrors where every character in the story reflects meaning and purpose. *Legally Blonde* (MGM) did this with extraordinary clarity, using all of the major character types to accomplish the task.

> "Everyone and everything that shows up in our life is a reflection of something that is happening inside of us."
>
> – Alan Cohen

I have contradicted a lot of the conventional wisdom regarding character creation, which will lead to my theory on minor characters before I recap the five major character types. Questioning and reconceptualizing maxims do not make me right

or anyone else wrong. What the story gurus teach is always in my mind as I make tough choices to subvert those teachings when doing so best suits my storytelling needs. In the end, you may disagree with me, and that's cool.

Plutarch wrote, "The mind is not a vessel to be filled but a fire to be kindled." So let's explore and consider my rebellious notions on character from that perspective. In the years since studying screenwriting in college, my personal outlook on character types has veered slightly away from the traditional classifications I was taught in several ways. Here are a few examples. Some traditional teachings of major character types suggest:

1 A protagonist is always the central character of the film.
2 A love interest has to be a romantic relationship with the central character.
3 Characters cannot serve more than a single character type at a time.
4 Only one character is designed per character type.
5 Minor characters do not have to serve a singular, specific purpose.

I disagree with all of these teachings.

I'll quickly review these out-of-the-box points below. It ends with my expansion into minor characters because one realization leads to another. This chain of realizations leads to the culmination opinion (or wide-shot perspective) on how this WGA writer always imagines all characters, from biggest to smallest. Let's go. through it, starting with the common character rules I'd like to dispel.

Protagonists are always the central character of a film

There's a common misconception that the protagonist must always be the central character of a screenplay. *Protagonist* is not synonymous with *central character* as much as most teachers and industry professionals preach this maxim. The central character is the script's dominant character that a film follows. He or she functions as the eyes through which the audience sees the story. Meanwhile, the protagonist is the character who is designed to arc (change) – successfully or not – over the course of the movie. Those are two, very different things. Now, the protagonist is the central character most of the time, and that is the most common and widely accepted method of storytelling in Hollywood. That said, there are plenty of examples of successful films that do otherwise.

Keeping this concept simple, we can see that mentors have often been central characters in films. For example, we can see that *Back to the Future* and *Stand and Deliver* have central characters that inspire others to arc instead. In *Braveheart*, Robert the Bruce is the protagonist with the full-blown character arc, whereas William Wallace serves as the mentor and central character. The title character of the movie *Mary Poppins* mentors Mr. Banks to value family and life more than money.

The central character can be the love interest as well. In Disney's *Beauty and the Beast*, the story is told from the perspective of Belle, a wide-eyed girl from

a small village. She loves to read great, escapist stories, and then she winds up in one of her own. It's Belle's perspective that the story follows. Meanwhile, the Beast is the protagonist that undergoes a major character arc.

A love interest has to be the object of the central character's romantic affections

Some people superficially define a love interest as the object of romantic desire for a character. That's not how I define this character type. Every character serves a specific, deeper purpose in telling the story. Antagonists oppose an outer journey, allies support one, and love interests inspire the protagonist to achieve the desired character arc. Love is the one thing that has the power to change people. Now, romance clearly is one of the best and most satisfying ways to inspire a protagonist to grow, but it's certainly not the only way.

A great example of this is the comedy *Twins*. Vincent, the protagonist, has a romantic character in his life that he's constantly letting down, but it's Julius, his brother, who helps Vincent change his selfish ways. Meanwhile, Linda, the romantic character, serves as an ally that echoes how strong a sibling relationship can be if Vincent would only have a little faith in people.

In *Spy Kids*, love for the kidnapped parents inspires two children to transform from bickering siblings into a team of super-spies learning how to work together. The love interest is the premise-defined character who leads the protagonist to proving the premise as he or she arcs with its realization. This character does not have to be in a sexually based relationship, and in some movies (such as family films with a child protagonist) a romantic character wouldn't necessarily be appropriate. Love from family members and the dearest of friends or brothers in arms can also inspire people to change.

Each character serves one specific character type at a time

Some screenwriting gurus declare each character in a script can serve only one purpose at a time. They insist there is only one protagonist, one antagonist, one love interest, and one mentor or ally. These gurus delineate these characters into small, specific microcosms. When you are learning the craft of screenwriting, it's important to make sure that each character type's purpose is being fulfilled by some role in the script. This fulfillment of purpose is crucial for telling a fleshed out story. I understand that it's smart to "plot" a script with a specific character for each purpose, covering the bases. This allows the writer to explore every aspect of effective storytelling and presentation during the process of generating the script.

The gurus are half right. Young writers need to learn to crawl before they walk, then walk before they run. Therefore, teachers train these newbies to color inside the lines and to master form and function. That said, sometimes these great teachers draw those lines in the sand a bit too thick for me. They say there is no overlap.

I disagree. A skilled artist blends colors and makes the lines disappear. In the same way, a great writer should make every character count. A writer may design with one character type in mind to make sure that base is well covered, but the writer has to let the character breathe and be who he or she is. That leads to character-type overlap. Characters take on a life as individual as human fingerprints. You can't force a character to stay in his or her lane when that would be out of character.

Even character purists contradict their own edict of one type per character in a script when confronted with characters that fulfill more than one category. They call the character that serves more than one type a *shapeshifter*. The shapeshifter is a caveat to the rule that a character only serves one purpose at a time. For example, in Alfred Hitchcock's 1960 classic thriller, *Psycho*, Norman Bates is a love interest who reveals himself as a peeping lust interest who spirals into becoming the protagonist with an antagonist lurking inside of him. Throughout these changes, it's true that this character is never more than one type at a time.

That said, just because a character serves one type and changes in the middle of the story, it's not true that a character never serves more than one purpose at a time. We will begin our little rebellious declassification regarding the singularity of one character type at a time with some examples.

Look at the character of Wyldstyle in *The Lego Movie*. She constantly pushes Emmet to be a better man, more courageous; won't be romantic with him until he arcs (which holds his feet to the fire); and is the model of a hero, which is Emmet's character arc. If you look at all that she does, she clearly serves the purposes of both ally/mentor character and love interest throughout the film. She's not even shapeshifting; she's constantly both of those things.

In the classic comedy *Twins*, Vincent is the protagonist with a solid character arc, and his ally as well as the person who inspires him to change his ways is Julius, his brother. Yes, they each have other romantic relationships in the film, but it's only the love of his brother that changes Vincent in ways Linda never could. Julius teaches Vincent the meaning of family, without which Vincent would never be able to have a successful relationship with Linda.

Characters can serve more than a single purpose. Go watch the slow-burning classic 1982 thriller *Deathtrap* and see those characters overlap and shapeshift to serve multiple purposes: protagonist, antagonist, and love interest.

St. Elmo's Fire features an ensemble cast of characters who are coming of age, bridging the gap between college and adulthood, each being arcing protagonists, allies, and love interests simultaneously. The characters all share an arc of learning to take action after a lifetime of sitting in school, talking about things, and following others' lead. They also inspire one another's character arcs as any good love interest does. Simultaneously, each one is an ally of the other's outer journey to take life by the horns and grow up. Ensemble films are so rarely written well because characters often pull double and triple duty. This is a tremendous amount of character work to orchestrate while keeping each character clear and unique.

Some writers have a hard enough time sculpting one protagonist's character arc in two hours, while *St. Elmo's Fire* juggles seven of them. Kirby and Kevin

both have to grow the courage and bite the bullet to get the attention of the women they love. Reflecting one another, Billy and Jules both have to stop hiding from responsibility through hiding in their vices. Wendy needs to stop holding on so tight and cast herself away from everything that keeps her from being free. Leslie needs to pull her head out of her ass and see Alec for who he is, while Alec needs to realize you can't be a selfish prick and expect those you love to sit around and take abuse. Such abuse will cost you. Each character addresses the core premise, and all seven of them face reality and have a clear character arc. I use the seven protagonists of *St. Elmo's Fire* as an example for my next argument.

Scripts are designed with only one character per character type

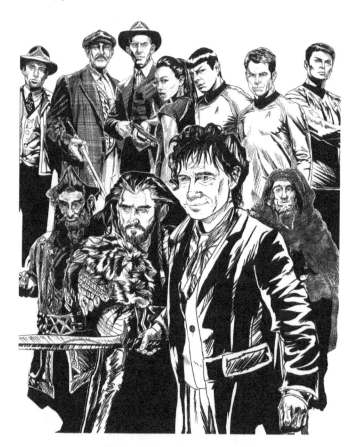

Figure 12.2 Matt Mitchell – Whether fighting crime, exploring deep space, or taking an epic fantasy adventure across Middle-earth, some missions require a lot of backup.

Character credits: *The Untouchables* (Paramount Pictures); *Star Trek* (Paramount Pictures); *The Hobbit* (MGM, New Line Cinema, Warner Brothers)

If you look back at the previous chapter on allies, movies like *Legally Blonde* prove the inverse as well. Multiple characters can serve a single purpose. Elle has a fleet of allies, including law students, gal pals, and professors. In fact, this tool of having several characters serve one purpose works exceptionally well in crime thrillers, fantasy, or superhero-team movies such as *The Hobbit, Star Trek, The Untouchables, The Usual Suspects*, or *The Avengers*. These casts illustrate that it takes a slew of different yet equal characters all reflecting one another to accomplish a task. Everyone on the team is an ally, holding one another's feet to the proverbial fire. Harry Potter has Dumbledore's Army in *Harry Potter and the Order of the Phoenix* and the Beast in *Beauty and the Beast* has a castle full of allies all supporting his outer journey to break the curse that haunts them all. So, as we face the fact that multiple characters can service a single purpose, and vice versa, the fabric of previously constructed rules and delineations continues to unravel.

This unraveling brings us back to each of the major character types and the fact that there can often be more than one of each. As I have explained, there are two types of mentors (a true and false one), two kinds of love interests (the other being a lust interest), hero and antihero, antagonists with and without a consciousness (disaster films, for example), and, without me having to explain it, we know antagonists have their own allies fighting the protagonist's outer journey instead of assisting it.

We have explored all the *major* character types, but antagonist allies allow us to devolve into exploring all *minor* characters. This leads me to my last common character belief I wish to disprove.

Minor characters do not have to serve a specific purpose

Michael Hague teaches how allies are a type of reflection of the protagonist. I'd like to take that concept a huge step further. Just as some characters reflect the protagonist, I believe all characters throughout a script, big or small, should reflect the premise and must partake somehow in all the arguments for or against it. Let's not forget that when we look in the mirror at a reflection, what we see is not only the same, but it is also the reverse. What's right is left, and what's left is right. The image is inverted. So, let's start with major characters and work our way toward minor characters.

Though Vivian Kensington is Elle's antagonist for her outer journey to marry Warner and does not start the film as an ally to Elle in *Legally Blonde*, they begin to work together on the Brooke Windham case. Vivian reflects how Elle would like to be treated, but they are polar opposites. Elle is a spunky, fun, super-positive, pink-obsessed blonde who sprays her pink resumes with perfume and keeps company with sparkly, loud gal pals from L.A. Vivian is a snooty, driven, prepared, conservatively dressed, super-serious, raven-haired, legacy, blue-blood, Harvard law freshman. As a result, Vivian is taken seriously and has even usurped the affections of the ex-boyfriend for whom Elle changed her entire life and applied

to Harvard in order to win back. In short, Vivian embodies everything an uninformed outsider might think an Ivy League law student is supposed to be; yet Elle can never and will never be like Vivian because it's not who Elle is (just as all reflection characters and allies should be different). This pair is antagonistic, yet Vivian is a reflection of Elle's growing career aspirations. So, the question becomes, "Can Elle achieve everything Vivian has, or will Elle's immeasurable optimism, love, and dreams not be enough to help her rise above the trials she must endure just because she's different?" Vivian Kensington is both antagonist and the reflection of everything Elle thinks she wants to be at the end of act 1 in *Legally Blonde*. This is a great example of how an antagonist and protagonist may reflect one another.

The trait of well-designed allies to mirror the possibilities, potentials, and pitfalls for the protagonist is something all characters can do for all sides of the premise argument. Let's discuss a couple of classic science-fiction cinematic examples. Allies can shapeshift into antagonistic characters or the reverse, reflecting which side of the premise these characters come down on as the story unfolds. Francis in the sci-fi classic *Logan's Run* starts as an ally and partner before he becomes the antagonist. Meanwhile, in the *Star Wars* saga, Darth Vader shapeshifts in *Return of the Jedi* from antagonist into a reflection character of Luke's potential fate as the Emperor takes over as the antagonist. In the end, Luke proves to be this most legendary baddie's inspiration for conversion, inspiring the former Jedi back into a good guy and ally. Through exploration of how premise affects the characters, it allows them to start off or end up being good or evil (aligned on either side of the premise the writer is trying to prove, whether for or against the protagonist).

If you have ever made a photocopy of a photocopy, the image loses a degree of clarity. It can be like a game of grapevine or telephone. Differences and dissonance develop in the details. In a script, this development happens because the protagonist is a reflection of the script's premise through a character arc. Then the antagonist, love interest, and mentor each reflect a different side of the protagonist's inner and outer journeys to force clarity on what is being learned by the protagonist (which is the premise). Then, like when a mirror faces another mirror, there are reflections upon these reflections, such as the false mentor to a true mentor and a lust interest to a love interest. Well, antagonists have them, too.

I am now circling back to the antagonist chapter as promised. It's time to define the secondary antagonistic forces I mentioned that I would classify. Examples include Dr. Jonas Miller in *Twister* or any enforcer antithetical to the protagonist's mission or arc, like Ash in *Alien*, Carter Burke in *Aliens*, Bane in *The Dark Knight Rises*, Ogre in *Revenge of the Nerds*, Crispin Glover's character Thin Man in the film adaptation of *Charlie's Angels*, Laugher in *American Ultra*, and Draco Malfoy in *Harry Potter*. These characters reflect and oppose protagonists. They are not the antagonists, but, instead, reflections of arguments against the premise and belief system the protagonist is fighting to achieve with his or her character arc. You see this in video games when there's one antagonist, but the player has to defeat other unique characters that guard various levels. These characters all

support an antithetical side of the premise from the protagonist, each serving as individual echoes in an enclosed story that serves as a powerful, reverberating echo chamber, all amounting to proving one clear thing.

This discussion brings us to a grand and visual climax for these chapters on character types. So, if you can write a film in which multiple characters can fall into each of the character types, why would you write a character that doesn't support the premise? The character types are about assigning characters a purpose, and every character should serve a purpose. In a truly great script, every single character can and should reflect the premise in some tiny way. Therefore . . .

All the characters together create a giant hall of mirrors

Everyone reflects everyone, and every character, in some way or another, reflects the premise, whether he or she shares the belief system the premise is trying to prove or the opposite. After all, it stands to reason that each character must serve a purpose in the story. Otherwise, that character has no business being in the script.

To explain this point in a visual (as we screenwriters are prone to do), imagine standing in a bathroom facing a large mirror over the sink, looking at yourself. Now, on the wall to your left is a medicine cabinet with a mirrored door. When you open it, the cabinet mirror faces the large mirror over the sink. What happens when you look at the mirrors in this position is an endless tunnel of reflections in either direction. The larger mirror in front of the sink is the premise of your story at the center of everything. The medicine cabinet mirror surface is the protagonist, who directly reflects the premise. All the subsequent reflections back and forth between them, big and small, reflect those two fundamental surfaces, and those reflections are the other characters within the script.

So, if the medicine cabinet mirror is the protagonist, the reflections inside that mirror going back into infinity include the love interest, mentor, and allies. When you look on the big premise-mirror reverse side of things (clearly on the opposite side of the premise, the opposite side of the protagonist), you see the antagonist. Behind the antagonist are the further reflections of that and other opposing belief systems (i.e., lust interest, false mentors, henchmen, bounty hunters, an army of undead monsters, Death Eaters, etc.). Every character in the script reflects those two major surfaces, and each parallel image represents a perspective on the premise being explored.

Therefore, this provides even minor characters a purpose far broader than other story theorists and analysts have ever stated. The echo characters in this echo chamber are expansive and all-inclusive. If every scene is about your premise (as it should be), every character has a place in telling and experiencing that core of your story. This means every character does serve a purpose, and every character given a name in a script should be some form of thematic reflection or echo character.

This character theory is most evident in ensemble films. For example, in *The Big Short*, the film not only has a central protagonist in Mark Baum, but it also has a reflection protagonist in Charlie Geller, who reads the same report as Mark Baum and takes action in his own way. Meanwhile, Charlie has his own supporting characters with an ally, Jamie Shipley, and a separate mentor, Ben Rickert. All the film's characters revolve around the singular, painful premise that the bubble of lies created by the rich to get richer will burst, but the common man still pays the price. It was no surprise to me that a film using echo characters large and small throughout the script won the 2016 Academy Award for Best Adapted Screenplay.

Therefore, not only is every *Enterprise* crewman and red shirt–wearing member of the away team in *Star Trek* a reflection character (a protagonist ally illustrating the importance and high stakes of every mission), so are the characters they fight against (whether the main antagonist or their henchmen). Characters working for whatever antagonistic force that exists in any script reflect the villain's belief system, which is the antithetical reflection of the script's premise and protagonist's journeys. This exemplifies my hall of mirrors analogy.

In *Unbreakable*, the antithetical concept of fragility versus indestructibility in the form of David versus Elijah illustrates perfectly how protagonist and antagonist are a form of reflection, which is the inverse of the other. Notice how almost every major character type comments on the struggle between identity and potential in *The Incredibles*, from Frozone to Syndrome in the same reflective dynamic. Tai Lung was originally trained to be the Dragon Warrior by Shifu in *Kung Fu Panda*. The same but in reverse, it's a trip to Bizaaro World if you're a DC Comics fan. *The Shining*'s REDRUM and MURDER keep flashing in my head.

All characters reflect in some way the premise, the hero's journey, their goals, and the opposing belief system on which you base your story. Design even the smallest roles with premise in mind; think about how they comment on that hypothesis. Create well-thought-out characters for actors, regardless of your script's cast size. Think about how the polished and affected art-gallery employee Serge in *Beverly Hills Cop* is the epitome of opposites to Axel Foley, the gritty, broke, screw-the-rules Detroit cop. Serge illustrates the dichotomy of Axel's arrival to this flashy town, drawing attention to the classic fish-out-of-water scenario. It's the total inversion or reverse perspective of lifestyles of these characters that make that interaction so incredibly memorable and amusing.

So, to make a long story short, every character, from the protagonist of any screenplay right down to the tiniest of roles, like in *Get Shorty* (Bones' Buddy #2 on IMDb or Escobar's Bodyguard #2 in the film's actual credits), always reflects the premise. If you know the 1995 film *Get Shorty*, the metaphor of this reflection will surprise you if you look it up. If a character does not reflect the premise, the character should be one of three things:

- Removed.
- Given a purpose.
- Combined with another character that actually has a purpose.

Be sure that every part serves a purpose engaging in the argument over premise or facilitating how other characters do. I hope this philosophy helps you to create meatier characters and elevate the quality of the roles you sculpt. *Casablanca* does this brilliantly with minor characters, like the young couple trying to escape and even the patrons at Rick's taking sides when the anthems are played in his club. It's meticulous effort to make even minor characters important and meaningful, which has to be one of the many reasons why *Casablanca* was voted by the WGA membership as the best screenplay ever written.

Sadly, some screenwriters write whatever comes to mind, filling necessary gaps with vapid, willy-nilly, and purposeless characters to move the story along instead of taking the time to give minor characters real meaning. Some stick to the rules they read about, and they don't find the cracks in the walls that give characters texture. Writers should heed Stanislavski's (1936) advice given to actors that there are no small parts, only small actors. The same can be said for writing small roles. Just as great actors can breathe life into small roles, you, too, can make something out of a small part. This doesn't mean give small characters more script space; it just means do more with the little amount of space the character needs. Let these characters reflect the message of the script in some small way. This can be done by augmenting the location or situation or simply giving the character some personality.

Every character in the script reflects some aspect of the hero's journey, which is why mirrors are used to such powerful effect in so many films. In *Enter the Dragon*, the protagonist slowly makes gestures and takes actions that insinuate that he cannot be a mindless fighting contestant to the pleasure of a madman, even if he was born and built to play that game. He eventually becomes the revolutionary inside this ultimate fighting competition prison camp for the title of best in the world. He's surrounded by reflections, brutal combatants from around the world. The climactic fight sequence leads to a final showdown in a hall of mirrors. It can be said that Bruce Lee is literally in a fight with many images of himself all around. The challenge is to be the champion and liberator he's known he should have been during the entire film.

Every protagonist in a well-written climax is in a battle with the self against his or her inverse, reverse, opposite self (use whatever term you wish that is symbolically a mirror) in the climax of any film in order to earn the label hero by achieving his or her character arc. This is why antagonists so often say to the protagonist at some point in the film, "We're the same." On a smaller scale, every character in a movie is one of those reflections, surrounding and inhabiting the premise and protagonist.

The questions

- How might atmosphere characters (background/minor roles) act to serve the premise?
- What can reflection/echo characters do to illustrate opposing opinions to your premise?

- Within the five major character types, who might surprise the reader and switch types?
- How would two unique secondary antagonistic forces refute the premise and serve the antagonist's needs?
- What is each major character type's relationship with the premise?

The five major character types wrap-up

The "purpose" of these character types is to help inspire writers to think long and hard about the tasks of each role they create, remembering to consider what each type of character is designed to do in a well-constructed screenplay. Each purpose satisfies certain requirements in the telling of any given story, providing deeper meaning. As we wrap up this final chapter on the major character purposes that all writers should understand and know how to formulate, let's summarize:

1 The protagonist is designed as a statement in direct correlation to the writer's premise for the story with a big character arc (a transformative inner journey). That character arc proves the writer's point, be his or her fate happy or tragic.
2 The antagonist personifies the strongest possible argument against the protagonist and premise (often representing a popular belief that the writer wishes to argue against). This force is the chief obstacle to the protagonist's success.
3 The love interest comments on and challenges the protagonist into completing the inner journey and character arc. Due to a deeply emotional connection with the central character, only love has the truly transformative power to change a person.
4 The mentor is a personification of the protagonist's outer journey (the external mission), serving as a role model and teacher.
5 The allies mirror the protagonist's outer journey as a constant reminder of the value and stakes in the story. There characters *reflect* the possibilities of the protagonist as an ally or as premise counterarguments.

Meanwhile, all characters echo or facilitate an argument regarding the premise in some respect, even if they are not on the writer's side of the script's ideology/hypothesis.

Remember, as you lock down the details mentioned for each of the five character types in your story, each of the supporting or conflicting characters should be proactive with external goals/mission. They are not simply trying to fulfill their character type's designed mission, doing something for or to someone else because the plot says so. No character should read as strictly reactive to serve the plot or character. In short, don't just describe them as doing their job in that character type. Make sure you give each one a personal reason/goal, that, in turn, happens to affect the protagonist in the required way, which makes them realistic and not just a writer's fabricated, one-dimensional, plot-serving apparatus.

The house of cards

In this story-building process every element of the foundation leans upon another to hold all elements in place. Genre tells everyone how the premise will look and feel before it's cracked in half and examined through two journeys. The inner journey illustrates how the premise is true, convincing the protagonist so thoroughly that he or she changes. The outer journey provides the mission during which that inner journey gets explored and realized. We have mentors who educate the protagonist about how to succeed in an outer journey. Protagonist allies question and support the outer journey. Antagonists fight against the outer journey. If the outer journey isn't clear, none of those characters can be properly designed. Meanwhile, the love interest is inspiring the protagonist's inner journey. Everything supports something else.

If you pull one thing out, something will be missed. Foundation stones crumble. If you do not get the journeys right, it's impossible for all the supporting characters to do what they are designed to do. These elements and characters all weave together like a perfect lattice, and an audience notices when a story is exceptionally well thought through and told. That's what this story-building process provides me. This is my foundation work before I have to worry about the minutia of plotting the moment-by-moment execution of story.

This complex layering explains why I am a bit amazed by writers who just start writing and don't outline. It's impossible if a writer were to attempt to do all of this via reverse engineering once a story is written (not to mention a huge detour). I neither praise nor condemn those who choose to write that way. Some writers simply need to feel their way; every artist has a method that works for him or her. Sometimes something that's organic and interesting is a far better read than something that's exceptionally well plotted. Writing freestyle and without a net has its benefits because meticulous plotting can become obvious, predictable and, as a result, boring. Therein lies the challenge of script execution. Making the well plotted unfold in an unpredictable way is a different skillset altogether, and some "planners" don't have that talent.

I can't help but wonder if the great make-it-up-as-you-go writers would have the best of both worlds if they did the preliminary conceptual work. In short, these techniques should help the freestyle writer as well, whether they are taken into consideration before writing the first draft or afterward while editing.

Going beyond character

So far, we haven't outlined anything. We've simply explored options and given characters meaning. Maybe you will start to see characters in a new light. Sometimes one character can serve a single purpose or multiple purposes, and at other times multiple characters can serve a single purpose. If it were cookie-cutter every time, stories would lack individuality, and the final result would be far too formulaic and predictable to engage an audience. I think it's "in-the-box" thinking that is a significant problem with many movies being made today in Hollywood.

It's important for writers to understand these character types, the purpose each serves in telling the story, the proper design of them, and their function. These points are crucial to designing an effective cast of characters that will make your premise and story fully realized.

In conclusion, whenever I write a script, I go through a diligent outlining process, and a key component of sculpting any plot is the classification and assigning of the roles each character will play in the unfolding and execution of the story. The five major purposes provide perspective, flavor, and shape to the story I intend to tell. Each purpose has a job to do. All five roles are integral to telling a story well, and I hope this breakdown helps you better define the qualities and purpose of those characters in your stories.

Exercise 12

Assemble the five major characters for your story and describe the following:

1 Protagonist's inner and outer journey
2 Antagonist's goal
3 How the love interest inspires the character arc
4 How the mentor instructs the protagonist for the outer journey
5 How the ally exemplifies stakes and helps the protagonist with the outer journey

These character-defining statements should be written as follows:

* The protagonist's inner journey goes from _____ (*single-word character flaw/personality trait*) to _____ (*single-word cure for the flaw, an opposite behavioral trait*).
* The protagonist's outer journey is to accomplish _____ (*a mission with an exceptionally clear, specific, visual, 100% physical finish line for the outer journey*).
* The antagonist's goal is to _____ (*a specific, measurable accomplishment*), which makes the protagonist's outer journey to _____ (*write the specific outer journey here*) impossible to achieve.
* The love interest inspires the protagonist to become _____ (*cure of the inner journey*) by _____ (*three specific examples on how the love interest inspires the protagonist to achieve his or her arc through action – not just saying to do it*).
* The mentor teaches/trains the protagonist how to _____ (*three specific physical actions*), without which the protagonist cannot accomplish _____ (*the protagonist's outer journey*).
* The ally provides backup for or reflects the outer journey to _____ (*state the outer journey here*) by _____ (*list three specific ways in which this character supports and takes action*).

These sentences should contain no more nor less information than stated above.

Qualifiers

- Everything should be clear, easy to understand, and literal. Everything needs to make perfectly logical sense, succinctly defining these characters.
- There should be no vagueness or generalizations in what is being done or how it affects the story. A writer needs to be specific with what actions these characters are doing that illustrate this specific character fulfilling his or her duty in the script in relation to the protagonist's journeys and premise.

It should be clear that all character types tether together to present all perspectives on a single premise through their roles and duties as their major character type. All characters fit the different sides of the premise and suit the genre. These major character types are 100% interconnected. This is the house of cards:

- Premise is the strongly worded opinion/hypothesis (with a strong counterargument) being proven by the script. The premise inspires every character because they all play a part in arguing this opinion.
- The protagonist's inner journey proves the premise.
- The love interest's actions inspire the inner journey.
- The protagonist's outer journey is a situation/mission that inspires a character to have an inner journey, which proves the premise.
- The antagonist's goal conflicts with the protagonist's outer journey and has a perspective that is a common misconception about the truth regarding the premise.
- The love interest participates in the outer journey, whether he or she is an ally or not.
- The mentor is a special type of ally that teaches the protagonist how to succeed in the outer journey.
- The run-of-the-mill ally is the one that holds the protagonist's feet to the proverbial fire during the outer journey and serves as an example as to what the outer journey might result in if the protagonist succeeds/fails.
- The characters should all fit the genre so the story reads like a cohesive narrative.
- All characters express a perspective for or against the premise through action.

Make sure your characters overlap and serve one another in the above stated ways.

With all of the supporting characters, be sure to state more than what they are doing. We all know these supporting characters are satisfying a purpose relating to the protagonist's outer or inner journey. You must also include *how* they specifically will do those things. This means we want these supporting characters to do more than advising, encouraging, threatening, or cajoling here. That's just hot air. You need to state how they are doing those things physically when writing for a visual medium.

The best-designed supporting characters will fulfill their characters' purposes through their actions, not just by telling the protagonist what to or not to do in

dialogue. That would be too on the nose. What do those characters physically do? What actions do they take? In short, this calls for visuals because film is a visual medium. So, you don't just tell us what they do; show us how they are going to do it. Yes, this is an example of putting to use the old adage, "Show, don't tell."

Those actions should reflect and befit the genre you selected, which will help define who these characters are.

Disqualification

For the outer journey and all supporting characters, don't make the character breakdowns about what the characters say or think. It's not what they say; it's what they do that matters. In visual mediums, stories are about how characters take action.

Act 3

Culmination

Some assembly required

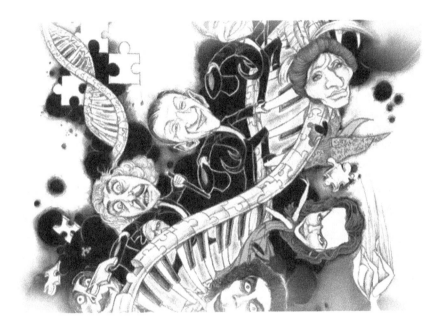

Figure 13.1 Jacob Redmon – Putting all the pieces of story DNA seamlessly together is like the choreography one can only find in musicals and musical numbers that stick with us our whole lives, whether they're classics like *Hello, Dolly!* (20th Century Fox), *Top Hat* (RKO Radio Pictures), *Singing in the Rain* (MGM), *Cabaret* (Allied Artists Pictures), *Moulin Rouge!* (20th Century Fox), the offbeat cult classic *The Rocky Horror Picture Show* (20th Century Fox), or Frankenstein and The Monster "Puttin' on the Ritz" in *Young Frankenstein* (20th Century Fox).

Now we add up all we have created and ensure that all the elements fit together like the pieces of an assembled puzzle. The structure of predesigning a story starts at a single point (premise) and divides into two paths when it reaches the

protagonist. Those paths are the protagonist's two journeys: inner and outer. Though these roles are related, the character types are divided into jobs that assist on one of these two roads. Then all these ideas come back together to create a singular story.

The premise is the basis for the inner journey of the protagonist (the character arc). The writer proves his or her premise when the protagonist's experiences throughout the story have permanently changed the personality and belief system of the protagonist with his or her compelling cinematic argument. The love interest is the character who is the chief influence in giving the protagonist the deepest desire to change, for love can get someone to change his or her ways. Meanwhile, the antagonist is the strongest possible counterargument to the premise, usually a common misconception. That common misconception is probably the reason the writer feels so compelled to tell this story, and the writer wants to explain to the world why they've got it wrong. Sometimes, the boldest of writers are trying to change the world, and the character arc is representative of how the writer wants to see the world change.

The outer journey stems from what must be a physical accomplishment (goal or mission) that the protagonist sets out to achieve (traditionally at the end of the first act, a quarter of the way into the story), and he or she can only be successful if the protagonist fulfills the character arc. This physical task is arduous and personifies exactly why the protagonist needs to grow or change. To make sure that this second path is not easy and exceptionally clear to the viewer, we populate it with characters who oppose it (the antagonist) and those who explore how he or she might succeed or fail, which is why we have mentors, allies, and other reflection characters. Every major character has a job to do in one of these two major journeys. Once the characters' paths are plotted, the elements all converge once more and join to form one story.

I see all of the aspects of concept creation that lead to this chapter as a strand of DNA. When staring at it from any one side, it almost looks like a chain. Now, look at the DNA equivalent of a single link in that chain. It's a spiraling ladder. The two sides of this ladder are the inner and outer journey.

While a story is in the conceptual designing phase, genre is the glue (hydrogen bond) that binds the pieces together. Genre keeps these characters and ideas moving as one so they don't writhe and wiggle out into oblivion without guidance. Genre keeps them tethered together in one reality. It's the fabric that runs between the two journeys. The lining up of these elements, including the characters and their duties, assures the writer that he or she has figured out the singular, main story of the screenplay – a single-story DNA strand. Now that we have done all of this, you have the sequencing you need to create a screenplay concept that can be shaped into a well-structured story because you have a strong idea with all of the major elements and perspectives needed to construct it.

The questions

Now that you have designed a character for his or her functionality, it's time to use that functionality to inform character personality. A lot of young writers go nuts imagining what a character keeps in his or her refrigerator, thinking about what the character likes to wear, and determining the height, weight, hair color, and other physical features of the character. Personally, I don't find this kind of work helpful, but each writer thinks differently.

As is the case with story creation, I believe in always working from the inside out. Story stems from premise, and character stems from something deeper as well. Put each character's purpose in the story under a microscope. Ask why the character behaves as he or she does and why that behavior began so that the characters stop looking like they were designed to serve a purpose and start feeling like flesh and blood, born to contribute to the plot in the way that they do.

- What is each character's goal? What do the characters want as the deepest desire of the heart? You can ask this question of supporting characters as well. What are they trying to accomplish that serves the protagonist's journeys in the way that it does?
- Why does the character want that goal? What's motivating the character? What reward is the character hoping to achieve by fighting the fight?
- We don't want our story's setups leading to predictable payoffs for the main characters. That outcome would be boring. Therefore, great writers ask themselves how the character's hopeful (projected) outcome differs from the actual reward that the character receives for facing his or her flaws and fears, whether the character triumphs or fails?
- What are the conflicts for the character in pursuing his or her goal? What's standing in that character's way of getting it? What are the potential ultimate challenges, setbacks, and difficult situations? What needs to be overcome? Where and when would be the worst places these disparaging moments could happen?
- How will triumph in the final analysis satisfy the character? What does it mean if triumph is achieved?
- Like steel and blown glass, the characters' personalities are forged by fire. What doesn't kill you makes you stronger. We ask for the source of each character's probing pain. The origin of the pain reveals the trials, tests, and traumas that make each character the flawed person he or she is upon entering the world of our story. Traumas are especially important because they are the foundation of personal flaws. What was each character's defining trauma?

- Each character's personal history has some success, which led to the pursuit of skills that a character uses to compensate for his or her personality flaw. For every trauma-based character flaw, there is a skill the protagonist has developed to make up for that flaw. For example, if someone is a coward, he or she becomes adept at laying low. What success fueled the realization and exploitation of each character's greatest skill?

These are all things a writer can ask once the characters' purposes have been sorted and form the interlocking chain of your story. I review my visualizations and brainstorm lists while answering these questions because everything overlaps and feeds into everything else. It's all connected. You may come up with your own questions, but I find these to be a great start. They help me explore the possibilities of situations for any story.

Lastly, I ask myself one final question that must kick off the third act of this book. Each act starts with a major question:

Act 1: Who is the writer?
Act 2: Who is the hero?
Act 3: Who is the central character?

We've figured out who's telling the story and how the writer is telling it in act 1. Act 2 explores the characters that will give the writer a voice. Now, in the third and final act, we must ask the question that sets us on the journey to conceptualizing our cinematic story:

Which character has the most exciting circumstances while providing the best perspective from which to see and understand the protagonist's character arc?

It is most often the protagonist with the character arc. You should know that some people might disagree with your choice if you chose anyone except the protagonist, but it is still a choice. Once you know whose point of view the script will follow, you're ready to build the story.

Now, before you do any of that, let's finalize the character list and the functions of those characters.

Exercise 13

You'll notice that the lists of questions toward the end of most chapters, including this one, were not part of the exercises. This is where they come into play.

Clarify your answers to all those questions, starting in Chapter 1, and assemble them in order of dramatic escalation, the most powerful and dramatic being last. Layer them together and reveal things, constantly raising tension.

If you answered all the questions, you will have way more ideas than you can actually use in the screenplay. Some of them may not work with other ideas. Choices will need to be made.

Keep the best and cut the rest.

It will start to look like a story.

From concept to story

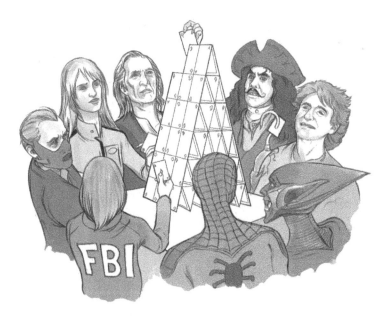

Figure 14.1 Paul Mendoza – All the characters work together to tell a story, no matter how opposite in personality or goal they are. Each character is unable to effectively fulfill his or her purpose without the other. Clarice Starling and Hannibal Lecter (*Silence of the Lambs*), Spider-Man and Green Goblin (*Spider-Man*, Columbia Pictures, Sony), The Bride and Bill (*Kill Bill Vol. 2*, Miramax, Walt Disney Studios), and Peter Pan and Captain James Hook (*Hook*, Columbia Pictures, Sony) all play a vital part, working together to build the house of cards for their stories.

"'Good story' means something worth telling that the world wants to hear. Finding this is your lonely task . . . But the love of a good story, of terrific characters and a world driven by your passion, courage, and creative gifts is still not enough. Your goal must be a good story well told."

<div align="right">—Robert McKee, Story: Style, Structure, Substance,
and the Principles of Screenwriting (2010)</div>

Up until this point, each chapter has been about working on individual pieces of a puzzle. This is where they all come together.

Once I've generated a meaningful premise, a specific genre, the brainstorming list, the protagonist's two major journeys, and the supporting characters, all of these elements congeal in my head, forming a series of big story moments. I add those ideas for scenes and sequences to the ever-growing brainstorm list of visual images and situations throughout every part of the development process I have written until now, including character creation.

A few small tricks

Listen to music

As I write, I sometimes listen to movie scores or classical music that fits the mood/tone/genre. Doing so frees up my mind and gets my imagination loose. I rarely use music with lyrics while I brainstorm.

Naming characters

I assign character names with the aid of a baby-naming book and online name searches. I never start two characters' names with the same letter, unless I am trying to draw an obvious parallel connection, like Tweedledee and Tweedledum. I make sure that the sounds of the letters in the name match the character's personality – hard, voiced consonants for hard-minded characters (with letters like B, K, D, Z); soft, airy ones for the more vulnerable, weak types (letters like S, P, F, H); names with a hum to them for someone smooth (L, M, N, V). The important point is to make these names sound how you want them to feel. I research what each name means in the baby-naming book I have at home and various websites. Though the names may change, at least to start, the meanings behind the names I pick are fitting.

Delving into character personalities

When contemplating potential character personalities, you can consider scouring these character-defining concepts for ideas:

1 Briggs-Myers
2 Chinese zodiac
3 Astrological signs
4 12 Greek archetypes
5 The four humors/humourism
6 Commedia dell'arte characters

This is just a character-brainstorming tool. These different ways of examining character might help you answer the three main questions about character behavior:

1 What's making the character's life difficult?
2 What's this character's approach to problem solving?
3 What is each character's worst nightmare scenario?

You can design characters' personalities to elicit the answers to these questions. Characters put each other into dreadful situations they are hoping to avoid. You can lean on each characters' flaws to provide angst for all the characters that surround him or her.

In short, whatever helps you clearly define your characters in definitive terms is a fabulous resource as you try to capitalize on characters with strong personalities and perspectives.

Moving forward

The protagonist's outer journey tells me the most basic aspect of the cinematic tale that will dominate the film's central conflict. As the ideas flourish under the umbrella of that knowledge, I go back and asterisk the big scenes and images that I feel might be impactful enough to fit the bill of my tale's major turning points. They develop into the structural tent poles of this story. I affectionately call them the, "Oh, crap" moments. That said, it isn't until I have a grasp of which beat has the magnitude to fulfill the heavy responsibility of the climax and end of the film that I am comfortable saying to myself, "Okay, it's time to bullseye this idea." That's when I am ready to organize all these parts into a singular story idea.

As we do that, first thing is first. Concept is king.

Concept versus story

The most successful spec scripts are what the industry calls *high concept*, meaning the story has a great hook. If writing and selling screenplays happens to be your endgame, then the writer thinks long and hard about creating ideas that fall into this classification. It's a situation that sounds crisp, clean, clear, entertaining, and singularly fresh to movie audiences in the way it's presented. You should be able to see the mass audience appeal of it with obvious storyline potential. For example:

• A cynical, prima donna weatherman gets trapped in an endless loop of one ridiculous, annual holiday, which is his least favorite of the year, and forced to relive that same day over and over until he finally learns to appreciate every day.
• A trailer park teenager masters a space fighter-pilot video game only to discover it's a test designed to search Earth for a great ace space pilot who can save the galaxy from the invasion of an evil alien armada.

- A habitually lying lawyer is magically cursed by his own son's birthday wish to tell the truth during the most important week of that lawyer's life and career.

That's *Groundhog Day, The Last Starfighter*, and *Liar Liar*. You can see these unique and specific ideas shine through in films throughout history, going back to films like *Some Like It Hot* to more modern classics like *Hook, Shakespeare in Love, Back to School, Jurassic Park*, and *Shrek*. Just the ideas in these tales get the reader thinking about all the different ways the story could go. In a marketplace dominated by remakes, sequels, and adaptations – all of which will be OWAs (open writing assignments) that go to writers with more experience – a newer writer stands a better chance by writing a high-concept spec to get in the door. So, where does a writer get this magical, uniquely original, yet seemingly universally attractive idea?

We go through the brainstorm list and look for a twist on something commonly known and combine it with what we want our story say. We just have to use our imaginations, which is what we do. For this summary, I'm going back to my chapter on genre visualization, and I'm going to look at the short list of sci-fi images toward the bottom. I'm looking at "vast emptiness" in "outer space." These elements remind me of the following philosophical question: given the endlessness of the universe, how can we possibly be alone? Yet, there is no major trace of any communicative extraterrestrial life form that we've been able to discover anywhere in our galaxy or beyond it. How is that set of circumstances possible? We inhabit one planet, and we've got junk floating around all over space, rovers we've left on Mars, flags on the moon, etc. It leads me to the inevitable question . . . Who is cleaning up after everyone else if we are not alone?

Writers have asked this janitorial question before in science-fiction stories like *The Hitchhiker's Guide to the Galaxy* and *Wall-E*. The big question is, "Can you tell this story in a totally unique way that is nothing like the way it's been done before?" Keep looking at your list of brainstorm images as you expand it. Two more words, "isolation" and "marooned," struck me from that list. What if a space janitor got marooned on our planet of hoarders, collectors, keepsakes, and tchotchkes? Real life is messy; right? It's like someone drops TV's Monk on Earth with no regard for any human's experiences. His idea of helping someone with a good deed would be criminal. This disconnection between Monk's universe and ours would make a great, typical fish-out-of-water themed journey. It obviously is about a person who learns the value of things, yet helps others by figuring out ways of not throwing out the baby with the bathwater. The protagonist's inner journey and outer journey become clear.

You design an antagonist to rival the protagonist's outer journey and probably have the same character flaw as the protagonist, only the antagonist won't change. You'll flesh out a love interest to inspire the inner journey. Design ideas for supporting characters as well, knowing full well that you may never use them in the script. This is about giving the premise shape, size, and definition, filling in the gaps.

Scour your brainstorm lists on premise and genre. Find elements that can serve as a spark for the concept of each premise. If your list isn't cutting it, watch movies, episodes, and professionals playing video games in the genre of your preference. Playing the video games would lead to diversion, but you can take notes while watching someone play. Stay on task. Comic books are a great source of imagery and inspiration. Write down what others have done, but don't stop there. Use those ideas as a visual springboard for new images and build upon them. If an idea is not coming to you, continue to brainstorm and review it again. Repeat this process until your idea crystallizes and can provide enough information to create a succinct story idea.

In the end, if this method simply isn't working, it may not be the right time for you to write this story. Hit the reboot button. Switch genres and start brainstorming images again. Eventually, you will have brainstorm imagery on a slew of genres, and you will be able to check them against premise ideas you have for multiple pairing options. This working method changes up all the visuals and tone. You can use each genre or premise repeatedly as you mix and match, depending on whether you are a one-genre writer or a truth-dedicated premise-inspired scribe.

Story

We will start by filling in these blanks to provide a nuts-and-bolts overview:

> (The tentative story title) **is about** (the central character's name) **who decides to** (set out on an outer journey that will change his or her life forever) **by** (how they intend to go about achieving that physical goal). **We will know** (central character) **has succeeded at the end of the movie when** (the protagonist, which may be the same character) **has** (achieved this specific inner journey and fulfilled the character arc).

The story doesn't have to be worded as a spicy pitch. You're just locking down an idea in simple words so that you have a clear picture of what you are going to write.

> *Back to School* **is about** a successful, middle-aged, corner-cutting owner of a successful chain of retail stores, **who decides to** inspire his son to give college a second chance **by** enrolling in the university himself as a student. **We will know** he **has succeeded at the end of the movie when** he has finally taken his own education seriously and learned to stop cutting corners.

For my sci-fi concept, a rough example would be:

> Godliness **is about** a meticulous neat-freak space janitor marooned on Earth, **who decides to** clean up our planet on every level **by** invading everyone's space for a thorough dematerialization of anything not needed for the basics

of human survival. **We will know** the space janitor **has succeeded at the end of the movie when** he or she **has** learned to respect that some people's trash is another person's treasures.

Now, I never show this fill-in-the-blank version of my story idea to anyone else. I am just putting my story idea into a form that proves to me that I have a movie idea that can be written. Once I figure that out, I combine this cookie-cutter story-at-a-glance with the genre, character, and all the brainstorming visuals to formulate a distinctive logline worth showing other people.

Exercise 14

Fill in the blanks to put your story into its simplest terms:

(The tentative story title) **is about** (the central character's name) **who decides to** (set out on an outer journey that will change his or her life forever) **by** (how they intend to go about achieving that physical goal). **We will know** (central character) **has succeeded at the end of the movie when** (the protagonist, which may be the same character) **has** (achieved this specific inner journey and fulfilled the character arc).

Loglines

Figure 15.1 Paul Mendoza – Creating the pitch-perfect sentence (or two) to get the interest of others and inspire confidence in your specific story idea.

"Get a good idea and stay with it. Dog it, and work at it until it's done right."
– Walt Disney

A logline is a marketing tool used to pitch the concept of your story by combining its distinctive, quantifying unique elements into a succinct and sellable idea. You will want to be specific, remain true to the soul of the project, and include no superfluous details. Scrutinize every word. This logline is what you will show people to represent your idea.

Loglines are a sales tool used by writers and their representatives designed to make producers and executives want to stop whatever they are doing and hear more about a script, regardless of the medium. Loglines are difficult for many writers because . . .

This is not storytelling; it's story selling

A writer can rewrite a logline a hundred times before he or she finds the version that is the most striking for his or her particular story.

Being overtly general or vague is a common mistake in executing a great, advanced logline. For example, the logline "The story of a man whose deceased wife continues to communicate with him after her death" leaves out way too much information. It could be an outrageous comedy, a tragic drama, or a supernatural horror story. A logline should give its reader a clear idea of what makes the story truly special. It must explain what makes this script worth reading when the potential buyers already have a stack of scripts on their desks to read.

Loglines pitch two things:

1 What the bulk of your awesome story is about
2 How the story achieves its ends

The logline should focus on what your protagonist is trying to accomplish for all of act 2. That's your story. It should not be just a bunch of setup or information from act 1.

It should all center on the point of view of the protagonist. Make the action proactive on the protagonist's part, not just reactive. A protagonist is not defined and made interesting because of what happens to him or her but, on the contrary, by the choices he or she makes in confrontation. Be sure to include the action they are taking (choices they are making), not just what happens *to* them. You do not want your "hero" to read as boring or passive. What the protagonist is *specifically* trying to do and what it may cost are important. For example, "they could lose it all" is way too vague and generic.

Writers need to set the stage of a large canvas to hook producers, studios, and audiences. Stories should have high stakes. An excellent story reveals something about the protagonist that makes him or her appear dynamic and worthy of taking time to watch. In short, the story plays a huge component in actually telling everyone who the character is through his or her actions.

You must show the genre, not tell it. Your word choice needs to illustrate the tone. Words like "battle," "fight," and "chase" will tell the reader you have an action story. "Gory," "haunted," and "torture" will show horror. "Outer space" and "teleportation" scream science fiction. "Cowboys," "outlaws," and "train robberies" indicate a western. You get the idea. *Show* the reader that you understand what goes into the genre you are writing.

A logline also contains a lot more than story; it gives the full tone of the story through its wording. The logline needs to accomplish three basic tasks:

1 Hook the reader's interest.
2 Tell the script's core concept.
3 Make the reader wonder how something cool like that will be told.

If your logline does not perform all those tasks, nobody is going to ask to read your script, and getting your script read is the first step to getting work as a writer.

What makes a logline?

There are many different logline formulas. Opinions vary on the best length for a well-written logline. Most believe it should be only one sentence. Some believe 15 words is the maximum length to make sure it's clearly high concept.

For me, these are my own personal rules and restrictions at this point in the writing process:

A logline should

1 Contain no more than 55 words.
2 Be no more than two sentences in length.
3 Be told from one perspective (that of the central character, usually the protagonist).
4 Contain one adjective that identifies the protagonist's character flaw when he or she is first mentioned. This adjective hints at the inner journey and character arc.
5 Contain one primary conflict/mission/goal (the protagonist's outer journey). If you know three-act structure well, this is what the central character sets out to accomplish at the end of act 1. This is the main story. The more difficult the task seems, considering the character flaw or the situation, the better.
6 Contain one antagonist (or antagonistic force).
7 Give the era (if not grounded in present day).
8 Give the setting, which often helps convey tone.
9 Deal with high stakes (traditionally death or love is on the line).
10 Convey with finesse the genre in the phrasing of the logline. This conveying is best done through verbs.
11 Should have some scope and size to it physically, historically, or emotionally, making it worthy of cinematic exploration.
12 Contain information that must be specific to your script and sell the person reading it on what makes your story *unique*.
13 Everything above must come together and make complete sense to the reader. This task is particularly difficult to achieve for supernatural, science-fiction, and fantasy films because these strange realities must be made clear. So, you

have more to do, and you get no extra space in which to do it. For example, you wouldn't just give the name of something in an alternative reality if nobody would know what it means. Therefore, avoid names in such situations. Instead of Planet Hoth in the Star Wars universe, a writer might just call it an ice planet.

Regarding that elusive requirement of uniqueness . . . It stands to reason that the concept and perspective of your script must sound fresh and original, or else the script will not give its reader any reason to read it. The work must be distinctive in order to goad executives or producers to take a gamble on less experienced scriptwriters.

Different theorists have different ways of combining these elements into a logline for your script. Just as there is no single recipe for a chicken dish, so is the case for loglines. The reason I make lists and brainstorm so much is because I do not believe in single-solution recipes. The best bet is to gather the information mentioned above and experiment. The most common order tends to be:

- Character flaw for the adjective
- Protagonist
- Outer journey
- Antagonist
- The global or personal stakes

The logline should never contain:

1 Clichés.
2 Questions.
3 Script titles.
4 Multiple storylines.
5 Supporting characters.
6 Anything vague or generic (nothing on the nose or obvious; for example, "a homicide detective must solve a murder" is not enough).
7 Character or plot backstory.
8 Passive phrasing like, "This is the story of . . ." Avoid passive verbs such as *has, is, are* as well as suffixes, including *–ed* and *–ing*.
9 Similarities to other films without something big and tangible that makes it a distinct story.
10 Genre names (the logline should make the genre clear to the reader without having to name it).
11 Exclamation points (because they come across as over-the-top, unless it's a whacky, heightened kids film).
12 A main conflict that sounds like it can all be accomplished in a single scene.
13 No errors in English mechanics, grammar, syntax, sentence structure, or punctuation. This pronouncement means that it always ends with a period, and there should be no confusing, unwieldy, or run-on sentences.

To touch more precisely on vagueness and clichés, you won't get people interested without hooking the reader on specifics. This point is an important one. Something like "She uncovers a dark secret that changes everything" is both cliché and vague. Never use phrasing that reads as cliché, like "And their lives will never be the same again" or "Where the truth isn't always what it seems." In short, if you can hear the overdramatic DUM DUM DUM music chords in your head after the sentence, chances are that you need to take it down a notch and get more specific about the unique qualities of the moment you are trying to describe. You're not writing the quick synopsis for general audiences on Netflix. This writing is for trained eyes that know story and are sick of cliché-ridden pitches by amateur copycats thinking they can sell ideas that are just like every other movie that's already been produced.

Avoid writing things like "A character must give up his world to embrace another's," because we have no idea what that means. Amateurs will mention that their character has "a big secret," "a dark past," or that their story has "big twists," and then *not* tell the reader what that secret, past, or twist is because they want it to be a big surprise. Do not do that. You don't get to keep secrets from your readers in a logline. If you don't want them to know something, don't bring it up at all. We can't picture the movie or get excited about it if the writer is vague about the details. Industry professionals don't get excited about a story that is about something you won't tell them. In fact, making this move has the exact opposite effect you want it to: it makes readers annoyed. Readers think, "Here's another self-righteous, newbie writer who thinks *not* telling me what their story is about excites me." You want to impress a reader? Say what your script is about in a way that does excite him or her. In any size pitch, it's about what you show them (not what you don't). Avoid generalities and sweeping, vague statements. A writer needs to be clear what is unique to this story and writer. Catch the interest of your reader by answering these questions:

- Why will an audience find the world and concept of your story interesting?
- What is the main conflict of the story?
- What is the awesome obstacle?
- What's at stake?

Here are a few famous examples of well-executed loglines

- *Gladiator*: A general returns to ancient Rome as a gladiator to seek revenge on the corrupt prince who butchered his family.
- *Shakespeare in Love*: A young, broke Elizabethan playwright falls in love with a lady way out of his league and betrothed to a dangerous lord, which inspires the scribe to write the most romantic play in history, *Romeo and Juliet*.
- *Pirates of the Caribbean: Curse of the Black Pearl*: A seventeenth-century tale on the Caribbean Sea where a self-serving pirate enlists the aid of a new

crew to battle undead pirates and reclaim his ship from his mutinous first officer.

For your consideration, here are some examples of two-sentence loglines

- *The Godfather*: In the 1940s, a soldier returns home from a tour of duty to his powerful Mafia family. The soldier's family struggles to protect their empire from the other violent New York crime families as leadership passes to him.
- *My Big Fat Greek Wedding*: Toula's family has exactly three traditional values, "Marry a Greek boy, have Greek babies, and feed everyone." When she falls in love with a sweet but WASPy guy, Toula struggles to get her opinionated family to accept her fiancée, while she comes to terms with her own zany family and heritage.
- *Titanic*: A lowly drifter and young aristocratic woman fall in love aboard an ill-fated voyage across the Atlantic in 1912. These lovers fight society's unwritten rules about class barriers personified by the woman's fiancée as they all struggle to survive one of the most infamous high-seas tragedies in history.

You will notice that none of these sound like any major movie that ever came before it. Each has a uniqueness of story even though it fits perfectly in its preexisting genre. Your logline needs to be that unique if it's going to make an executive think it would be worth producing.

All the work you pour into your script does little good if you don't entice people to read it with a fantastic, original logline.

Walking the line between illustrating the high stakes of your story while not veering into clichés is crucial. Come up with your own way of dramatically wording it.

Believe me when I tell you that I know writing a good logline entails a lot of work for the production of 55 words or less, but a logline can make or break the decision of whether someone reads all those months of work a writer puts into creating a script. A logline is a lot more than story. It hooks the reader, gives the full tone of the story, and tells the film's core concept. The logline makes your tale sounds cool and unique from other movies in the genre, yet so seemingly perfect for it that it makes the reader excited to hear how that story will be told. If your logline does all that, people will ask to read your script. And getting your script read is the first step to getting work as a writer.

Some genres are harder to write loglines for than others

I would be remiss if I did not acknowledge that loglines in certain genres are more difficult to sculpt. It's easier to explain a straightforward story in the genres

of comedy, drama, action, adventure, romance, crime, thriller, road, historical, sports, disaster, or coming of age. Those loglines are simpler because the writer is explaining a common cinematic situation. Even in something as fantastic as a supernatural ghost story or a monster-based horror film, the reader will be familiar with the types of plots involving spirits and other scary creatures. These are all easy worlds for a reader to comprehend.

Loglines are infinitely more difficult to write when the writer has the exact same amount of words to tell a story that is set in an uncommon situation. That's why fantasy is arguably the hardest genre for which to write a logline.

Fantasy (and occasionally science fiction) can be tricky to pitch in simple terms because the basic reality in which that story is based requires some explanation. That explanation is crucial so that the reader understands what the writer is asking him or her to read. I'm not talking about sci-fi or fantasy concepts with which any reader might be familiar, such as time travel or medieval swords and sorcery. I refer to films like *The Matrix*, *Star Wars*, *Harry Potter*, and *The Wizard of Oz*. The wildly extraordinary realities in which these stories are set demand some setup within the same constraints as other loglines. A writer must establish the unique world he or she has created so that it makes sense and provides perspective before throwing outer journeys and antagonists at the reader.

When done well, these loglines are often best served by using two sentences. The first establishes the world, and the second provides the outer journey and antagonist. Here are some classic samples:

> *Star Wars*: An orphan farm boy on a desolate planet learns of his familial ties to an ancient mystical power known as the Force. As he learns to use the Force, the boy ventures into outer space to deliver vital information to the Rebel Alliance about the Galactic Empire's planet-destroying Death Star run by Governor Tarkin.
>
> *The Matrix*: A young hacker discovers sentient machines created our reality to enslave humanity. Now, he must lead a rebellion to free mankind while being hunted by virtual assassins no man has ever defeated.
>
> *The Wizard of Oz*: A tornado transports a runaway farm girl to the magical land full of amazing talking creatures, only to realize that all she wants is to return home. But to earn that trip home, she will have to face-off against the Wicked Witch of the West.
>
> *Harry Potter and the Sorcerer's Stone*: An 11-year-old wizard made famous for surviving the death curse as an infant heads to a boarding school for witchcraft and wizardry. While there, he sets out to solve a mystery, which leads him to the dark wizard that made him famous and killed his parents.

One last sentiment

If you cannot come up with a concept that fulfills these qualifiers, your issue is not screenwriting related. It's about your personal voice as a writer, loving what you

have to offer the world, embracing that unique voice, believing your voice has a place in the world of creative writing, and finding monetary value in it. I firmly believe every writer can succeed in these endeavors, and it's important that you see this success in yourself.

It's crucial to feel this way because even talented writers may never get their big break with its financial windfalls. The writing industry is full of rejection. If you do not get excited and believe in your own ideas, you will never see past the litany of rejections to find the person who finally gets it. Like a sales job, it takes a hundred rejections to find the right one in the writing world. Confidence (not ego or cockiness) is required.

Exercise 15

Write the logline for your script.

Qualifications

- Protagonist
- Protagonist's outer journey
- Antagonist
- Use words that convey tone and genre without naming it
- Time period if not present day
- The global and/or personal stakes

Optional

- A single adjective for the protagonist that specifies the character flaw
- Consider making it clear whether love or death is what's at risk

Disqualifiers

- Clichés
- Script titles
- Backstories
- Passive tense
- English errors
- Genre naming
- Question marks
- Supporting characters
- Exclamation points (with the possible exception of family films)
- Stating the moral message (no soapboxes)
- Anything vague or generic

Chapter 16

Three-act structure

Figure 16.1 Michael Sanborn – The protagonist's dangerous path to success or failure can feel like wandering lost in the desert until you study the proverbial tent poles of structure and how they work to create a constantly escalating story.

"The longest process on any project is the beginning. The research and doing a treatment . . . so I know exactly where I'm going."

–David Seidler

There are dozens of learned, screenwriting gurus out there with an endless number of books that break down and explain the industry-wide accepted pillars of

three-act structure. Each story analyst and author explains his or her take on the same general principles handed down from generation to generation, using his or her own vocabulary for these universal moments most commonly found in a traditional script. This chapter will clarify some of those differences for you, consolidate the vocabulary for multiple methods of structure deconstruction, and distill all the ideas into one chapter so that you can see how (no matter what you call it) it all boils down to a few unifying concepts. My goal in doing this is not to undermine any of these concepts, but to show how they all are right, good, and serve the same theory of story structure. This chapter may prompt you into studying them further by providing a better understanding of how they all fit together.

The focal point of this summary will be to explain how three-act structure works and breaks down universally into the three phases of story. I call them the three Es:

- *Establishing* the status quo serves as the story's bookends
- *Escalations* in the outer journey where an action occurs significantly increase the stakes.
- *Evolutions*, motivated by the escalations, is where the protagonist struggles to achieve the physical goal (outer journey) and experiences his or her profound character arc (inner journey).

Consider this industry-wide, universally accepted mathematical blueprint as the step-by-step structural support system (like weight-bearing beams in the construction of a building or house) that keeps the script from falling apart. There is a reason that these critical moments of escalation and evolution are universal in multiple entertainment-writing methodologies.

Let's start with some "big picture" structural basics. The three acts are in direct correlation to the universal terms *beginning*, *middle*, and *end*:

- In act 1, everything is set up and introduced. This is an attention-grabbing *beginning* that establishes the protagonist's want, yearning, or need (e.g., survival, a lover, a red balloon, etc.) in the first quarter of the script. This is the only time that writers should allow coincidence to play a part in the unfolding of their stories.
- Act 2 is the *middle* of the story, featuring constantly escalating intensity, conflict, and stakes during the pursuit of need or satisfaction. This pursuit usually consumes a little over half of the script's page length without bringing about resolution.
- Finally, act 3 is the end of the story, which includes the climax and resolution of the tale. The conclusion should offer an unexpected yet totally satisfying *ending* that makes people want to share it with friends.

This structure is something all writers need to master, even if they decide later in their writing careers to throw out these paradigms. In those cases, you should be able to explain to producers, executives, and readers that you understood structure, the rules you broke, and the reasons for doing so.

Along the way, each of the establishing, escalating, and evolving phases have a purpose. Now, different script analysts number them differently, but as I will explain, this is my character-driven, fundamental way to create stories utilizing three-act structure. It's important to note that every escalation (1) tracks the status of the outer journey specifically and (2) should describe a singular, specific, pinpointed moment when everything changes. Each escalation must live up to its individual, particular description, as described below. Meanwhile, the establishing and evolution phases are sequences, not a singular moment.

I must reiterate that little of this is original. To exemplify this, I placed the Syd Field terminology in ALL CAPS, Michael Hauge in *italics*, Paul Chitlik is in bold, and Christopher Vogler in "quotations." Let's explain them now.

Act I (the beginning)

Establishing: prologue (crisis, flaw, and skill)

Scripts often start with the teaser, which is the *setup* for your protagonist and story by establishing the status quo. Sometimes the first few pages are all you get to hook your reader, so you want to make sure your story starts brilliantly. To give the scene visual scope in a visual medium, set it at an "event" that speaks to the genre and theme of your film. For example, a romantic comedy might start at a wedding or engagement party (*Bridesmaids*), or a coming-of-age film might open with a graduation (*I Love You, Beth Cooper*) or, in a horror/coming-of-age film, a young girl's first menstruation (*Carrie*). The location and emotional content of the scene should set the tone and genre of your story. This location sets the status quo for where your characters are in the universe before they make efforts to change this reality. In the three examples I just gave, whether you're always the bridesmaid and never a bride, a college graduate with no set pursuits in the real world, or a girl becoming a woman, this identifies a character's state of being. After all, we must make clear what something *is* for the audience before that status is rocked by circumstance, forcing it to change.

Therefore, the beginning of any script should exemplify your protagonists' everyday **ordinary life** before the events of your story change the character forever. There should be a specific moment that defines what the protagonist is like in the beginning of your story, with a counterexample the writer should mirror at the end of the script, perfectly illustrating the character arc. There are three ways in which a writer can exemplify this:

1 An action crisis
2 A situation crisis
3 A character crisis

Most use an action crisis or event such as a death, arrival, departure, burglary, hostage taking, or murder. A situation crisis is just when the central character gets

a piece of surprising news but no action is taken at that moment. Character crisis could be a divorce or break up that brings about a meltdown, a flare up – some type of personal or emotional moment, like an attempted suicide, for example. I try to pick a crisis that best suits the genre, putting the protagonist in a situation that best illustrates his or her character flaw. I'll say that again with clarity; this is crucial. This crisis should result in the protagonist acting in a way that exemplifies the character flaw.

This is where the writer sets everything up. It's what Joseph Campbell calls "The Ordinary World," which is a sharp contrast from the world he or she will be venturing into for act 2. It's here that we introduce the central character, his or her ambitions and limitations. The bond with the audience forms through identification and recognition. Your protagonist exists in this "Ordinary World" throughout act 1. Do not confuse ordinary with boring. The writer needs to grab the reader's attention on page one of a script, and the writer cannot grab anything by writing mundane situations. This need for initial excitement is why most scripts start off with a crisis or an event.

Always be certain of your point of attack (the exact moment you start your story), where nothing integral comes before it and something must follow. It forces action to be taken.

So that means know where/how to start your movie with:

- Mood/genre
- Theme/story
- An event that suits the genre
- Definition of character and conflict

The conflict that you start your story with (because conflict is needed in every single scene of any good story) should be grounded in establishing your protagonist's character flaw and serve as a setup for the character arc he or she will achieve. As a reminder, the protagonist chapter explains how a character flaw is also a hint at that character's strongest skill. For example, if a protagonist's flaw is cowardice, he or she probably knows better than anyone how to hide. Illustrating this skill as part of the establishing prologue's crisis serves as an excellent setup for utilizing that skill later on in the story when the protagonist is in a horrific situation.

Don't make the amateur mistake of thinking just because this is the first act setup that it does not require conflict. This tension just needs to come strictly from the character flaw and inner journey until the outer journey is revealed.

Most important, make your readers wonder what happens next. Start the story. Make the beginning quick and clean. Hook the readers and reel them in with great character, spot-on genre execution, and move the story right along. The first five pages need to be a page-turning attention grabber.

Lastly, make sure the attitude of the script's ending fits the attitude with which you started the script. These are the bookends and should emotionally and visually comment upon one another. The film *True Lies* has a fantastic example of this.

Escalation 1: catalyst

Did we arrive at the INCITING INCIDENT without taking too long, usually one-tenth of the way into your script? This is the moment that throws a wrench in the works of your protagonist's everyday life. This totally unexpected disruption and complication form yet another opportunity to reveal more about your protagonist with how he or she responds to this abrupt moment.

This *new opportunity* creates a new situation for your protagonist so we immediately get to see the character reacting to something meaningful: a character-defining moment that tees up the outer journey, begins the conflict for our central character, and plays into the character's flaw. This tells the audience loads about the protagonist, makes the protagonist feel authentic (everyone has flaws) and helps hook the reader's interest.

This is the "Call to Adventure." Something happens early on to set the unique story in motion. Something new happens (a big shocker), which nudges the central character out of his or her comfort zone. It answers the question, "Why is this character going to consider doing something out of the ordinary?" It can be a discovery or new arrival. Situation examples of this beat include: the gauntlet is thrown down, a threat to normal life is realized, or a great wrong has been done. Think of it as an alarm sounding before the air raid. This is the story's trigger or catalyst moment from which action must be taken to either stay in the ordinary world (the everyday reality as your hero knows it) or to leave it behind (to embark on a journey with unforeseeable circumstances and costs). Does your script have all that in the right place? Great.

Evolution 1: reaction to questions raised

Now, nobody wants to have to change or risk life, love, or limb. Therefore, as a result of the inciting incident, the protagonist must deal with this *new situation*. It is only natural that the protagonist's first reaction is a "Refusal of the Call," in which the lead character expresses hesitation and fear. This is the protagonist's first subconscious struggle with beginning the inner journey. If there is no hesitation, chances are you need to increase the stakes. Fear helps humanize your protagonist and makes him or her feel realistic to a reader. Facing something scary builds empathy for the protagonist. If the character is given no choice to flee the trouble ahead, you are not putting your protagonist in a position to be proactive. The character must have a choice.

Often, the refusal leads to a "Meeting of the Mentor and a Gift," someone with bravery or wisdom who helps guide the protagonist on the correct path to accept the awesome responsibility of making a reality-changing decision. After all, nobody leaves his or her comfort zone without an ally to give him or her help or a shove in the right direction. Someone or something inspires a protagonist's overcoming of reluctance to change his or her life.

When given, the gift is something to help with the protagonist's outer journey. In the original *Clash of the Titans*, Perseus receives a slew of gifts from the Greek

gods, including a helmet of invisibility, a sword, and a reflective shield he will use to defeat Medusa. In *Star Wars*, Obi-Wan provides Luke with his father's lightsaber. Hagrid brings Harry Potter the acceptance letter to Hogwarts, takes him to Diagon Alley, and loads him up with supplies, including the twin magical wand to Voldemort's and the pet owl that will one day save his life. Not every story includes a gift, but it's a frequently used tool.

Escalation 2: decision

> "If you want something you never had, then you've got to do something you've never done."
>
> – Unknown

These unexpected, spiraling circumstances lead your central character to PLOT POINT 1, the climactic **end of act 1**. This hits roughly one-quarter of the way into your story (at the latest). In this moment, as a direct result of escalation 1 (the inciting incident), the central character breaks away from the status quo and makes a tough decision that will change his or her life irrevocably forever. That choice triggers the protagonist to take a defining action that must be dynamic enough to make this character worthy of being the central character. The character takes a first, voluntary step outside his or her comfort zone. The first step is always the hardest, and this is a big step.

This decisive act has profound effects on the character and begins his or her journey in overcoming the protagonist's character flaw. This step starts the character arcing of the inner journey as well as the physical, outer journey. A whiney, rural farm boy decides to go on a galactic adventure with Obi-Wan in *Star Wars*; a cowardly fish decides to traverse the dangerous Atlantic Ocean to retrieve his son in *Finding Nemo*; and a Viking youth desperate to belong decides to contradict his people's views, helping the dragon he shot down in *How to Train Your Dragon*. This is the protagonist's decision to go on the outer journey. It's *the change of plans*. Every major, future escalation in your story should be a direct result and consequence of this moment. If it is not, you have a story without a central plot (also sometimes called the "A-plot"). Supporting characters may have small, background stories with a beginning, middle, and end, but all other plots (B-plot, C-plot, etc.) should reflect the A-plot and premise.

Obviously, this climax in act 1 must be worthy of the price of admission to a movie theater, popcorn, soft drink, and overpriced Junior Mints. Okay, there is no price too high for minty yumminess, but you get my point. This climactic decision must be worth the high cost of buying the game, the comic book, or buying the whole season. Harry Potter leaves with Hagrid in *The Sorcerer's Stone*, Jeremy and John in *Wedding Crashers* accept an invitation to spend the weekend, Neo takes the red pill in *The Matrix*, and a Baggins leaves the Shire of Middle-earth in *LOTR* and *The Hobbit*. Did you nail that beat, meeting all the above criteria? Cool.

At this point, the protagonist commits to change, "Crossing the Threshold," leaving his or her "Ordinary World" in order to enter a new, unexpected "Special World" where trials and growth will take place. There can be some barrier to be contended with, such as a bridge, partition, or gatekeeper/guardian to protect the gap between worlds, much like Cerberus does for Hades' underworld in Greek mythology or Asgard's Heimdell as seen in the *Thor* films. Guardians are a metaphor exemplifying obstacles to breakthroughs in our lives and a brief test of a protagonist's worthiness. Examples include Cash in *The Family Man*, Clarence in *It's a Wonderful Life*, and the three kidnappers of Buttercup in *The Princess Bride*, the latter illustrating Wesley's worthiness to pursue his outer journey (returning from death the first time) to ride into the sunset with his true love. This is where we enter . . .

Act 2 (the middle)

Evolution 2: first steps

This is where the central character makes some initial *progress* through constant confrontation. If, biblically speaking, act 1 is the ordinary life of slavery in Egypt and act 3 is making a new ordinary life in the freedom of the Promised Land, then act 2 is the 40 years in the desert. Act 2 can feel like that sometimes because it tends to be a touch longer than act 1 and act 3 put together, dominating the majority of the film like a great wide open empty expanse that we do not get to fill with introductions or conclusions. It's simply the escalator between floors. Constantly getting bigger, higher, scarier, and tauntingly closer to a final confrontation with constant landmines at each step without ever getting there. This is the hard part.

Metaphorically, writers put protagonists in a tree and keep throwing rocks at them – and the rocks just keep getting bigger while those branches keep getting thinner. Your second act contains the complications with ever-rising tension, stakes, and restraints. It's a pressure cooker and roller coaster with waterfalls. You must have ever-building momentum, where one thing leads directly and unpredictably (yet logically) to another until these events can only come to one unpredictable end. In *The Karate Kid*, you would never think that Mr. Miyagi's young, scrawny karate student would possibly be able to dismantle and defeat each martial artist–trained bully in a karate tournament at the end of the film, and in front of a live audience no less.

Never lose track of the story or ride. Keep it linear if you want readers to be able to follow your story. We have a finite amount of time to tell the most important moments of a character's entire life. Don't dillydally. The first half of the second act traditionally contains what the protagonist discovers he or she needs to know about this "Special World," including the introduction of "Tests, Allies, and Enemies" (the situations and characters your protagonist now must deal with on this adventure). In the first *Harry Potter* film, tests include getting into Gryffindor, riding a broom, and proving himself a quality Quiddich seeker. Harry's allies become Ron and Hermione, while enemies Draco and Professor Snape surface.

Do not mistake this start of act 2 as a new form of act 1, focusing on setups. Every scene is a battle for the protagonist to accomplish what he or she set out to do at plot point 1. Anything that is brought into the story should be written into the story as obstacles and allies to the task at hand. The time for an introduction scene or anything happening due to luck is long past. The protagonist is taking deliberate action in each scene.

This is the part of the tale where you often see training sequences as the protagonist makes some progress toward being able to complete his arc and goal. Act 2 is a constantly intensifying, building set of circumstances that follow with life and/or love at stake. This set of scenes lays the groundwork for "The Approach" toward the center of the script, where the drama/comedy escalates to the point at which the protagonist faces an impending failure, defeat, or death at . . .

Escalation 3: consequences

Best known as the MIDPOINT of your script, this **turning point** takes place in the dead center of your script and is in the heart of the movie. It is also referred to as the belly of the beast because the protagonist is literally furthest from his or her goal at this point. It's a major tide turner. Some writers make this a big positive moment (usually leading up to a tragic ending) where there is a major revelation, but many writers make this moment a setback to offset a satisfying finish.

Rightfully called *The Point of No Return*, this is "The Ordeal" that serves as the central crisis of the script. Protagonists face their greatest fears and taste death/ loss. The midpoint should illustrate that the fear they felt just before plot point 1 was justified. The inner journey character flaw is leading to nightmare-worthy outer journey complications.

In this major escalation moment, the stakes become clear to the central character and how much attainment of that outer journey can cost. When someone decides to take action at escalation 2, the central character does not often realize what he or she stands to lose, and the midpoint is the moment he or she does. Whether the character stands to lose life or love, this moment physically illustrates that peril. This goes well beyond threats, overhearing something, and hot air being exchanged. This beat contains action with true physical and emotional danger. The stakes become exceptionally real and higher than ever seemed possible when making the choice to set out on this outer journey at the end of act 1. So, this moment isn't just new information; something should physically happen to show the potential cost of the outer journey in this visual medium.

This turning point answers the question, "In no uncertain terms, what does the central character personally stand to lose if he or she fails?" This cinematically exemplifies the highest stakes (loss of life or love) to which the writer will deliver a crushing blow at escalation 4. In *Star Wars*, the crushing trash compactor of the Death Star sequence is a great example of this midpoint. In the romantic comedy *Wedding Crashers*, the love interest gets engaged to the antagonist.

Please note this beat is the opposite moment in a tragedy. The protagonist can clearly see for the first time exactly what he or she stands to achieve if success-ful in what proves to be an impossible task. It is important to inspire a character toward his or her tragic ending with good reason to face death head-on. It allows an audience to understand why the character went through with it.

Whether it's a high or low point, if you sneak in a big reveal, a surprising twist in the middle of the film is always a plus when plotting.

Is this major escalation roughly in the middle of your script? Check.

Evolution 3: reeling

In the wake of the midpoint, the protagonist often experiences a moment (and only a moment) known as "The Reward" for having survived the great obstacle. For example, Luke Skywalker escapes the trash compactor and detention area with Princess Leia. Daniel Kaffe finds his star witness, Lt. Col. Markinson, in *A Few Good Men*. Sam Witwicky gets the AllSpark in *Transformers*. Michael Oher's scholastic efforts lead to the reward of playing football in *The Blind Side*. It could be a material item to help achieve the outer journey or a celebration or love scene. Don't forget to keep the conflict present. We're not out of the woods; we're deeper into them now.

Complications and Higher Stakes ensue. The deep sigh is short-lived as he or she commits to finishing this journey. From this midpoint in the plot, tension and stakes continue to build throughout the second half of act 2. Compound the suspense by increasing the danger closer to the end. Scenes should become ever shorter to build tension, which quickens the pace of the film as it builds to a crescendo.

Nothing should ever go as planned. Things can work out for the better, but never as planned. Nothing predictable. It must be difficult for this character, and for this person more than anyone, because the character should have been specifically designed (through the character's inner journey exemplified by his or her charac-ter arc) to have trouble with what he or she must overcome. Push your characters way out of their comfort zone at this point of the story to have them do things they would never normally do (heck, maybe they wouldn't have even considered it at the end of act 1). And everything must be believable. Nothing should seem out of left field, but there should also be constant unexpected complications. The protagonist must make continuous progress and decisions. Things must go wrong. Create anticipation though foreshadowing with deaths, plot twists, dangers, etc. In the rom-com *Wedding Crashers*, the antagonist is closing in on the protago-nist's secret. John's flaw of habitual dishonesty bubbles toward the surface, and he misses his opportunity to come clean. Complications and stakes multiply.

Escalation 4: horror or hope

The tasks and tests get increasingly more difficult until the protagonist reaches the **low point**, known structurally as PLOT POINT 2, the climactic moment of act 2.

This is the point at which your protagonist experiences the worst of all things or *the major setback*; his greatest nightmare is fully realized. The high stakes mentioned in escalation 3 have become inevitable.

This is where we see the worst of all things happen, and it happens to the person the protagonist holds most dear. It may include death (Obi-Wan in *Star Wars*, Bela Lugosi in *Ed Wood*, Althea in *The People Versus Larry Flynt*, Agent Coulson in *The Avengers*), mortal wounding (Dr. Henry Jones in *Indiana Jones and the Last Crusade*, Marius in *Les Misérables*, Robby Keough in *Outbreak*), or kidnapping (Morpheus in *The Matrix*, Mary Jane in *Spider-Man 2*, Dana Tasker in *True Lies*, Mary in *Three Men and a Baby*). If it's a love story, this is where the breakup occurs.

The central character has lost and has no hope. The protagonist leaves or is completely chased out of the dream. The protagonist has lost more than he or she ever planned on losing when the journey was embarked upon. He or she loses it all. This horror occurs roughly three-quarters of the way into the script (or a touch later). In many instances, the character flaw catches up with the protagonist, serving as a suicide pill. The liar's truth is exposed, the thief is caught, the impetuous gets outwitted, and the coward keeps his or her head down at the worst possible moment.

This low point happens either because the protagonist fails to achieve the outer journey, which is more common, or the protagonist achieves an outer journey that sets off an unexpected result. In the instance of the latter, the protagonist either realizes that what he or she has wanted was the wrong thing all along (and achieving it has cost the protagonist what he or she really should have been pursuing) or that achievement of the mission triggers a reaction the protagonist could not have predicted, making the situation far worse than he or she imagined. Consider the following two examples of success resulting in a terrible twist of fate:

- In *Liar Liar*, Fletcher wins the court case and the promotion only to have lost his family because he made work the priority over his son.
- In *Star Wars*, Luke Skywalker gets the readouts of the Death Star to the rebellion only to lead the Empire straight to their secret base.

No matter what the case, this is a key moment in forcing the protagonist to achieve the character arc (inner journey) in act 3.

Now, all of the above is the case *unless* it's a tragedy, in which case the opposite happens. In a tragedy, in order to properly break the hearts of audience members at the end of the story, this should be a moment where the central character thinks he or she has achieved his or her goal. It is the highest point of hope. Success is at hand, and the plan can work.

Whether you end act 2 in despair or euphoria, hope or horror, it is followed by a reversal of fortune in act 3. The tragic ending would have a character reach a high point instead of a low point at the end of act 2. Then, when the protagonist either (1) refuses to learn his or her lesson or (2) the plan goes awry, tragedy strikes.

The second half of great films builds a series of complications so incomprehensibly inescapable that your audience is dying to know, "How the hell are they going to get the characters out of this?" Leave your lead no way out, no way to win. This way you cannot mess up your ultimate task, which is to make the climax and resolution thrilling and unforeseeable. That's how you keep the audience on the edge of their seats. Sometimes I write myself into a corner on purpose. I cage and corner my protagonist (surrounded only by unbeatable or horrific options), unsure of how even I can get my central character out of trouble until I'm faced with that moment in the script. And then the solution must make perfect sense and be plausible. Make your own job really hard; the reader will appreciate it. There can be no easy way out. It must be a seemingly impossible goal like that in *Star Wars* (a few small, one-man fighters against a planet-size space station with enough firepower to blow up worlds), and our lead must go through it due to the impact and meaning of the alternatives.

As a side note, one trick to getting the central character out of the impossible situation is best handled by setting up a skill in the establishing prologue while establishing the character flaw. Then you can pay off that skill here, when you need something to get the protagonist out of this messy situation alive.

The protagonists face another choice. How do they respond to this complete loss? This low point hurls them out of the "Special World" and places them "On the Road Back" to the new "Ordinary World" they must inhabit.

Act 3 (the end)

Evolution 4: the phoenix

The central character, who has lost it all at the low point, finds the courage within to stand up against insurmountable odds, charging into the resolution of the story. Here lies "The Road Back" after facing a beating or loss that would make most surrender. Now, the only way out of it is to either (1) turn and hide in the "Ordinary World" from which the protagonist came, the worse for wear, or (2) break through toward "The Resurrection" for *The Final Push* toward a climactic test where the protagonist is purified and redeemed. The protagonist needs this moment of revelation to rebuild, going from abject despair to finding the motivation, energy, and revitalization necessary to stay in the fight of his or her life. The protagonist realizes what he or she must do, no matter the cost.

If the end of act 1 is the choice that earns the central character the right to be called a protagonist, this is the moment he or she earns the right to be called a hero. Here the protagonist may stand with far less than with what he or she started, choosing resurrection. He or she transforms as a result of all that happened in act 2. Like a phoenix from the ashes, the protagonist rises to the challenge a changed person. This is the final evolution; an arc has occurred.

One of the most important things to remember at this point in the story is that an outer journey should be accomplished as a result of the inner journey. This means

that the inner journey must be completed here before the outer journey can be concluded during the climax of the story (escalation 5). How this works structurally is that the character flaw is often somehow responsible for the protagonist's low point (escalation 4). That is the proverbial straw that breaks the camel's back, which demands that the protagonist change forever.

Sometimes a writer will give the protagonist a chance to run away here in the wake of escalation 4, but, as a changed person, he or she has come out the far side of the trial by fire, having been forged into a stronger person. If act 2 has taught the hero something, it's that he or she would rather die as the person he or she has become than accept defeat and go back to the way things were.

In the rare instance where the writer is creating a central character that is a failed protagonist (who has all the facts and decides not to change his or her stubborn ways), the lack of arc may also become clear here as well. This is commonly used when the protagonist is a terrible person, but a central character's failure to arc doesn't always have to be a bad thing. It all depends on how you utilize this failure to change. The whole film can be trying to prove that everyone's morality has a breaking point, and the protagonist refuses to yield, becoming a martyr. Some characters need to change in order to sacrifice themselves for something greater, and other characters need the strength to stay the same, illustrating the power of their convictions. William Wallace is such a character in *Braveheart*. In these more positive situations where central characters refuse to change, we do not call him or her a failed protagonist. The protagonist has not failed anyone. This character evolves to the role of mentor and surrenders the role and title of character-arcing protagonist to a different character that learns from this example.

Escalation 5: the ultimate showdown

The thing that happened at escalation 1 and the action taken at escalation 2 have led to this inevitable confrontation. This is the film's CLIMAX, the epic final battle. Thus, this escalation must be the biggest moment of your film. In the last major conflict sequence of the story (which runs the last 15% until the last 5% of your script), this highpoint with everything on the line needs to surpass all expectations, reverse expectations where possible, and perhaps even include a justified twist or reveal. Awe the audience. Your protagonist either succeeds or fails in this **final challenge**.

A trick for providing great twist endings is to use a seemingly unrelated setup to justify your climactic surprise. For example, several films have used this one: the protagonist does a magic trick for a child in the first act of the story. This is part of establishing the protagonist's backstory, his family, and his relationship with his relatives as the black sheep, perhaps. The kids love him as the cool uncle, but the adults talk about our protagonist behind his back. Anyway, the script establishes early on in the story that the protagonist has "sleight-of-hand" skills (i.e., making something disappear up his sleeve). Then at the end of the film, the protagonist secretly uses that skill to switch loot with the bad guy, who actually wound up with

the wrong briefcase. Obviously, that setup has been done to death, but you get the idea of setting up the twist early in an inconspicuous way.

Establishing: epilogue (renewal)

In the last 5% of the script, we experience *The Aftermath* and let the audience quickly and simply out of our story with what the French call a DÉNOUEMENT, and what Vogler calls "The Return with the Elixir." In an ideal situation, this hard-won elixir heals the wounds of the hero and his or her wounded community. It can be a physical item (like the children and Shiva Lingam stones in *Indiana Jones and the Temple of Doom*) or a perspective change for all. The protagonist shows mastery over the character flaw he or she started the story with, to the benefit of the "Ordinary World."

This last 5% of the film is a **return to normal life** that has been forever changed. Just as we opened our film during the routine life of our protagonist in an establishing prologue, we end it with an antithetical slice of how different the new ordinary world is in the wake of our protagonist's two journeys. This ending shows how the choices made changed the protagonist, his or her perspective, and the reality around him or her. It's common for the type of crisis that started the story in the establishing prologue to happen again here; only the protagonist handles the similar crisis differently this time, perfectly illustrating how the character arc has changed the character forever.

This is the other bookend of your script, the film's premise having been proven. After the completion of the outer journey, this ending illustrates the achievements of both the inner and outer journeys. The end must answer the questions you raise if you want your audience to see, read, watch, or play your entertainment over and over again. This ending must be three things:

1 Honest to the characters, theme, and story
2 Satisfying
3 Not boring/gripping

A few last thoughts on structure

In the writing of each step, ask yourself how the central character's personality or fatal flaw can be integrated into the circumstances, making the outer journey more difficult on the protagonist, such that the outer journey and inner journey are both in play during any given scene.

This knowledge of three-act structure is helpful in laying the foundation of an outline or treatment. Sadly, many writers forget that this knowledge is equally useful after the first draft of the script has been rewritten and edited for content. If the timing of the five escalations in your script are too dramatically far apart or close together in your story, the script will often read like the writer got lost in the

woods. When the page counts are too far off from where they belong after sorting story issues, this page-count problem indicates to the writer exactly where he or she needs to work the hardest to get his or her script back into shape. For example, if your script's end of act 1 is roughly in the right page parameters for your script, but the midpoint appears 15 pages out of place, you now know where to target your revising efforts.

If the midpoint is 15 pages too late, creating a chain-reaction making the entire script too long, you know that you need to cut 15 pages from between the end of act 1 and your midpoint. In the opposite situation, if the plot points come too early, that writer can assess where he or she needs to generate fresh, new, better, dynamic scenes that build properly from one plot point to the next.

That said, please remember that we do not drive ourselves crazy over just a couple pages long or short here or there; you do have a little wiggle room. To use an example from another endeavor, in construction, just because support beams are in every house and building it does not mean that every single house or building looks identical to all the others being built.

Writing tip

I'll end this review of basic structure with a piece of advice. The subplot, or "B-plot," is a secondary story (usually the love story if the genre is not romance) that also comments on the film's premise. In romantic films, it can be a supporting character's love story that serves as a reflection of the central romantic relationship to establish the stakes involved.

I like to track the B-plot through the second act with what Syd Field calls pinch 1 and pinch 2. Pinch 1 takes place midway between plot point 1 (end of act 1) and the midpoint. The second pinch occurs halfway between the midpoint and plot point 2 (the low point). This pinch reminds you to develop your subplot throughout the second act and to make sure that major developments happen to it at least twice in the middle half of your script.

For example, one pinch could be the first moment the two characters realize their feelings run deeper than friendship, or deeper than hostage and hostage taker, or deeper than doctor and patient. The second pinch could be a first kiss or almost kiss. It could be a betrayal, a major letdown, or an allowing of the other person getting away only for them to come back because they won't leave their counterpart behind. I plan pinches because I like to have structured markers to hit in the wide-open space of act 2.

Defying structure

Many independent filmmakers like to insist that there is no such thing as one way to tell a story. To address that, allow me to quote one of the great independent filmmakers. It was at a symposium about screenwriting during the Cannes Film Festival of 1962. Jean-Luc Godard, a famous "anti-structuralist" of his age (yes, I

made up that term), was arguing a point with Henri-Georges Clouzot, who angrily insisted that Godard must at least concede that every story should have a beginning, a middle, and an end. Godard thought about the question a moment, and then answered, "Yes. But not necessarily in that order." We can analyze this statement by looking at Quentin Tarantino's film *Pulp Fiction*, which most people think has no three-act structure. I respectfully disagree.

Pulp Fiction starts with a quick, mood-setting, crime-based teaser in a diner, which plays into the end of the film as it should. And then the film dives into Vincent Vega's average day of running a dangerous errand for Marcellus Wallace (his boss). We find out Vincent is dealing with a "situational crisis." He has to take out the boss's wife, Mia. At Escalation 2, well aware of the danger because he knows that Marcellus threw a man out of a fourth-floor window for massaging Mia's feet, Vincent takes Mia on the date. All of these beats exemplify Vincent Vega's fatal flaw, an inability to change the course of his dangerous lifestyle of bad choices with reckless abandon. This character quality makes sense for an anti-hero protagonist, a hired hit man and heroin addict. He practically courts trouble.

The midpoint of the film, Vincent's "Ordeal," is his death (talk about a *point of no return*). That's one serious setback that tells the audience exactly what kind of trouble his flaw can result in, getting an all-too-literal taste of death. The final challenge is the cleanup of Marvin's body. As a result of Vincent Vega not changing his reckless ways after experiencing a date with his jealous crime boss's wife, almost killing her with heroin, and a bona fide miracle (surviving the many bullets fired at him at close range), we know what happens to him. We saw it at the midpoint. His fatal flaw and unwillingness to experience that character arc (or character curve) is what ends his story in tragedy, while Jules (the ally) lives as the example of how it could have ended for Vincent had he listened and learned. Vincent could have survived. That is absolute perfect three-act structure, whether Quentin planned it that way or not. Honestly, I think you can look at almost any contemporary financially successful film and pinpoint where it hits these different escalations in some way or another.

Summary

Michael Hauge has a 6-stage act structure, plus 5 turning points, making 11 story sections; Paul Chitlik mirrors Hague; Christopher Vogler and Joseph Campbell have 12 universal story sections, all of which run parallel with one another and the late Syd Field's three-act structure. The list of structural theorists and analysts goes on, but it almost always boils down to the same basic story phases. Each of those writers brings some new and wonderful perspective, but they all seamlessly serve as an overlay to one another because they are all built on the same, timeless storytelling paradigms dating back to ancient Greece. This overarching story structure is unilateral across the wide expanse of all entertainment-writing structural schools of thought.

In the end, you can use this roadmap of beginning, middle, and end to double-check all the structure points in your scripts and ensure that you are spacing these escalations appropriately.

The fun thing is also that when you look at a script in sequences or scenes, each of them has its own beginning, middle, and ending. Scenes are a micro version of story. Something happens in the beginning of a scene, which forced the protagonist to make a decision and act. Conflict ensues. Tension mounts. It may bleed into other locations as that situation resolves or gives way to a new situation as the process starts all over again.

Why three-act structure works

Writers do not use three-act structure just because it's a system we have seen work. There is a much deeper and subconscious reason for its continued success. Stories are told as a reflection of life as we understand it, and significant life-changing experiences go through the major three-act structure escalations. Life starts with some sense of normalcy (prologue). Something happens that deeply affects us and makes us reconsider our actions (escalation 1). In the wake of that, we make a decision to do things differently (escalation 2). When trying to be the different person, at some point we find out what this means and what's at stake if we continue to act this way (escalation 3). Inevitably, something goes wrong, as life does (escalation 4). Then we have to deal with whatever has happened and face the issue head on, either succeeding or failing (escalation 5). The experience has altered who we are and how we behave (epilogue). In short, three-act structure is not merely a paint-by-numbers formula for storytelling. Three-act structure allows art to imitate life. All human beings have experienced at least one life-changing event, which is why it works. That is why this is the most effective, truthful, and easiest way to communicate stories to total strangers all around the world. It is a universal experience.

Exercise 16

Layer three-act structure over that series of rising action you organized in Exercise 13. First, select the ideal establishing and escalation beats of your story and plug them into three-act structure, making sure each meets the necessary structural criteria. Welcome new ideas into the mix as needed.

1 *Establishing prologue*: Introduce the central character through one of the three types of crisis situations, which befits the genre and whose reaction exemplifies the protagonist's character flaw and skill.
2 *Escalation 1*: An unexpected incident shocks the central character out of his or her comfort zone, which results in highlighting the protagonist's character flaw and serves as a catalyst moment leading to . . .
3. *Escalation 2*: The central character makes a life-changing decision to pursue his or her outer journey that will change his or her life irrevocably.
4 *Escalation 3*: The central character experiences the full weight of the risks involved with pursuing the outer journey.

5 *Escalation 4*: The central character's worst potential outcome appears to now be the reality.

6 *Escalation 5*: The central character confronts the full power of the antagonist in a final showdown for all the proverbial marbles that illustrates the protagonist's character arc (or the lack of achieving it).

7 *Establishing epilogue*: In a situation that harkens to the prologue crisis, the protagonist responds differently, illustrating how the character has been forever changed by the experiences of the outer journey.

Qualifiers

- Each beat contains a clear and present conflict.
- All escalations contain one easy-to-follow outer journey.
- Each escalation means something monumental happens, after which actions are taken to a higher level of intensity and stakes.
- Each of the above should list a specific, pinpointed, singular moment of action. This means they should only be one sentence each.
- These beats focus on the central character of your story and are told from his or her perspective.
- The end of the story confirms the premise without equivocation or contradiction.

Disqualifications

- Compound or multiple sentences.
- Multiple actions in any one of the above seven moments.
- Consecutive establishing or escalation beats feel like they could take place in a single scene.
- A character simply being given a choice is not an escalation. A character must make the actual decision and take bold action.
- The act of threatening a character or offering a plan never qualifies as an escalation. Threats and plans are just hot air. Something must actually happen that raises the stakes.

Flesh out the evolution beats between the escalations to fill in the final blanks of your organic story-growing outline or treatment.

Place questions answered from earlier in this book that were not an establishing or escalation beat into its proper evolution section.

Make sure each of their structural requirements are met.

Integrate all those brainstorming images that you feel would enhance the story and tone.

AND TO FINISH, WE PUT EVERYTHING WE HAVE LEARNED TOGETHER.

Next, I include the blank form I use when generating a story, which my friends who have adopted it affectionately call the "Tabbline."

Organic story growing

Premise

What you are trying to say that is never actually verbalized in the script? What is it about the story that engages both the heart and mind? Know why you must write this script. What's your source of energy and what draws you to this story? What original opinion is worth your last words on Earth?

Genre (no more than two)

Brainstorm a list of visual imagery and ideas spawned by the above information, keeping each brainstorm separate.

Story

"_____" is a story about _____, who wants to _____ by _____. We will know _____ has succeeded at the end of the film when he or she _____.

Logline

Major character types and purposes

PROTAGONIST OUTER JOURNEY: What is the protagonist's external goal with a clear, physical finish line?

- The protagonist's outer journey is to accomplish _____ (*a mission with an exceptionally clear, specific, visual, 100% physical finish line for the outer journey*).

PROTAGONIST INNER JOURNEY: What is the personality flaw of the protagonist that must change (creating a character arc) so that he or she can accomplish or realize what he or she needs to about his or her outer journey?

- The protagonist's inner journey goes from _____ (*single-word character flaw/personality trait*) to _____ (*single-word cure for the flaw, an opposite behavioral trait*).

ANTAGONIST: Who is it? How is this character the primary obstacle to the protagonist's outer journey?

- The antagonist's goal is to _____ (*a specific, measurable accomplishment*), which makes the protagonist's outer journey to _____ (*write the protagonist's specific outer journey here*) impossible to achieve.

LOVE INTEREST: Who is it? How does this character inspire your protagonist to evolve and achieve his or her character arc?

- The love interest inspires the protagonist to become _____ (*cure of the inner journey*) by _____ (*list three specific examples on how the love interest inspires the protagonist to achieve his or her arc through action – not just saying to do it*).

MENTOR: Who is it? How does this person set an example for the protagonist and teach him or her how to achieve the outer journey?

- The mentor teaches/trains the protagonist how to _____ (*three specific physical actions*), without which the protagonist cannot accomplish _____ (*the protagonist's outer journey*).

ALLY: Who is it? How does this person back up the protagonist or illustrate the stakes involved with the pursuit of the outer journey?

- The ally provides backup for or reflects the outer journey to _____ (*state the outer journey here*) by _____ (*list three specific ways in which this character supports and takes actions that inspire the protagonist to carry on in his or her pursuit of the outer journey*).

Charting major plot points

Establishing prologue (crisis, character flaw and skill):
Escalation 1 (catalyst/inciting incident):
Escalation 2 (decision):
Pinch 1 (B-plot development):
Escalation 3 (consequences/midpoint):
Pinch 2 (B-plot development):
Escalation 4 (horror or hope):
Escalation 5 (ultimate showdown/climax):
Establishing epilogue (dénouement):

Plotting the story

Each number on the story beat sheet below must:

- Have meaningful conflict.
- Contain fresh plot developments, circumstances, and immediate goals.
- Generate three to five pages of script-worthy action and dialogue.

Act 1

1 Establishing prologue
2
3 Escalation 1
4

5
6 Escalation 2

Act 2A

1
2
3 Pinch 1
4
5
6 Escalation 3

Act 2B

1
2
3 Pinch 2
4
5
6 Escalation 4

Act 3

1
2
3 Escalation 5
4 Establishing epilogue

For a free digital download of this step-by-step outlining form, which you can use for any and all of your own script idea development, please go to: http://www. michaeltabbwga.com/download.

This *Step-by-Step Guide to Generating Stories* is a path of sequential steps laid out for you here. Now, it's your turn to do this with your story. I hope you find it as useful as it's been for me.

Reverse engineering from plot to premise

Figure 17.1 Brent Sprecher – Now that you know how to construct a meaningful premise into a full-fledge story idea, you have the knowledge to do it all in reverse as if you have a story time machine. With the deductive intellect of *Sherlock Holmes* (Warner Brothers), the daring of Robin in *The Adventures of Robin Hood* (Warner Brothers), and the guidance of someone always working in reverse to figure things out like Leonard in *Memento* (Newmarket Capital Group, Columbia TriStar, Summit Entertainment, AMBI Pictures).

"The longer you can look back, the farther you can look forward."
—Winston Churchill, speech (1944)

Why would any writer develop a story foundation in reverse?

This chapter is for writers who already have a story and must now reverse engineer a properly crafted foundation and soul into a preconceived story idea. There are many reasons a writers might find themselves facing such a task:

1 Newer writers decide to start writing because they have what they think is a great idea for a book, show, or film. That's traditionally what I have seen inspire men and women to take up the proverbial pen for the first time.
2 Writers are often inspired by stories that are currently in public domain. We all recognize that Hollywood is far more likely to bet on characters and stories that already have a history of success with audiences. We see this phenomenon with the endless barrage of revamped versions of Sherlock Holmes and Robin Hood stories. A fresh and original take on something with name recognition goes a long way.
3 This developing in reverse also applies equally to historical, true, or biographical stories inspired by real people and events. Recognition value is why we see so many true stories on film.
4 The most common writing job for a professional screenwriter is when he or she is given the opportunity to pitch on or write a specific preexisting project for a production company or studio. Whether it's working on an adaptation, performing a rewrite on a preexisting script, or writing on a TV show someone else created, a working writer will need to know how to dig down to the roots of a story and fertilize them with fresh and fitting ideas.

In any of these cases, a writer needs to be capable of reverse engineering all the way back to pinpoint a powerful and original premise just as tailor-made for the story as when the story is born from a premise. So, I use this technique for fleshing out the foundation of adaptations, true stories, or original story ideas. Once the screenwriter has selected a story to develop, the writer reverse engineers a strong foundation for the script and gets the layout in order.

Remember, the protagonist's inner journey leads us to and proves the premise. The premise is the core foundation we are trying to root out with this process because it's from the premise we can construct outward and upward. When these things are not readily clear in the source material, be it a historical event-based film or in the case of adaptation, the screenwriter is tasked with the difficult job of trying to sculpt these foundational elements out of the giant block of story. The deconstruction process and order is explained below.

The steps for reverse engineering anytime the writer begins with plot/story idea:

1 Identify the dominant genre.
2 Identify the A-plot (the main story for the script), which must suit the dominant genre. For adaptations of true stories and other source material, you do

this by pinpointing the climax and figuring out what the endgame is for the main characters.

3 Writers also hone in on an A-plot because it identifies the protagonist's outer journey. Once you figure out what the outer journey is, you can begin to ask yourself which character's perspective is the best one through which to witness that mission. We're not just looking for a protagonist.

4 Identify the central character of that main plot. It's not always clear which character it is when dealing with adapting from other mediums into screenplays. The central character will be the character that makes the difficult choices. Those choices trigger the major structural escalations (as explained in the previous chapter). Sometimes it's not one character that makes those large choices in a book or true story, and the writer will need to figure out which character will best fall into that role of making more of those decisions in the script. Central character selection is part of the arduous task that stems from adapting historical events or preexisting intellectual property (IP) into screenplays. For example, novels often have several plot lines and don't always follow a single character's point of view. When such a tome is being adapted, massive simplifications need to be made so the story can be curtailed into a two-hour, visual story that feels complete. This is why some of the best literary-based adaptations come from short stories, not novels. Short stories are traditionally more focused. If there is some confusion as to which character the writer should focus on, an experienced screenwriter hedges his or her bets with a strong protagonist. That said, this step is to identify the central character.

5 Now, identify the protagonist with a significant character arc, which is often and ideally the central character but not always. Pick the active character with the largest character arc. Yes, size matters. The reason is because the larger a character arc is, the clearer direction that writer will have to find the premise.

6 Write out the exact inner journey of the protagonist, going from _____ to _____. If it helps, think of this in terms of identifying what the protagonist wants (outer journey), and, more important, what that character actually needs, whether he or she knows it or not. The latter leads to identifying the inner journey.

7 It's time to define the unique, meaningful premise of the screenplay using the inner journey and outer journey for direction, bridging the A-plot (outer journey) and the character arc (inner journey) into a single cohesive story with something important to say (premise). Find that original truth buried deep within the actions and characters of the story.

8 This is where you start building outward again. Make a list of the most memorable moments from the source material. The more visual these are, the better. Can you tie them to the genre in more visual ways? The hardest part for any adaptation is having to cut some of the wonderful details and nuances

from history or the original source material because there simply isn't enough space in a screenplay to include them all. That's why going back and locking down a premise is so important. Premise helps the writer select which of all those great details takes precedent for making it into the final, darmatically shorter screenplay.

9 Adjust where necessary to make the story more cinematic and the premise clearer. You can flesh out the complete picture of the foundation elements with a premise and genre-based brainstorm with jaw-dropping visualizations for a visual medium. You expand upon the original story and open up your mind beyond the source material's confines. Consider the potential global as well as personal stakes.

10 Start to build outward by making sure the other major character types are designed properly as follows:

a The antagonist should have his or her own exceptionally strong motives to achieve a goal that require the protagonist to fail in achieving his or her outer journey.

b Define the love interest by how he or she inspires the inner journey.

c Identify the protagonist's allies in the pursuit of the outer journey.

d Decipher if there is a mentor among the allies and explore how he or she teaches or trains the protagonist to achieve the outer journey.

11 Write the logline.

12 Identify or create a proper genre-based establishing crisis that brilliantly illustrates the character flaw and highlights the protagonist's related skill to kick off the story.

13 Identify or create the five three-act structure-escalation beats.

14 Identify or create the epilogue that best illustrates life in the wake of those escalations and how everything is different as a result of the character arc as a counterpoint to the prologue's establishing of the character flaw.

If you plan on pitching the idea (like for an open writing assignment), pinpoint the 10 most visually cinematic beats of the story, including the major structural escalations, being sure to find inspiration from the most exciting parts. Put them in order of intensity with the most intense being last. This is what you'd pitch to buyers. A pitch should be about 10 minutes.

To sum up this approach, no matter what your reason for reverse engineering your screenplay and working from the outside inward to find the heart of the material, this is how I make sure that the work I create still has a soul.

Thank you for being the kind of person who cares enough about our craft that you read this book. I wrote it specifically for you in hopes that one day you will take these concepts and flourish. And remember, when you figure out things that I never did, pass on what you learned. Write an article. Write a book. And write well, my friend.

The final exercise

Select one of the following:

- A story idea you have and want to write
- A true story or preexisting IP over 75 years old in the public domain (just make sure your version of this story is not similar to someone else's adaptation from within the last 75 years for copyright infringement reasons)
- A more recent story or IP that you wish to adapt (after you make sure the rights are available for purchase)

Run your chosen concept through the 15 steps mentioned above.

If you *love* what you have come up with, start writing, unless you must first purchase the adaptation rights.

Good luck and good writing!

One last thing . . .

My next book on the craft of screenwriting is about the final process of making a good script read better. It's a breakdown of all the editing tricks this WGA writer uses when polishing a script.

Learn more about me and sign up for updates at **www.MichaelTabbWGA.com**.

Final words of advice

Informed writers learn the rules so well that they can eventually set them aside and finally, truly play with craft. Similarly, an actor can only surrender to the call of a character once he or she learns his or her lines and can put down the script. If a writer wants to evolve beyond common storytelling devices and the screenwriting books everyone has read in order to evoke the best and most creative results from their brains, that writer must start by learning the rules. Once a writer has truly absorbed the great screenwriting gurus, he or she should consider where deviation from the tried-and-true methods would work for that writer and screenplay.

My bibliography contains the cream of the crop books on the craft of technical screenwriting standard practices. Those books should be in every screenwriter's library. Why? They lay out the rules that the well-read, smarter nonwriters who work in our industry understand; knowing that language is crucial to success in the industry. I still plot a concept during the development process in this formulaic way, which is exceptionally important when you have to explain your story to others. Therefore, it makes perfect sense for a film school to teach students the black-and-white concepts with definitive rules.

That said, if everyone writes by the same rules all the time, the same scripts will keep getting written. This reasoning explains why so many scripts read so predictably and seem so formulaic. Therefore, some of my perspectives contradict previous notions in my character-type definitions, but this is just how I see it. I have theories based on successful, previously produced films and tricks that have led to me having a career in screenwriting.

A wise screenwriter makes "informed decisions" to violate established rules. Such decisions form the point of convergence at which a skilled craft evolves into art. Every professional writer should develop his or her own approach to the writing process. Individualizing how story comes together and characters fulfill their purposes in a script is an important part of any writer's evolution. That personalization is a part of mastering the craft. All writers have the ability to custom design personal techniques for getting characters to speak to them. Making these decisions is how great writers learn to break the rules in a way that declares their individuality in their work. The rules constantly evolve in art to keep it fresh.

If I teach a class, I expect students to use my techniques, but I would never expect anyone to stick to my methods alone. Give them a try, use the lessons that work for you specifically repeatedly, and ditch the rest. My editing motto has always been, "Keep the best and cut the rest." Fill in any gaps with the techniques of other writing philosophies that work best for you in order to find your individual story development process or invent your own. I end with a toast to your evolving artistry. Cheers!

Bibliography

My resources and recommended books

Aristotle. *Aristotle's Poetics*. New York: Hill and Wang, 1961.

Campbell, Joseph. *The Hero with a Thousand Faces* (2nd ed.). New York: Pantheon Books, 1968.

Chitlik, Paul. *Rewrite: A Step-by-Step Guide to Strengthen Structure, Characters, and Drama in Your Screenplay* (2nd ed.). Studio City, CA: Michael Wiese Productions, 2013.

Egri, Lajos. *The Art of Dramatic Writing: Its Basis in the Creative Interpretation of Human Motives*. New York: BN Publishing, 2009.

Field, Syd. *Screenplay: The Foundations of Screenwriting* (rev. ed.). New York: Delta, 2005.

Froug, William. *Screenwriting Tricks of the Trade*. Hollywood, CA: Silman-James Press, 1992.

Goldman, William. *Adventures in the Screen Trade: A Personal View of Hollywood and Screenwriting* (reissue edition). New York: Grand Central Publishing, 1989.

Hauge, Michael. *Writing Screenplays That Sell, New Twentieth Anniversary Edition: The Complete Guide to Turning Story Concepts into Movie and Television Deals*. New York, HarperCollins, 2013.

Martell, William C. *The Secrets of Action Screenwriting*. Hollywood, CA: First Strike Productions, 2000.

McKee, Robert. *Story: Substance, Structure, Style and the Principles of Screenwriting*. New York: Regan Books, 1997.

Stanislavski, Constantin. *An Actor Prepares*. New York: Taylor & Francis, 1936.

Swain, Dwight V. *Techniques of the Selling Writer*. Norman, OK: University of Oklahoma Press, 1981.

Trottier, David. *The Screenwriter's Bible* (6th ed.). Hollywood, CA: Silman-James Press, 2014.

Truby, John. *The Anatomy of Story: 22 Steps to Becoming a Master Storyteller*. New York: Farrar, Straus and Giroux, 2008.

Vogler, Christopher. *The Writer's Journey: Mythic Structure for Writers* (3rd ed.). Studio City, CA: Michael Wiese Productions, 2007.

Walter, Richard. *Essentials of Screenwriting: The Art, Craft and Business of Film and Television Writing*. New York, NY: Plume, Penguin Group, 2010.

Watt, Ian. *The Rise of the Novel: Studies in Defoe, Richardson and Fielding* (notations ed.). Berkeley, CA: University of California Press, 1974.

Additional works cited

Chekhov, Anton. *The Unknown Chekhov: Stories and other Writings of Anton Chekhov Hitherto Unpublished.* Translated by Avrahm Yarmolinsky. New York: Farrar, Straus and Giroux, 1954.

Coffin, William Sloane. *Credo.* Westminster: John Knox Press, 2004.

Dickens, Charles. *Great Expectations* (2nd ed.). London: Penguin Classics, [1861] 2003.

Hemingway, Ernest. *Death in the Afternoon.* New York: Scribner, 1932.

Hemingway, Ernest. *The Old Man and the Sea.* New York: Scribner, 1952.

Lukyanenko, Sergei. *Night Watch.* New York: HarperCollins, 1998.

Romano, John. "James Baldwin Writing and Talking," *New York Times*, September 23, 1979.

Salinger, J. D. *The Catcher in the Rye.* New York: Little, Brown and Company, 1951.

Shakespeare, William. *Shakespeare's Titus Andronicus: The First Quarto, 1594*, ed. Joseph Quincy Adams. New York: Charles Scribner's Sons, 1936.

Special thanks

Caitlin, Elijah, and Natalie Tabb – The three reasons I never give up on life and its meaning.

Christa Tabb – Who used to meticulously read everything I wrote too many times. I'm so grateful.

Uncle Donald and Aunt Sheila – Those kindly relatives who used to let me read my stories to them before I was any good

Karl Stenske and Jason Lowe – My high school pals and fellow cinephiles

Daniel R. Trevino – My high school drama teacher, who taught me that a career in the art is serious work

Full Sail University, program director *Noelani Cornell* and the students who inspire me to keep giving back, including lifesaver Denise Deems and my Course Director's Award recipients

Writers Guild of America, West, my union, whose sole mission is to protect and nourish all entertainment writing professionals

All those writers and friends who have read my scripts and given me extensive feedback time and again over the years with absolutely nothing in it for themselves, including:

Shane Abbess	Frank T. DeMartini	Marlana Hope
Chris Alexander	Ian Dietchman	John P. Nelson
Alex Barder	Carleton Eastlake	Peter Hyoguchi
Karen Barna	Allen and Susie Estrin	Vicky Jenson
Robert Bella	Ethan Feerst	Doron Kipper
David Eric Brenner	Eric Gable	Randy Kiyan
Adam Buchalter	Clifford J. Green	Aaron Mason
Andrew Caldwell	Jake Guswa	Thia Montroy
Jonathan Callan	Jack Herrguth	Jerrod Murray
Peter Cornwell	Donald Hewitt	Eduardo Penna
Kenneth Cosby	Isaac Ho	Stephanie Reuler
Steven de Souza	Erich Hoeber	Joe Riley

Andrew Robinson	Joelle Sellner	Stephanie Waterhouse
Andrew J. Rostan	Richie Solomon	Joseph Weisman
Brian Rowe	Sean Sorensen	Julie Anne Wight
Glenn Sanders	Dylan Stewart	Micah Ian Wright

and the wise and incomparable Garrick Dowhen. He helped make this book infinitely better.

I would be less than I am without you all.

Illustrators

Foreword

Jason Lockwood (illustrator) and Denise Deems (letterer)
www.jasonjlockwood.com

Chapter 1

Greg Lee Dampier
www.gregdampier.com

Chapters 2, 3, 4, 6 (Hollywood Squares: Villain Edition), **9** (Guidance Counselors), **10, 11** (Bowling), **12** (Legally Blond), **and 13**

Jacob Redmon
jnredmon603.wixsite.com/redmonstermedia

Chapter 5 (Protagonists)

Brandon Perlow (illustrator) and Denise Deems (letterer)
www.newparadigmstudios.com

Chapter 6 (Monster/Disaster Antagonists)

Brian Lathroum
www.thepictaram.club/instagram/insomnia_customs

Chapter 7

Robert Carrasco
www.instagram.com/artofrobertcarrasco/

Chapter 8

Lauren Maria Gruich
www.laurengruich.com

Chapter 9 (False Mentors of *Harry Potter*)

Kaitlin "Katt" Cassidy
www.facebook.com/ArtOfKattCassidy

Chapter 11 (Call Center)

James Baggett
www.facebook.com/jamesbaggettartdesigns/

Chapter 12 (Protagonists' Allies)

Matt Mitchell
www.Rebel-Studio.com

Chapters 14 and 15

Paul Mendoza
www.pauljmendoza.com

Chapter 16

Michael Sanborn
www.msanborn.com

Chapter 17

Brent Sprecher
https://brentjs.deviantart.com

About the author

Michael Tabb is a decade-long current and active member of the Writers Guild of America, West (WGAW). He has developed projects for and with Universal Studios, Disney Feature Animation, Intrepid Pictures, Paradox Studios, and Imagine Entertainment; comic book icon Stan Lee; producers Lawrence Bender, Mark Canton, Sean Daniel, David Hoberman, and Paul Schiff; directors Mike Newell and Thor Fruedenthal; fellow screenwriters Jonathan Hensleigh and Evan Spiliotopoulos; and Academy Award–winning actor Dustin Hoffman, to name a few.

With a love of giving back, Michael has spoken on entertainment writing for UCLA, NYU, USC, Florida State University, Columbia College of Chicago's Semester in L.A., the Florida and San Diego Writers Conferences, the Screenwriters' World Conference, Comic-Con International, various film festivals, and his union, the Writers' Guild of America, West (WGA). Michael volunteered time to guest instruct inner-city youths for the Writers' Guild Foundation Community Outreach Program and serves on the WGAW's Writer's Education Committee. He co-created and spearheaded the WGA Mentor Program from its inception for its New Members' Committee. Michael is a multiple award–winning MFA screenwriting educator for Full Sail University. He was educated at USC, NYU's Tisch School of the Arts, and UCLA's School of Theater, Film & Television Professional Program in Screenwriting.

Endorsements

WGA scriptwriting professionals who endorse the book

"Tabb's book asks you to look deep within yourself and answer a fundamental question; why are you writing this particular story? Why are you even writing in the first place? It gives you some very pragmatic tools to help make your writing more soulful and authentic."

– David S. Goyer
WGA Screenwriter/Creator
The Blade and *Batman Begins* trilogies, *Dark City, Jumper, The Puppet Masters*

TV's *Krypton, Da Vinci's Demons, Constantine, Flash Forward*

Games *Call of Duty: Black Ops I & II*

"A comprehensive, honest, and heart-felt look at the craft of screenwriting. Writers at all levels will find something in this book to inspire them to do their best work."

– Nicole Perlman
WGA Writer
Guardians of the Galaxy

Upcoming films: *First Man, Captain Marvel, Black Widow, Detective Pikachu, Sherlock Holmes 3*

"The best way I can think to get yourself writing again if you're stuck would be to have Michael Tabb come over with a bottle of bourbon and a couple of glasses and talk you through things. The second best way would be to buy this book and read it. You can supply your own bourbon."

– Bill Prady
WGA Writer/Creator
The Big Bang Theory, The Muppets, Gilmore Girls, Dharma & Greg, Caroline in the City, Dream On

"Michael Tabb has thought long, hard, and usefully about how to write screenplays with vision and intent. He understands premise, character, conflict, drama; far more importantly, he can impart wisdom about all of them without condescending or 'dumbing down.' I know of no better guide to the work of writing that happens before we write."

– Howard A. Rodman
President, Writers Guild of America (WGA)
WGA Writer
August, Saving Grace, Takedown

"Are you a writer? Then you're a fraud, right? Every time you stare at that empty page, you feel it in your bones. The movies I have written have grossed over 5 billion in box office, and STILL, I feel like a fraud every time I start a new project. When I read Michael's book, I felt a lot better. Michael is not only a great screenwriter, but he understands how to explain screenwriting in a way that I never could and in a way that helped me move forward. It is so strange to have a decent man you know help you, through his writing, help you become a better writer. I got a free copy of his book on my shelf, but I would've paid for it. Writers like Michael who help other writers understand the art or the craft of screenwriting are truly among our best and brightest. Think about it. He is helping his own competition! Only a wise and true class act would ever do that. This book is yours. Consume it!"

– Roberto Orci
WGA Writer/Creator
Transformers 1 & 2; Star Trek 1, 2, & 3; The Amazing Spider-Man 2; People Like Us; The Legend of Zorro; Mission: Impossible III

TV's *High School 51, Sleepy Hallow, Hawaii Five-0, Fringe, Alias, Matador, Xena, Hercules*

"Tabb provides an insightful and engaging guide to the process of breaking story and character. Writers looking to set a strong foundation for their first or next script would be well served by reading *Prewriting*."

– Carlton Cuse
WGA Writer/Creator
San Andreas, Rampage

TV's *Tom Clancy's Jack Ryan, Lost, The Colony, Bates Motel, The Strain, Nash Bridges, Martial Law, Crime Story*

"It's vitally important for aspiring writers to understand that a professional screenwriting career is built upon the relentless pursuit of asking the right creative questions and then finding the most satisfying answers. In his new book, *Prewriting Your Screenplay*, writer and teacher Michael Tabb generously shares his innovative approach to meeting that challenge. His original method of generating story,

character, and theme will be valuable to both veterans and novices, and should help any writer get past the fear of writers block."

– Jeff Melvoin
Emmy-award winning television writer-producer
Chair of the Writers Education Committee of the
Writers Guild of America, West
*Designated Survivor, Army Wives, Alias, Early Edition,
Northern Exposure, Hill Street Blues, Remington Steele*

"I wish I had this book when I was just starting out – but it's still immensely helpful. An indispensable handbook of the craft written by a seasoned veteran and accomplished writer. A must read for anyone serious about screenwriting."

– Marc Guggenheim
WGA Writer/Creator
Percy Jackson: Sea of Monsters, Green Lantern

TV's *Arrow, Legends of Tomorrow, Troll Hunters, No Ordinary Family,
Eli Stone, CSI: Miami, Law & Order*

Games *Singularity, X-Men Origins: Wolverine,
Call of Duty 3, Perfect Dark Zero*

"The book every writer has been waiting for – a step by step guide to nourish and develop your idea for a screenplay, book or story. Invaluable and vital."

– Evan Spiliotopoulos
WGA Writer
*Beauty and the Beast, The Huntsman: Winter's War,
Hercules, Tinker Bell and the Lost Treasure*

"Michael understands the nuts and bolts of storytelling like no one else – Whether you're penning your first script or your thirtieth, this book will make you a better writer."

– Damon Lindelof
WGA Writer/Producer/Creator
Star Trek (2009), *Star Trek Into Darkness, World War Z, Prometheus*

TV's *Lost, The Watchmen, The Leftovers, Nash Bridges, Crossing Jordon*

"Michael Tabb's book will challenge writers to do the hard work in polishing that rough idea into a clear artistic vision. I wish this book was around when I was writing my first screenplay, or even my forth screenplay."

– Edward Ricourt
WGA Writer
Now You See Me 1 & 2, Jessica Jones, Wayward Pines

"Teachers of screenwriting often miss the most basic truth that writing should be fun and that writers should work from their gut, not from their fear of rejection. In *Prewriting Your Screenplay: A Step-by-Step Guide to Generating Stories*, Mike Tabb simplifies the process of story writing and character development to its most essential elements, in the process inviting the reader to embark on the joyful journey of self discovery that is screenwriting."

– Douglas Day Stewart
WGA Screenwriter/DGA Director
*An Officer and a Gentleman, The Blue Lagoon,
The Boy in the Plastic Bubble, Thief of Hearts, Listen to Me*

"Writing for television means you cannot afford to have writer's block, and coming up with new ideas is the hardest part of the job. I wish I'd read this book years ago! *Prewriting* has an original premise, which is only fitting for a book about original premises."

– Brannon Braga
WGA Writer/Executive Producer
Star Trek: First Contact

TV's *The Orville, Salem, Terra Nova, Flash Forward, 24, Star Trek:
Enterprise, Star Trek: Voyager, Star Trek: The Next Generation*

"Great advice for budding screen-writers and those more established. A rich resource to find the creative code and original strengths within yourself, and most importantly, tips on how to sustain passion for a project through the trial-by-fire of re-writes on the writer's journey to getting it produced and onto the screen."

– Alex Proyas
DGA Director/WGA Writer
I Robot, Gods of Egypt, Dark City, Knowing, The Crow

"Michael Tabb is a powerhouse. He's one of those writers that I envy – he is ALWAYS writing. Ever since I've known him he has constantly pumped out quality work at a steady pace. He's a machine! And, after reading *Prewriting Your Screenplay: A Step-by-Step Guide to Generating Stories*, I now know his secret. There are a lot of "how to" books on writing but Tabb's book is the first one I've come across that gets to the heart of the matter: how do we find a consistent method of digging out our deepest authentic feelings and ideas? If you have ever stared at your blinking cursor on a blank page, this is the book for you. Michael Tabb proves that we all have our own stories that need to be told. We think manifesting them is hard work, but Tabb shows us it is effortless."

– John Lehr
WGA Writer/Creator
10 Items or Less, Quick Draw

"All too often, screenwriters, eager to start writing, will be tempted to skip the hard work that needs to be done before typing the words 'FADE IN.' That's why so many screenplays, even by talented writers, are doomed from the start. Now, screenwriter and screenwriting teacher Michael Tabb comes to the rescue with a book centered on the all-important work the writer must do beforehand, the most neglected, challenging, and rewarding part of the process. Grounded in Michael Tabb's deep understanding of how a premise is created and how characters come to life, *Prewriting* identifies each step of what for many is a chaotic, or even subconscious, process. This invaluable book combines those insights with down-to-earth, practical observations on the influence of genre, the varied functions the characters could fulfill, and how screenwriters can approach the story building process more systematically and more creatively at the same time. *Prewriting* offers thoughtful, practical and creative advice on all aspects of building a successful screen story. This should be on every screenwriter's bookshelf."

– Daniel Petrie, Jr.

WGA Writer

Beverly Hills Cop, Turner & Hooch, Shoot to Kill, Toy Soldiers,

TV's *Combat Hospital*

Educator endorsements

"In the ever-burgeoning catalogue of books treating screenwriting, Prewriting is an authentic standout. In fresh, accessible language, Michael Tabb posits provocative insights into the art, craft, and business of creating compelling dramatic narratives. The book is surely useful for screenwriters both new and experienced, but also for novelists and playwrights and, indeed, anyone interested in writing or reading or seeing on the screen well turned, engaging stories."

– Prof. Richard Walter

Screenwriting Area Head, Associate Dean

UCLA School of Theater, Film and Television

"All professional screenwriters know that screenwriting is half art and half science. Master teacher and accomplished screenwriter, Michael Tabb, knows a lot about both. In this important new contribution to the art and science of screenwriting, Tabb guides the novice and the professional through the absolute essentials of the screenwriting craft. He understands that the science side (the rules that all screenwriters must follow) are not an impediment to the art side (creative inspiration), but a requirement to it. Everyone who is currently making their living screenwriting and everyone who intends to should read this book. Immediately."

– Allen Estrin

Senior Lecturer, Screenwriting

American Film Institute (AFI)

"*Prewriting* is amazing! What I love is that this book is clearly written by a working writer. *Prewriting* does a fantastic job of breaking down the key elements and building blocks of screenwriting into simple terms. It provides a clear, step-by-step guide that is practical as well as creatively stimulating. As a working writer, I plan to rely on *Prewriting* as one of my new, go-to toolboxes. As an educator, I will make *Prewriting* required reading for all the courses I teach."

– Donald H. Hewitt
Screenwriting Lecturer
School of Theater, Film & Television
University of California, Los Angeles (UCLA)

"It's taken me many, many years to learn what Michael has distilled into this book. I wish I knew all these things when I first embarked on my career. I've been to USC film school, I teach at USC film school, and I've had stellar jobs working for ICM, Tom Cruise and Paramount Pictures just to name a few. But I can tell you that I would have gone further and faster had Michael's advice and guidance been available to me when I first started. He is knowledgeable, insightful, and he is right about what it takes to succeed as a writer."

– Sebastian Twardosz
Screenwriting Lecturer
School of Cinematic Arts
University of Southern California (USC)

"No sane person would attempt to run a marathon without training, would they? In my years of teaching screenwriting, I was amazed at how many of my students would balk at the idea of pre-writing, which includes premise building, character developing, structure plotting, and script outlining. What Michael Tabb's book does is give every student who loves writing a practical way to do all of that. He lays out each of the steps a writer needs to take before writing FADE IN, which are essential to creating a winning screenplay. This book gives the intellectual nutrition screenwriters need in order for them to start this screenwriting race. It helps guide writers to the choices they need to make in order to create a screenplay that works on all levels. I give *Prewriting* my highest recommendation.

– Kenneth Cosby, MFA
USC Screenwriting, Professor
NYU Writing for Television, Professor

"Michael Tabb. Screenwriting is a labor of love for him – and so is this book. The knowledge and experience he's gathered over the years has compelled him to document it and share it with others. My passion is and always has been television, but the same rules, structures, and hurdles apply. It's how I design the workshops I teach at UCLA. This is a scholarly, beautifully written (and illustrated) tome. It can apply to all forms of writing. Anything that needs an 'idea'. It's about process,

which is what writing is. Not formula. Process. And Mr. Tabb has processed it well!"

– Bill Taub
WGA Writer-Producer
UCLA Extension Writing Instructor

"Filmmaking, unlike other arts, is a collaborative form. No film can get made and profit (key phrase 'profit'), after the script is approved, without a Producer, a Director, a Financier and a Distributor who understand story. Michael's tome is a necessary read for all creatives to be able to thoroughly understand the story, its spine, its premise, its genre and how all characters within the story fit together in order to make & sell a successful movie. A Must Read."

– Dov S-S Simens
Dean
Hollywood Film Institute

"As a professional writer for Disney Animation and having written for Dream-works, The Weinstein Company and other major studios, I plan to use *Prewriting* to make my work even better. Mr. Tabb has distilled his story creating process into the most comprehensive and meaningful writing aid I've had the pleasure of reading to date. As an educator for Young Storytellers, I do and will recommend this book to writers of any age who want to be a professional storyteller in any medium. It explains how to develop a story with meaning, how to design charac-ters to serve that meaning, and gives its readers a series of exercises to help them create their own strong story foundations from scratch over and over again. It is accessible for beginners and will even push experienced writers to improve their craft. In short: Michael Tabb has written the newest, must-read textbook for all would-be writers in the entertainment industry."

– Ricky Roxburgh
Screenwriting Educator
Young Storytellers

"I'm a working film producer who's sold projects to all the majors, and began my teaching career at UCLA. I've taught at Pixar, DreamWorks Animation, and Blizzard, and conferences including Great American PitchFest, Screenwriters Expo, and Screenwriters World. I have devoted much of my career to persuading screenwriters, both the pros and my students, of the importance of pre-writing. It is far more effective than rewriting. Screenwriter and author, Michael Tabb, has not only persuasively made this case in his book, *Prewriting*, he offers up a comprehensive set of powerful tools to completely craft a successful script *before* you type 'Fade in.'

While there is a universal acceptance that 'Concept is King,' there are few answers offered on how to come up with a great idea. This is the first book I've read that teaches you how to brainstorm in search of inspiration. Tabb lays his

own process bare so you can learn from him. I love Tabb's discussion of genre – pertinent, penetrating, and insightful. And to a story geek like me, downright sexy.

Prewriting takes you through discovering your story's thematic premise, to choosing the most impactful genre, crafting compelling characters, and ultimately incorporating these elements into a powerful story. Tabb motivates you to progress through the steps with invaluable information, enlightening examples, and skill building exercises, until you have created the foundation for a truly a successful story."

– Barri Evins
Producer and Story Consultant

"What do you want to say with your story? If you want to have a clearer understanding of how to define this in your writing, you will want to read Michael Tabb's book, *Prewriting*. Michael dives deeply into the WHY, creating a compelling debate with your story, genre, writing characters with purpose and intention and so much more. I devoured this book. It is in direct alignment with a lot of what I teach. Michael's approach is totally accessible. You will hit many 'aha' moments that will elevate your writing to the next level. I very highly recommend this book."

– Jen Grisanti
Story/Career Consultant
Writing Instructor at NBC, Author, International Speaker

"With *Prewriting*, experienced screenwriter Michael Tabb is your intense and passionate guide through the step-by-step process of designing a story from the inside out. Challenging many of the assumptions of conventional screenwriting theory, he shows you how a pro really lays out the internal wiring diagram of a story. With batteries of probing questions to ask yourself about your characters and premise, he defines the advance groundwork that allows you to start the script with confidence that your story will be coherent and meaningful. An important contribution to our body of knowledge about screenwriting and story development."

– Christopher Vogler
Author
The Writer's Journey

"At last, solid guidance on what to do and the decisions to make *before* you start writing your screenplay. Just as a movie has a preproduction stage, so a screenplay has a prewriting stage."

– Dave Trottier
Author
The Screenwriter's Bible, Dr. Format Tells All, and host
of *keepwriting.com*

"A great screenplay begins with a great plan. With Michael Tabb's fantastic new book, writers now have the tools to do what is so difficult for many: face the blank

page with confidence and conviction, armed with the knowledge and guidance required to lay down the sound, thoughtful foundation required to produce a great screenplay, and never get writer's block again."

– Lee Jessup
Career Coach for Professional and Emerging Screenwriters
Author, *Getting It Write: An Insider's Guide to a Screenwriting Career*

"The consummate writer's writer, Michael Tabb will forever change the way you look at story, premises and character through his insightful approach to PREwriting, screenwriting and brainstorming. Michael gets inside the thought process of story and premise development in a fun way no one else has. With a nod to the masters, Michael's on-point analyses, exercises, and advice is a game-changer for writers at every level looking to defeat writer's block and create compelling stories. I cannot recommend this book highly enough."

– Danny Manus
CEO/Script Consultant, No BullScript Consulting
Director of Development, Clifford Werber Productions
Development Consultant, Eclectic Pictures
Director of Development, Sandstorm Films

"Michael Tabb brings not only his industry experience but also insightful, inspiring, and engaging educator to the pages of *Prewriting Your Screenplay*. Tabb engages the reader with a conversational approach to understanding the narrative components of screenplay construction. This is a master class in the art and the craft of screenwriting taught by a working screenwriter. *Prewriting* belongs on the same shelf as Egri's *Art of Dramatic Writing* and McKee's *Story: Substance, Structure, Style, and the Principles of Screenwriting*."

– Christopher Ramsey
Department Chair and Educator
Creative Writing Program
Full Sail University

"Michael Tabb takes readers and writers on a fun and inspiring journey where the ideas pop out and the words flow freely. *Prewriting Your Screenplay: A Step-by-Step Guide to Generating Stories* is a must read for anyone who struggles with or has ever struggled with writer's block. The advice and expertise that Tabb so generously shares with the reading public are invaluable for aspiring writers or seasoned writers who know what it's like to stare endlessly at that blank page on the computer screen. I feel like I've been let in on a secret that only a select few, elite writers knew – until now. As an educator, I can't wait to refer my students to this book when they complain, and they always do, of the most severe cases of writer's block."

– Stephanie Fleming
Faculty
Los Angeles Film School

"Michael Tabb might be the only film instructor to get me teary-eyed in class . . . and it was during his twenty minute practice lecture! *Prewriting* combines Michael's encyclopedic knowledge of film & writing and his love for the possibilities of art. Michael speaks to the reader plainly, honestly and with a real connection to the material. As a guide for a writer, it offers encouragement, concrete advice and sagely caution about the pleasures and potential pitfalls of creating any type of story. He provides sharp ideas for readers looking to develop their structure, genre, style and character, making this a valuable asset for experienced writers and newbies alike. Any screenwriting book equally adept at quoting Shakespeare and "Real Genius" warrants your attention!"

– Eric Conner
Former Screenwriting Department Chair, New York Film
Academy (NYFA)
Former Dean of Students, NYFA
Current Screenwriting Instructor, NYFA

"In regards of Michael Tabb, I consider him one of the top authorities in this field due to his wealth of knowledge on screenwriting and cinema history based on the professionalism and passion with which he shares them in this book, *Prewriting Your Screenplay: A Step-by-Step Guide to Generating Stories*. Michael shows us the basic tricks of storytelling necessary to craft a clear and concise tome. He does this with examples, anecdotes, and exercises that provide the reader an understanding of the steps required for proper story development, including character archetypes, genre selection, conflict, and structure building. As a screenwriting teacher, I would present this book to my students with confidence that they will receive a wealth of information, insight, and experience from a great teacher and screenwriter. Michael Tabb's *Prewriting* is absolutely a must read!"

– Edward Santiago
Beginning Screenwriting Lecturer
Austin School of Film

"In *Prewriting Your Screenplay: A Step-by-Step Guide to Generating Stories*, Michael Tabb raises critical questions that have long concerned writers and educators. Who's the hero when our main character does not fit the traditional stereotype? How do we avoid writer's block? What does a premise need to do? Why is genre relevant? How do character flaws make our protagonist stronger and clearer? What does love have to do with our protagonist and the story? And, how do genre trends affect a writer's decision-making? Tabb's book also includes many other thought-provoking questions, measurement exercises, and specific film references to challenge the reader to look at their work from a new perspective. Anyone involved in screenwriting or the development of film will treasure this book because it provides another avenue to help filmmakers become more

observant, reflective, and introspective. *Prewriting* helps us all create more professional screenplays."

<div align="right">

– DR Fraley
Transmedia Storytelling Producer
Department of Communications, Media & Culture
Bryan College

</div>

Prewriting is a uniquely riveting how to book that's written from the heart. I laughed. I cried. I was inspired yet again. Michael's love for screenwriting shines through with each and every word as he proves John Steinbeck wrong – writing is indeed not magic but can be quickly learned even from a zero baseline. As both a student and a teacher, I highly recommend this soon-to-be screenwriter's bible prequel, which should be required reading for any student of the craft."

<div align="right">

– Constance Younger, MS, MFA
California Certified Educator
Platt College

</div>

Index

Partial listing of movies mentioned